AFTER THE TEMPEST

After
the
Tempest

> *A novel* <

JOHN MENKES

2003 > FITHIAN PRESS, MCKINLEYVILLE, CALIFORNIA

Cover photo: "Blutgasse in Vienna" by Andreas Poeschek

Published by Fithian Press
A division of Daniel and Daniel, Publishers, Inc.
Post Office Box 2790
McKinleyville, CA 95519
www.danielpublishing.com

LIBRARY OF CONGRESS CATALOGING-IN-PUBLICATION DATA
Menkes, John H., (date)
 After the tempest : a novel / by John H. Menkes.
 p. cm.
 ISBN 1-56474-420-5 (pbk. : alk. paper)
 1. Jewish women—Fiction. 2. Holocaust, Jewish (1939-1945)—Fiction.
 3. Holocaust survivors—Fiction. 4. Vienna (Austria)—Fiction.
 I. Title.
 PS3563.E527A68 2003
 813'.54—dc21
 2003001286

To EM

There, sir, stop.

Let us not burden our remembrance with

a heaviness that's gone.

SHAKESPEARE, *The Tempest*, Act V, Scene I

AFTER THE TEMPEST

1948

T HE FLIGHT WAS ENDLESS. To start with, the departure of the Pan Am plane destined for Frankfurt and Vienna was more than two hours late. No one knew what the problem was. The purser's voice came over the intercom and reassured everyone that there were "a few minor mechanical problems that we are in the process of straightening out." That did little to appease passengers who had to remain in their seats and who were growing increasingly restless. When the plane finally did take off and had reached its assigned altitude, it encountered such strong headwinds that it was forced to put down in Newfoundland to refuel. It would be a brief stop, the captain declared, and passengers who chose to were permitted to disembark.

Careful not to disturb the young man in the seat next to her, Judith joined a pair of well-dressed, gray-haired Italian ladies. Together with several clusters of other passengers they left the plane and were shepherded into a cold and bare departure lounge. Bleary with lack of sleep and uncertain of time and place, they stood under travel posters of picturesque Newfoundland fishing villages.

"How do I look?" One of the Italian ladies asked as she opened her

large black crocodile leather purse and removed a mirror. She was wearing a cameo: the profile of a Roman lady with an aquiline nose.

"How does anyone look at this time of the night?" The women spoke broken English.

Snatches of conversation surrounded Judith.

"There's too much fog for us to take off."

"We're probably waiting for a change of crew."

A stewardess wheeled a trolley with hot tea and coffee through the lounge. She looked cold and resolutely efficient, unable or unwilling to respond to passengers' questions except to reassure them that the plane was almost done refueling and that it would not be too long before reboarding could start.

A fine spray of rain clung to the windows of the lounge and wrote an indecipherable script on the glass. Outside the night was cold and foggy. The lights lining the road that led to the airport gave forth milky cones, which dissolved in the darkness.

The tea was hot and strong.

"Where are you going?" one of the women asked Judith. Her nose was red and desperately needed powdering. Before Judith had time to answer, the woman wearing the cameo murmured something to her in Italian. From the tone in her voice it sounded like a complaint.

"My friend says that airlines have become very unreliable. Even American airlines. And the service is so impersonal. Don't you agree?"

"Do you fly often?" Judith responded.

"Not very often." The women lapsed into silence.

At last it was time to return to the plane. Judith's neighbor was still asleep; he stirred slightly as she settled herself back into the seat.

After the usual apologies came over the intercom the plane rose into a night of swirling dark winter clouds. Winter comes early to Newfoundland.

><

1934

In her dream—or was it in her memories—she saw herself at seven in
a land of swirling dark winter clouds, standing in a large room that
was brightly lit and warmed by a green tiled oven. The tapestries were
soft and furry to the touch, so that when she ran her hand over them
it was like petting a cat. The door to the kitchen was open. Through
it streamed the tempting warm odor of baking: hot yeast and choco-
late, cooked apples finely sliced to fill the strudel, and the sharp pun-
gency of brewing coffee. The dining room table had been covered
with an embroidered white cloth, and there were rows of knives and
forks, of spoons and napkins, saucers and upside-down cups awaiting
the birthday party. It was two o'clock; two hours before her party was
to start. Two hours seemed so endless, she did not know how she
could ever manage to wait. She had been dressed since lunch—a
white taffeta skirt, black patent-leather shoes that tapped as she
walked across the parquet floors—and her blonde hair was combed
out into two pigtails that reached almost down to her waist. She had
invited ten girls, but two of them could not come and neither could
Anton Kermauner. Anton was special and was the top person on her
list, even though her parents had not permitted her to invite him.

She had known that they would not let her invite him, even be-
fore she had written down his name. It was not because he was a
boy—her father said it was, but she did not believe him—rather
there was something else about him, something she could not under-
stand, and her parents did not want to tell her.

"Look at it, isn't it gorgeous?"

Marushka brought in the cake with its chocolate frosting so warm
that it must not be touched, and placed it on the side of the table fur-
thest from the oven. There it stood immensely tall with seven can-
dles inserted into a red and blue number seven.

Even though it was still early, Marushka turned on the lights and
they shimmered festively through the blue and white glass chande-
lier. The blue glass chandelier was the prettiest of all the chandeliers

in the house, not only because blue was her favorite color—it was a so much more well-behaved color than red—but also because the light was no longer the same when it came through the glass and fell across the white tablecloth. It almost looked as if ink had been spilled on the cloth, but of course since there was really no stain, she could enjoy the color without being scolded for spilling ink.

What a lovely chandelier it was, very modern, very expensive, and very easily broken. She and her mother had bought it on the Kärnt-ner Strasse, and it made such a large package they could not carry it home. Instead, two red-faced men with huge, rough hands and green visor caps had brought it to the house the following day. She had watched them mount it on the ceiling, amazed at how they managed to do so without breaking any of the glass tassels. Once when a bolt would not go in the way they wanted it to, one of the men had used a bad word. She knew it was a bad word, even though she could not tell what it meant.

All that had happened two years ago when she was still only five—in fact it may have been on that same shopping trip to the Kärntner Strasse that she had wet herself. Warm at first, it had soon become cold as it trickled down along the inside of her thighs. She had felt red and hot in the face when it had happened, speechless, only want-ing to hide. It turned out not to be so bad after all, for she was not slapped or even scolded. Instead her mother had taken her down the stairs into a public toilet, a small room that smelled horribly and re-minded her of bad and unwanted things.

"Where is my Birthday Child?"

Aunt Klea was the first to arrive. She swept into the room, tall, beautiful, and smelling wonderfully like lemons and violets all at the same time. "Well, Judith, you've managed to turn seven." She pulled her veil up and kissed the girl.

How smooth and cold her lips were, as if they had been bathed in snowflakes. But that was because it was so cold outside, and because she had just come from the railway station, for Aunt Klea was not the Snow Queen who held Gerda in prison in her palace at the North

Pole, even though she too was wrapped up in furs and looked for all the world as if she had arrived at the house by sleigh rather than in an ordinary black taxi.

Marushka came in and took Aunt Klea's fur coat and muff to dry in the hallway. When the furs were gone, a red-ribboned parcel appeared on the sideboard. It flourished a large bow.

"What did you bring me, Aunt Klea?"

"It's a secret. You'll have to wait until everyone is here before opening it."

In the meantime the snow had started to come down again. Gusts of wind picked up the flakes, whirled them into white fans, and drove them against the windows.

Aunt Klea sat down and crossed her legs. With the aid of a mirror she adjusted her make-up and lit a cigarette. One end of the cigarette was dark red. That was because it was intended to be smoked by women with lipstick. Marushka brought in the coffee and poured her a cup, which she topped with a spoonful of whipped cream that circled on the surface of the coffee like a tiny white cat readying herself for sleep.

"Good heavens, Marushka, what are you doing to me," Aunt Klea protested, "there is enough whipped cream here for three."

"It won't do you any harm, ma'am; it's nothing but the finest."

Aunt Klea sighed and stirred the cup: small, satisfied, clinking noises.

"How pretty you have become, Judith. I think your skirt suits you perfectly, and your hair—you look like a Tyrolean girl. Do you like coffee?"

Judith said she did not—it was too bitter. Nevertheless, Aunt Klea invited her to sit on her lap and, scooping off the peaks of whipped cream, fed it to her. The taste was so wonderful that Judith had to close her eyes.

"Doesn't that taste better than your cod liver oil?"

Of course it did, and she did not mind acknowledging it.

All at once it was four and the girls arrived. Singly and in pairs

they were let in by Marushka, who was running back and forth between the kitchen and the front door.

"They are here," she called. "Come quick, everyone's here."

Judith slid off her aunt's lap and joined the flurry of chatter amidst the overcoats in the hallway. Indeed all of the girls had come to her party; it was marvelous that the invitation her mother had written and had given Marushka to mail had the power to bring them to her house. Her words were as effective as if she had tugged at them and dragged them home. Now they all stood in the hallway stamping the snow off their boots, clapping their bare hands and puffing into them to make them warm.

"Look here, Judith, look what we have brought you," Ursula Schmidt cried. "You'll never guess." She was a tall, blonde girl, and she was always laughing. As if she did not have a care in the world. Everyone called her Ursel.

Large and small packages made their way to the sideboard and were lined up next to Aunt Klea's present that still had the largest and most elegant bow of them all.

"When are you going to open your presents?" Grete Neubauer asked. "I want to see what you got."

"Come on, let's do it now."

"I know what Anna got you. I'll tell you if you want to know."

Aunt Klea restored some order. Since she had no children of her own, she talked to them much as she would to grown-ups. And that of course caused everyone to become serious and very quiet.

Marushka brought out a large silver pot with hot cocoa and a bowl with whipped cream and filled the cups, topping each with a large spoon of cream. Soon the girls were laughing and chattering again, and while everyone crowded around the table the candles were lit, the lights were turned out, and everyone grew very still. For a moment the flames flickered over the cake, and their reflections flickered in the windows as if another, even more magical birthday party hovered outside in the snow-laden winter skies.

With one big puff Judith blew out the candles, all seven of them at the same time. Actually there were eight candles on the cake, for in its center stood the candle of life, and she had blown that one out as well. Then, with her mother and Marushka joining in, everyone sang birthday songs. Judith's favorite was the one about the fox that had gone out at night to steal a goose, and was never ever going to return it to its owner. After they had sung the verses several times, she started out with a song of her own:

"Oh, Valencia...."

It was all about the city of Valencia in Spain where there were many beautiful girls waiting to be kissed. Judith had heard the song on the radio, and it seemed just right for her birthday. Her mother stopped her.

"You mustn't sing it. You are much too young."

Judith suspected why. It was because of the part about kissing.

"No, I am not. I am seven years old."

"It doesn't matter how old you are, because you are off-key, anyway."

Discouraged by the last remark, Judith abandoned the song. In any case, lots of other things needed to be done.

With the girls crowding around she cut the birthday cake, licking chocolate crumbs off the tips of her fingers. Marushka handed out the plates, and it came out just right, so that there was more than enough for everyone.

In the middle of all the excitement Judith's father arrived. He took off his overcoat in the hallway.

"I'll be right with you. But first I have to wash my hands. One must always wash one's hands after one has seen a patient."

Soon he returned.

"Happy birthday, Judith," he said gravely, as if having a birthday were a serious matter. Judith couldn't reply for she had a piece of cake in her mouth, and with all the singing and laughing and shouting, she was flushed and hot all over.

Her father noticed it.

"You always get so excited about things," he told her, frowning, as if being over-excited were like being unkind to him.

Judith looked for her mother. She was unable to tell whether she had remained at the party, for at times she was so still that her presence would go unnoticed. Right now, she was standing by the side of the door, her back against the wall. When she saw that Judith was looking at her, she shrugged her shoulders, and as if that were not enough to indicate that she wanted to be left alone, she began to hum a song, quite on her own, smiling while she did so. None of that of course made any sense. Still, her hands were beautiful and well cared for, for she was a lady, regardless of what father would occasionally say about her.

"And what are the Czechs doing about all this?"

Her father had pulled up a chair next to Aunt Klea, and puffing a cigarette, joined her in a second cup of coffee.

"Max thinks the people are going to get rid of him before too long. It'll be the Communists and Socialists on one side and the Nazis on the other. In any case we don't give them more than another year."

"Then what?"

"Oh, I suppose Hindenburg will be called back in again."

"But the man is senile, everyone knows that."

"He'll be better than Hitler, that's certain."

Hitler was the man who ruled Germany, who made Jews wear yellow armbands, and who threw Jewish children out of school. It was good to live safely in a different country, even though the border between Austria and Germany was only a black line on the map, not even a wall. One morning, not too long ago, she woke up, terrified because she had dreamt that she was living in Germany, and that she would never again be happy. But when she had opened her eyes it was morning, sunshine streamed between the slats of the Venetian blinds, and she was still in Vienna and everything was the same outside.

"If England and France don't do anything to stop him, he'll soon take over Europe, and then we'll all be done for."

Her father's conclusion sounded so firm that Judith could not conceive that anyone would disagree with him.

The girls were ready to go home when Uncle Bernhard arrived enveloped in an aroma of cigars and rich burnished lotions. He apologized for being late, but he had driven his new Mercedes all the way from Stockerau, and the roads had turned to ice. Judith did not like Uncle Bernhard, and she would have been just as happy had he not come to her party. He was a very tall man with a shock of black hair that kept falling down over his eyes, and whenever he came he would start an argument between her parents.

"He is a good for nothing," Judith had overheard her father say one evening. Uncle Bernhard had come to her parents with a view of borrowing money to keep his hotel from going bankrupt. Judith's mother tried to defend her oldest brother.

"You won't face reality," Judith's father said, and raised his voice. "Your brother is a gambler. All he thinks about is money." Judith's mother burst into sobs and ran into the bedroom, slamming the door behind her.

That afternoon there were no arguments. For with Judith present, and with a glass of whiskey and a slice of the birthday cake on his lap, Uncle Bernhard did not want to borrow any money but instead showed Judith a few card tricks over her parents' objections. With his face blurred by laughter, he started to tell a story. Judith's father cut him short.

"You are out of your mind, Bernhard, not in front of the children."

Judith did not know why her uncle was not allowed to finish his story, and why her father was so annoyed with him. As it was, she too was annoyed with him, for he never asked her about school or about her friends, and when she offered to tell him, he was quite uninterested in what she had to say.

As it was, with road conditions as bad as they were, Uncle Bern-

hard soon left, having presented Judith with a perfunctory peck on the top of her head.

"She is beautiful," he said to her parents, as he struggled into his overcoat. "Keep her that way." Uncle Bernhard's wife and Illi, his daughter, who was Judith's age, were kept hidden from the family. Everyone knew that Aunt Sophie drank far too much, and that when drunk she would beat her little girl black and blue.

Later that night after Judith had gone to bed, said her prayers, and closed her eyes, a glitter was left from the day that shaped her dreams and turned them into birthday parties and into innumerable presents that joined hands and danced in a ring around her. It was a new and even more wonderful party that she dreamt of, and this time Anton had not been excluded. He was standing next to her at the dining room table and helped her light the candles. When the lights were turned out he was still at her side, and in the darkness Judith knew that when she grew up she would marry Anton and everyone would address her as Frau Kermauner.

❧2❧

THE CHANGING SOUND of the airplane engines aroused Judith. She sat up, and having wrapped herself in a blanket, for the plane had become chilly, looked through the cabin window. The plane was descending through the clouds. A green, doll-sized landscape appeared, complete with hills, black-and-white-checkered villages, and roads. As she leaned forward to see the display, she realized that she was trembling and that there was a strange queasiness in her stomach, the same feeling she would experience before an important and difficult exam.

She adjusted the hand baggage stowed underneath her seat and tightened her seat belt. When all these things had been taken care of, she was still trembling.

"It doesn't matter," she reassured herself. "I am tired from all the hours without sleep. It will go away."

She closed her eyes and tried to shut out the deep, churning sounds of the engines.

"You get off at Vienna?" the young man in the adjoining seat asked in halting English. The change in cabin pressure must have awakened him. His eyes were serious and pale gray, and he wore a green tweed jacket with a checkered tie that blended into its colors. From the intonation of his words Judith knew he was Austrian.

"Yes, I do…finally. It's been quite a trip."

"Hasn't it? You are American?"

"That's right."

"What's part of America you come from?"

"California...Los Angeles."

"How wonderful...the land of sunshine."

"I suppose it is." She did not want to enter into an extensive conversation, yet the young man's smile seemed warm and charming. She watched him put away his effects and turned to take another look out of the window. She had stopped trembling.

"Can you see anything?" The young man asked, closing the briefcase and placing it between his feet.

"Oh plenty. That must be the Danube, isn't it?" Of course it was the Danube; she could tell they were descending over the Brigittenau. It was only a matter of fitting what she saw below into the map of Vienna that she still remembered from her school days.

"You know the Danube is not blue?"

Judith turned to look at the young man and caught another smile. "Isn't it?"

"I'm sorry to tell you, no...unless you are in love." Still smiling, the young man leaned towards Judith.

"May I ask you where you are staying?"

"The Kaiserin Elizabeth."

"That's a lovely hotel. I am sure they will take good care of you there... Have you friends in Vienna?"

"I am meeting my fiancé."

"Oh, you have a fiancé?" His disappointment was obvious.

"Yes, his name is Anton Kermauner. Do you know him?" She was amazed at hearing herself pronounce Anton's name. It had been so long since she had last spoken the two words.

The young man shook his head, and bent down to adjust the snap on his carry-on bag.

Why did I tell him that, Judith wondered. I know Anton will not be there to meet me—not Anton, not my parents, not Aunt Klea, not Uncle Bernhard, no one.

This indeed was the case. When the plane finally landed and Judith emerged into the terminal, she studied the crowd of the expectantly waiting. Their faces were vaguely familiar; their gestures were those she remembered—had she not seen them in so many of her dreams? But there was no one to run up to her, no one to call out her name, no one to tap her on the shoulder. She claimed her luggage, three shiny American suitcases appearing ill at ease in these drab surroundings, and hailed a cab.

"*Wohin denn, gnädigstes Fräulein?*"

"*Hotel Kaiserin Elizabeth.*"

"*Konnma scho tuan….*"

On the way to the city she chatted with the cabby. There were the usual things a Viennese cabby complains about: weather, traffic, politics. Judith's German came back easily. It was like opening a long-unopened door and walking through corridor after corridor of an immense edifice that needed to be re-explored. The language came forth effortlessly, yet there was dust, memories, so many ghosts….

The cabby seemed puzzled by her appearance. Her speech was Viennese, her clothes were American….

"And where are you coming from, may I ask?"

"America."

"That's quite a place…but I wouldn't want to live there. People never have time for anything. Have you been to Vienna before?"

"Yes. Quite a few years ago."

"You're too young to have seen it in the good old days." His arm made a circular motion through the open window. "You see the life we have here now, there's no future for any of us. It wasn't like that in the old days when the Kaiser rode down the Main Avenue of the Prater in a splendid carriage drawn by two pairs of white horses. No one was poor then; everyone had enough for a baked chicken and a couple of little glasses in the Wirtshaus or out in Nussdorf. I suppose if we think hard enough about our past, the present no longer matters. But then, one might as well be on drugs, don't you agree, Miss, the end result is the same."

"I suppose it is."

Judith looked at the streets. The houses were gray, dark, devoid of color. Everywhere she looked there were bomb- and shell-damaged buildings, largely unrepaired, remnants of window frames that allowed her to gaze into the skeletons of destroyed apartments. And everyone looked so shabby. She was amazed how much she had become accustomed to the perfusion of multicolored billboards and neon signs, the gardens that glittered so splendidly, the palm trees that were everywhere in Los Angeles. All this lushness had become part of her life, and it was only when she was deprived of it that she had to admit its importance to her.

The taxi turned into a crowded Ringstrasse. That part of the city appeared less gloomy and impoverished. To enhance its appearance, the sun had come out, and in its light the trees lining both sides of the avenue glowed in colors that gave forth the first inkling of autumn.

"I must tell you, Miss, last week was something else again. The weather we had, I can't describe it, enough to make you throw up your hands. Just as well you weren't here. I wish we still had a few Jews around, we could blame the weather on them." He laughed.

1935

At the beginning of the following school year Judith first acknowledged that she was a Jew, and that consequently she differed from the rest of the world.

It was the first hour in the morning and the children stood up in class to announce their names. Last name, then first name and birthday. They started with the first row on the left: the small boys, beginning with Ernst Kendig who had freckles and still lisped, and who therefore, as everyone in class had already found out, attended speech therapy after school hours.

One by one the boys stood up, including Anton Kermauner, who with a quick toss of his head, made his straight blond hair fall over to the side. Then it was the girls' turn.

"I am Berger, Judith, and I was born on January tenth."

It was exciting to stand up in class, to feel everyone's eyes upon her, even hear a few whispers when she sat down. After all the children had introduced themselves, Mr. Prohaska asked:

"Any Protestants in the class?"

Grete Neubauer who sat two rows behind Judith raised her hand, as did Anna Redlich who was so tall that she had to bend her neck to talk to the girls in her class, and who because of her height sat in the last row.

"Good. Now then, do we have any Jews?"

Leo Rosenberg lifted his hands from the boys' side of the room. How ugly he was, Judith thought: small, with dark stringy hair that never was combed right, and a large hooked nose that dominated his face. And his nails were dirty as well: there always were thick dark lines under them. Everyone could tell he was a Jew from miles away. How different he was from Anton Kermauner. Anton was tall, with blond hair, and always neat and clean. Surely she would never be able to marry a Jew, for her hair was blonde, and her nose was just a little stub, exactly like Anton's. She hesitated raising her hand. Surely, if Leo Rosenberg was a Jew, she could not be one as well. But of course she was. She went to synagogue, was even trying to read Hebrew, so she put up her hand. So there were two Protestants in class, and two Jews, and the rest were Roman Catholic. From now on, when the priest came in for the hour of religious instruction, stood on the platform in his miter and long embroidered vestments, and addressed the class as "My little children," he undoubtedly did not include Judith, nor Leo Rosenberg, and probably not even the two Protestants who Judith knew did not believe in the pope.

There was a memory of the eternal light, of a small glistening red and gold frame that hung, encased in brass, suspended across from where the women sat in the balcony of the synagogue, its reflection

flickering endlessly in the stained glass windows behind them. There was also a memory of a voice. It was that of the rabbi, who stood before his congregation on a Shabbat morning.

"Not since the days of the Inquisition have the Jews been subjected to such perils of life and fortune. Across the border, only a few miles from where we are now gathered, our people are being degraded, cast out from society, imprisoned, beaten, and even tortured."

Judith leaned forward, her elbows spread across the balustrade of the balcony, so that where her sleeves were open the red velvet covering the wood tickled the inside of her arms.

"How has this come to pass?" Rabbi Wolf continued. "How has it happened that a civilized, law-abiding country that for centuries has prided itself on its culture has turned to evil, and has so degraded itself as to inhumanely persecute our people?"

The rabbi lifted his arms towards the congregation. The sleeves of his flowing black robes rose up with them so that for a moment he seemed like a huge eagle preparing to ascend from the pulpit and, with wings beating, circle the eternal light.

Judith had already met the rabbi.

"What a lovely daughter you have," he had told her parents, stroking her head. "What lovely blonde hair. One would guess her to be Nordic."

Her parents had smiled in appreciation, and then had turned to other matters.

"I hear your brother has left for Palestine," the rabbi remarked to her father.

"Yes, less than a month ago. He thought that the anti-Semitism in Vienna was too much for him."

The rabbi nodded: "We can all find anti-Semitism if we search for it. Isn't that so?"

"Of course," Judith's father replied, "you know what our former Mayor, Karl Lueger, once said, and that was quite some time before the war: 'When all's said and done, I am the one to decide who's a Jew.' And you know how many of his best friends were Jews."

The rabbi cleared his throat. Looking at Judith he declared:

"Anti-Semitism is like evil. It will always be with us, but we must never allow it to touch our lives."

Now, as she was listening to his sermon, Judith marveled at his voice: deep, resonating, powerful. Long, meaningful pauses separated his sentences, and heavy intonations underlined the most significant words.

"Let me tell you, my dear congregation, there is only one way we can deal with what is happening, and it is not an easy way. We must not be deterred by the lawlessness that we perceive to the north of our country. We must not be frightened by the excesses that we hear of, day after day. We must not imitate those of our fellow citizens, who, succumbing to the panic of the moment, have abandoned their homeland, or what is even worse, the faith of their forefathers. We must remember that all evil is temporary, and that the good that our Lord, the father of Abraham, Isaac, and Jacob, has vouchsafed us will remain with us forever.

"Our fellow Jews to the north are committing deeds of evil, just as far-reaching as those committed by the Nazis. Facing evil they have turned to evil, facing lawlessness they have abandoned the safety of the Law that was handed down to our forefathers on Mount Sinai, and facing a temporary anarchy they are deserting their homeland, their national identity, and the equality for which not only they, but also you and I, all of us, and innumerable generations before us have striven to achieve. Like soldiers deserting their regiment at the onset of battle they have deserted the remainder of Jewry, and in doing so they are perpetrating deeds as dark as the ones committed by those who, brown-shirted, are goose-stepping through the streets of Berlin.

"For many generations we Jews have struggled for freedom. We have striven for social maturity ever since the days of Emperor Joseph in the eighteenth century. Now that we have achieved both freedom and maturity, we have also acquired obligations. The foremost of these obligations, the one obligation that we must always remember and must always fulfill, day in day out, is that being free

27

means that one must choose between good and evil, that being mature one must recognize right from wrong."

There was much more to his sermon, more long words, words like responsibility, fortitude, patience, words which Judith already had heard at home, and which reminded her of the massive mahogany furniture in her parents' living room.

The service over, everyone stood outside the synagogue. It was a blustery day, mauve fragments of sky raced across the rooftops, and brief snatches of sunshine fell across the brick walls of the surrounding houses. The women were dressed in their best furs: high-collared Persian lamb, mink coats and muffs, the men in their winter overcoats with velvet collars.

"No games, please, Judith," her father admonished her as she was twirling herself around the fire hydrant.

Restrained, she walked heel to toe on the last bricks of the sidewalk—she was Juditha in her death-defying tightrope act—but in the course of her performance she bumped into a portly man wearing a stern-looking pince-nez.

The man gave her an annoyed look, and Judith responded with her most heart-winning smile.

A streetcar rolled by.

"Ding-ding," Judith called out to it. Two red wagons came to a halt in front of the synagogue. A man leaned out.

"Jewish shits," he shouted through the window. "Look at that bunch of Jewish shits. Just wait, we'll get you soon enough."

With a jeer his face disappeared. The streetcar bell rang out brightly and the wagons rolled away, rails humming mysteriously behind them.

The rabbi had seen and heard everything.

"These things will always be with us," he said to no one in particular, and stroking his black-sleeved elbow he turned to greet his congregation.

>‹

Judith no longer could recall where the Hotel Kaiserin Elizabeth was located. All that was left was a vague memory of walking by it with her father one Sunday morning on their way to the Stadtpark. Perhaps it was a dream, and she had never seen the hotel before. In any case, she was unable to match up the picture she had stored in her mind with its present appearance.

The taxi drew up at the entrance, she paid the fare, and before long she was in her room and out of her traveling clothes.

It was a wonderfully warm bath, and wrapped in huge soft towels, she felt so comfortable lying on top of her bed that she was asleep within moments. When she awoke it was late afternoon. A soft blue light flooded the room, and basking in it she felt happy. She had come home. At last.

She got up and looked out. There were chestnut trees below her window, the edges of their leaves turning brown: late summer. How well she remembered the leaves and the mahogany-stained nuts. Once, it must have been the fall before Hitler came, she had brought an apron-full home from the Prater, and using toothpicks, she had constructed a whole menagerie of imaginary animals from them. Now as she looked at the foliage below her window she saw a continuity everywhere and in everything. It was as if, finally, she had returned into a flowing stream, into a river from which she had been cast out, but which was ready to receive her again, envelop her, and carry her along for the remainder of her life.

She dressed quickly, and as the twilight gathered, she walked down the Ring. Without thinking, she crossed the Stuben Ring, and before long she was walking along the Danube Canal. Everything was familiar to her. She passed the place where on that fateful afternoon she and her father had met Mr. McGuire. She again leaned over the iron balustrade, although this time her chin was quite a distance above the railing. Walking on, she reached the Böcklin Strasse. It was as if she were being pulled by an unseen force, directed by unspoken demands, by a voice that told her where to turn and when. Indeed she must have walked through the very same streets before;

perhaps they had also served for the setting of some of her dreams.

She lost all track of time.

All at once she stood in front of her house. The street lamps had been turned on, but there was still a trace of daylight. She opened the gate and walked up the path. Nothing had changed. The walls were still that off-white color she had found so boring, perhaps they were a trifle grayer now, and there were flakes of paint under the eaves, and cracks on the wall: a complex pattern of lines that evoked a map of a river estuary. The door and window frames were the same dark green she remembered. Here too, the paint was cracked and peeling. On her left, in the small, untended garden, was the lilac bush. It had spread considerably, but it was the same bush that in spring had borne thick purple clusters. On her right was a row of tree-roses at the height of bloom. There were five bushes now; she only remembered four. A light was on in the living room. Her room, upstairs, was dark. She did not look at the plate outside the door, for she did not want to read a strange name. Instead she walked up the steps to the entrance. The door had not been repainted; she could still detect the scratch she had made when her doll carriage had turned upside-down. How she had been scolded for it!

She wondered what would happen were she to ring the bell. A strange face would appear at the door. She would introduce herself and be shown into the parlor—her parlor. It was better to leave her memories unmarred. She turned to go down the path into the street. At the corner, she bestowed one last, long look and walked to the next thoroughfare.

She passed a row of stores: a greengrocer's, a confectioner's, a butcher shop. "G. Platzer and Son," read the sign above the butcher's. So Inge's brother had gone into business with his father. Judith could not remember his first name. The windows were nearly empty: some pig's feet, a few small, evil-colored sausages hung from a chain. She looked inside. It was closing time, and there was only one customer left. A young man was leaning his elbows on the counter and chatting to the woman. That must be Inge's brother, Judith

thought. He had a razor-top haircut, very much in the American style. "I bet he collects jazz records," Judith thought, but she had no urge to enter the store and speak to him.

Instead she hailed a taxi, and before long she was back in the hotel. Having returned to her room, she switched on the light at her bedside and picked up the telephone book. She turned the pages to "K": Kendig...Kenstein...Kepper...Kermauner.... There it was: "Herta Kermauner." The same address, but there was no listing under Reinhard, and none under Anton. She picked up the telephone and asked the hotel operator to dial the number. It rang. Once, twice, three times. Judith could feel herself tremble, her heart pound. Why am I doing this, why, why, she wondered. She knew the answer. It was a matter of finding out whether the Anton she loved was reality or a creation of her fantasy.

1936

During the following year Anton sat across the aisle from Judith. By then she knew that Anton's father was a secret Nazi, and that this was the reason why she had not been allowed to invite him to her party. Professor Kermauner was an immensely tall, stern-looking man with a square whisk of a mustache on his upper lip. He was Professor of Germanic Literature at the University. She wondered whether he, like Hitler, wanted to make Jews wear yellow armbands, and have them go to Jewish schools. She decided that if he did, he would certainly make an exception for her. On the occasions when she had met him as he accompanied Anton to school, he had been very polite and friendly to her; not at all nasty as one might expect from someone who wanted to throw her out of school. She therefore decided that her parents had matters all wrong and therefore it was best not to think about it.

Judith and Anton had devised a series of secret signals that they

sent back and forth and which helped enliven the boredom of their classes. Anton looked much nicer in school than in the park. In school his blond hair was neatly combed and parted, and his face did not have the slightest speck of dirt or chocolate. In fact, he looked so earnest that many times she was tempted to attract his attention and then stick her tongue out at him to make him laugh, or should that be unsuccessful, pull her face into a Chinaman's grimace by drawing up the corners of her eyes with her fingers.

Between classes they had much to talk about.

"I know a good joke," Anton told her. "Do you know the difference between a blind man and a drunken sailor?"

"That's a terrible joke. I've already heard it."

"No you haven't, you're just saying that."

"Yes I have, and even if I hadn't, I can still tell it will be a terrible joke."

Anton was always hungry. Perhaps he was growing so fast that his lunch was too meager for his appetite, or perhaps he preferred to sample the lunches that other children brought to class. Whatever the reason, hardly a noon period went by without him casting covetous glances at Judith's small wicker basket in which a pink and white striped napkin enclosed an apple, a sandwich, and some surprise delicacy.

"What did you bring today?" he asked Judith one noon.

Rather than answer she pulled a chocolate rabbit from her basket and made it hop across his desk.

"Look at him go: hop, hop, hop. I'll bite one of his ears off, and you can bite off the other."

Marzipan strawberries were Anton's favorite.

"Can I have one of your strawberries?" he asked Judith one day.

In the bottom of her basket there were two of them wrapped in tin foil.

"No, you can't."

Actually she was not hungry but she wanted to see how badly Anton desired the candy.

"Please, Judith, just one."

"No, you can't have any."

"I'll pay for it."

"I don't want your dirty old money."

"Please, Judith."

"All right, but you will have to kneel down for them."

"I can't do that. The priest says that we must only kneel before God or Jesus."

"As you wish, but no strawberry then."

With a sigh and a grimace Anton kneeled down before Judith.

Overcome with a sense of power she pushed down his head.

"That's not enough. You now must put your two hands together and say 'Please.'"

Anton did as he was told.

"Open your mouth."

He opened his mouth and waited for the strawberry. Judith however kept him waiting in this position while the other children gathered around, giggling at the lanky blond boy who was kneeling before Judith with mouth wide open and his hands pressed together as if in prayer. Finally, tired of seeing him in his supplicant posture, Judith threw the strawberry at his face. He tried to catch it with his mouth but could not, and it rolled between his knees. Picking it up, he got to his feet and ate it without a word of thanks.

That night, while getting ready for bed, Judith remembered how Anton had kneeled for the strawberry she did not want, and with a pang of fear concluded that she had committed a sin.

Now in the normal course of events sins were punished, usually swiftly. This sin however had not led to punishment. None of the children in class had said anything bad to her. Even Anton, after he had eaten the strawberry, and had rolled the tin-foil into a tiny ball which he threw at Holzert while the teacher's back was turned, appeared not to have resented the episode.

Since the day had ended without either natural or supernatural punishment, Judith thought that the only way for her to avoid the

inevitable hellfire that awaited an unpunished sinner was to disclose everything to her mother.

"I made a boy kneel before me in school today," she confessed after finishing her evening prayer. Sitting up in bed she recounted the events of the recess period.

Her mother listened, and when Judith had finished she nodded.

"We are proud people," she said. She pulled the chair over to the side of the bed and sat down. Her long dark hair glistened in the lamplight.

"You and I are proud, for we know how very special we are."

With half-closed eyes she told Judith about the Mendozas, her forebears, who fled Toledo more than four hundred years before. The girl was fascinated by the story. Not a bit sleepy, even though it was way past her bedtime, she tried to picture them: intense, dark-robed men, and beautiful, black-eyed women, their long, ebony hair buried beneath fine lace shawls. She could see them climb the narrow, cobbled streets and go about their business in and out of dank alleys. Relentlessly proud, they were feared by the Spaniards for their wisdom and envied for their reputed wealth.

"Now you understand why you should not speak to each and every child in your class," her mother concluded.

Judith nodded and licked a fleck of toothpaste from the corner of her mouth. She relished its cool peppermint taste.

"I never talk to Franz Seidlmayr," she offered. Franz's father was a coal-dealer who owned a yard in Floridsdorf. "And I also don't talk to Inge Platzer, even though she asked me to be her friend." Inge Platzer was common too, for she was the daughter of a butcher.

"You know how much I wanted you to go to private school, but your father decided that you need the experience of mingling with children of all kinds of backgrounds."

Like Anton. She thought she might try out her mother's feelings about the Kermauner family.

"What about Anton?" she asked, knowing in her heart of hearts that whatever her mother might reply, she would continue to talk to him.

"Anton Kermauner?" Her mother repeated.

"I can talk to him, can't I?"

"Ignatius, Ignatius!"

These enigmatic words, uttered in a sing-song tone and followed by three small spitting noises, were a signal to Judith that Anton and his family must not be discussed any further, for they were Nazis. Judith understood the code. Nevertheless the prospect of having the son of a Nazi as a friend excited her. In her fantasy she saw herself being invited to the Kermauners. There she might hear Anton's parents talk about Hitler, listen to them describe the wonderful reforms he was carrying out in Germany, and find out what they really thought about the Jews, which of course did not include her. She remembered how only a few weeks ago she had heard Mr. Tristan describe how he would rid the country of all its Jews. An aging bachelor who lived a few houses down the street, he was chatting to Mrs. Semrath, the widow of a retired army officer, who spent her last years surrounded by photographs and sleeping cats. The two of them were standing by the lilac bush in front of Judith's house, while Mr. Tristan's dachshund was sniffing at the mounds of soil. Waldi had been taught to bark at Jews. At least that was what Marushka, blushing with indignation, had reported to her employers.

Nevertheless, her mother had not forbidden Judith to talk to Anton, so on the following day, the episode of the strawberry and his Nazi parents notwithstanding, the two of them walked from school to Mr. Gruber's stationery store to buy a fresh set of pencils. A month or so later, Judith, Anton, and their mothers even took a day's trip up the Danube in a paddle steamer. The children looked at the swirling water, sipped lemonade, and talked about school. When that became boring, they drew ships with endless amounts of smoke pouring from their funnels, while the women snapped photos and knitted sweaters in the broken sunshine.

><

⇸3⇷

"Hᴀʟʟᴏ."

"Frau Herta Kermauner?"

"Yes, yes, who is this?"

"It's Judith…Judith Berger."

"Judith Berger…no, oh my God, the little Judith, with her long blonde hair. My God, where are you? Tell me, child, where are you?"

"At the Hotel Kaiserin Elizabeth."

"The Hotel Kaiserin Elizabeth? That's a lovely place.… I am sure they are taking good care of you there. Now, look at me, here I am still saying '*Du*' to you, and here you are, a young lady. But you will forgive me, Judith—Fräulein Judith—I know I am always going to say '*Du*' to you. It'll be all right, won't it?"

"Of course, Mrs. Kermauner, of course. Tell me, how is Anton?"

"Oh that Anton, he doesn't show his face at home for weeks on end. You know, he has become bored with his old mother, it's understandable. You can't imagine how delighted he will be to see you again, you won't believe it when I tell you how often he talks about you. We've been wondering what has happened to you. I must know when you're coming over."

"Not tonight; it's been such a wearisome journey."

Actually, Judith was not that tired, but she felt that she needed

some time before she could face Anton. As a result of the phone call he had been transformed into a creature of flesh and blood who didn't come home because he was bored with his old mother. Mrs. Kermauner readily accepted her excuse.

"Of course. You must be exhausted. But it doesn't matter, we will see you tomorrow night instead. Seven o'clock...that'll give me time to get a few little things together. Nowadays that's not so easy, you can imagine what with the Occupation. And of course I'll make sure that Anton will be over."

After Judith had hung up, it seemed to her, for a brief time at least, that the events of the last decade had never occurred, and that it had been only a few days since she had last spoken to Herta Kermauner. Then she remembered that Reinhard Kermauner had not been mentioned by his wife. Could he have been killed in the war?

The next morning, following breakfast in the immense and deserted hotel dining room, Judith took the streetcar that ran along the Ringstrasse in the direction of the Prater. It was a dull morning. A heavy layer of low clouds covered the city: a threat of rain. Mechanically, without even knowing why, she got off at the end of the Prater Strasse and, picking her way through rubble and broken mountains of cement, headed in the direction of the giant ferris wheel and the burnt-out and twisted skeletons of the restaurants and amusement stalls that had once surrounded it.

1937

It was the first warm day of the year, and the Prater was crowded. School over, she picked up her red satchel, and her Diabolo. The latter was an hour-glass shaped rubber toy that danced on a string between two sticks. In expert hands, the Diabolo could be made to revolve faster and faster, until finally, in response to a tug of the sticks, it would fly up into the air. She would have preferred to

go alone or with Marushka, but her mother insisted on taking her.

"I don't want you to cross the streets by yourself."

The same predictable cautions. She wanted to reply, "And I'll be careful not to be bitten by a bear, or be run over by a submarine," but that would have been hurtful, and would only have resulted in the outing being canceled, or worse yet, in her mother assuming a far-off stare and humming to herself "Where is my homeland?," a song that always announced the unpredictable in her, be it anger, tears, or cuffs to Judith's face. It therefore was better for Judith to answer her mother in a falsely agreeable tone of voice and walk to the Prater with her Diabolo sticks over her shoulder, pretending that her mother, who walked a few yards behind, was really not her mother, and that she was all alone in the park.

At the First Rondeau there were clusters of children.

"This is a good place for you to play," her mother said.

Of course it wasn't. Judith knew none of the girls, and as for the boys, there was only Willi Moser, a fat, red-headed boy who was kicking a ball against a tree-truck, obviously bored being alone and with what he was doing. She, like all the other children, did not want to play with him, for he was no fun. He was slow and clumsy, and he invariably would change the rules to his advantage in the middle of any game.

The Second Rondeau was always better. There she might meet Anton, who was fun to play with, and whom she was planning to marry, and besides, even if he was not there, and she became bored, there was always the miniature railway to watch as it came around the bend and headed into a tunnel.

But there was nothing she could do to alter her mother's choice of the First Rondeau. Her mother selected a chair and sat down with her needlework. The attendant came over, a hunched, wrinkled woman with a kerchief wrapped around her head. There were huge black gaps in her mouth, and trickles of spit drooled into her tattered shawl. A few years earlier, Judith might have feared her as a witch.

"Beautiful day, isn't it, ma'am?"

"Oh yes, perfectly lovely."

"It's the first day I've put out the chairs. There might still be some mud between the slats."

"That's perfectly all right."

"Just let me wipe it off again for you, ma'am."

A cloth appeared from under her apron, and after a few perfunctory strokes that could hardly have had any effect, the crone straightened out as much as she could and with a quick movement pocketed her tip.

"You know ma'am, I've got a feeling that this will be a good year for us."

"That would be nice."

"Yes, Hitler will soon be here, and then we'll be sure to get rid of all of them Jews."

Judith overheard the entire conversation and it frightened her. But then she reassured herself that getting rid of the Jews did not apply to her; that it was meant for dark, ugly Leo Rosenberg and his likes. She would not mind seeing him thrown out of Vienna and sent back to Poland, the way he talked German, with his sing-song voice and completely wrong syntax. Obviously his parents spoke Yiddish with him.

Judith's mother did not respond to the old woman's remarks. Her face completely impassive, she took up her crochet-work, leaving the latter to hobble off to the next cluster of chairs.

Judith looked at her watch. It was eleven-thirty, so there still were seven and a half hours intervening before she would see Anton again.

Slowly, like a sleepwalker, Judith made her way towards the Inner City. How much smaller the city had become since she had last been there. Leaning on the damp iron railing she looked down into the brown waters of the Vienna River.

March 11, 1938

She knew something extraordinary had happened as soon as she woke up. For it was not that she awoke on her own, which did happen occasionally, but that she was actually awakened by her parents. They had turned on the bedside lamp and stood at the foot of the bed, holding each other's hands. Judith sat up and ran her finger up and down the side of her nose.

"We are going," her mother said. "Do you want to come with us?"

Half-asleep though she was, Judith could tell that her mother was crying, and that she had been crying for some time.

"Where to?" she asked. If she had not been so sleepy, she would have begun to cry as well.

"Into the other world," her mother replied hollowly.

Judith looked at her father, for she knew her mother was liable to make such desperate pronouncements without much provocation. But her father nodded. "It's all over," he said, choking on his words, "everything is all over for us."

"What is?" Judith asked. Frightened, she still wanted an explanation. She hoped that defining what had happened would make it less horrible. Her father remained silent.

"Do you want to come with us?" her mother repeated. "It won't hurt a bit, I promise." She stroked the girl's sleep-disheveled hair and smiled. "It will be over quite soon."

Judith understood what she meant. In some ways, she had understood her from the very beginning, but did not want to perceive the awful reality.

"But I don't want to die," she sobbed. "Tell me what happened, please. It can't be so bad, I know it can't be."

"You won't understand," her father replied.

Nevertheless he sat down by the side of her bed and told her what had happened that night. His sitting down was already a relief to Judith, for by then she had seen the towels that had been stuffed into the cracks around the windows, and she knew that her parents

intended to turn on the gas in the kitchen. But as long as he sat on her bed, he could not be in the kitchen where the gas stove was, so that at least was a good sign.

"Tell me, tell me," she pleaded with him.

"Hitler has marched in."

Now that was strange. How could Hitler have done that? He was supposed to be on the other side of the border, in Germany, and this was Austria, a different country.

"But he isn't going to run Austria, is he?"

"You poor little girl, you poor, poor little girl."

She tried to understand the situation. Austria must have become a part of Germany, and of course that meant she might have to wear a yellow armband and would be thrown out of school. But that couldn't be.

"What does Rabbi Wolf say about this?" she asked. "Have you talked to him?"

Her father shrugged his shoulders.

"What can he say? He is in the same place as the rest of us."

Her mother sat on the bed as well, which also was very good, for one could never tell about her. She was likely to run out into the kitchen and turn on the gas even while father was talking to Judith. Wide-awake now, Judith held her mother's hand and entered into the discussion as to what could be done under the present circumstances.

"He'll kill us all, I know it, he'll kill us all," her mother lamented.

Judith stroked her hand, and as she felt the soft warmth of her mother's fingers against her own, she sensed a small safe world from which even Hitler had been excluded.

The next morning everything was completely turned around. It was Saturday, but there was neither school nor synagogue. Marushka had set the table for breakfast. As always there were croissants and co-coa, but neither tasted quite right. That was probably due to a lack of sleep.

Later on, there was music and singing in the streets. Judith ran to the window with her cup of cocoa, climbed into the window seat,

and looked out. How bright and gay everything was. There were flags everywhere, large and small, all fluttering in the morning wind, and all of them new: red with a black swastika in the center. A unit of khaki-uniformed soldiers appeared at the foot of the street led by a band. Swarms of people lined the sidewalks, all in their best clothes and all of them waving small swastika flags. As they passed the house, the soldiers struck up a song, strong male voices in beautiful unison. Judith did not recognize the words, but since it was a good tune she opened the window and leaned out to hear it better. That moment her mother came into the dining room.

"Oh my God, what are you doing?"

She ran over to Judith and pulled her away from the window.

"They will see you," she said slamming it shut. "For God's sake they will see you." Her face was white and desperate.

Judith did not understand. "Do you know what they are singing?" she asked.

"I don't want to hear it."

"Listen...."

"Banners high, our ranks are tightly knit..." The rousing music sung by the columns of brown-shirted, steel-helmeted soldiers marching below the window drew Judith along. Defiantly, she pulled herself away from her mother and again looked down into the street. The voices were in perfect unison, strong and deep, accompanied by the slapping sound of heavy boots striking the pavement. The helmets glistened in the morning light and everything was so bright and beautiful that her mother's tear-stained face seemed to belong to another world, one from which Judith wanted to disassociate herself. Her hands on the window frame, she hummed the melody to herself, defiantly yet conscious that it was wicked to do so. Her mother put her hand across Judith's mouth.

"How can you? They are criminals, all of them."

At this moment her father entered the room. His face was ashen and distorted. To Judith he appeared as if he had wanted to smile at her, but something had broken within him. Indeed he was on the verge of tears.

42

"I have just heard about the Lerners."

He pulled her mother over and whispered to her. Obviously something was wrong with the Lerners. Judith knew them well. They had been to their house many times, last year the families had spent two weeks in Italy together. Mr. Lerner was a tall, jolly man with immense hairy hands. He was always laughing, and his repertoire of jokes was inexhaustible.

"Come on over here, Judith," he would call to her and deftly place her on his knee. The Lerners had no children, and for them Judith was the prettiest, the brightest, and the most spectacular child in the world.

"Tell me, young lady, do you know the story of Rapunzel? No? Well you should, for she had hair just like yours."

He then would tell her the story of Rapunzel, who was locked in a tower, but whose long blonde hair served as a ladder for the prince who would ultimately free her from the witch. As he did so, his attention would alternate between Judith and the glass of wine at his side.

"You always have Judith on your knee," his wife complained. But she loved Judith as much as he did. "One day you will wake up to find her quite a young lady and madly in love with you. Then what will you do?"

"What will I do? Come here and I will tell you."

With his forefinger he motioned his wife over.

"I will have to be in love with two women: you and Judith. Now is that so bad?"

But today something terrible had happened to the Lerners, something her father could only whisper about, and which made him want to cry.

"What happened, tell me, what happened?"

Judith tugged at her father's sleeve.

"Nothing, everything is all right."

"No, it isn't. I can tell it isn't."

So they told her. The Lerners had jumped out the window of their fourth-floor apartment.

Judith said nothing. Instead she wondered what it felt like to fall from a fourth-story window. Falling must be like flying: the cold air blowing past your face. But then at the end, the sidewalk came up to meet you. She shuddered, for there was no way she could think about that.

"They were people of high principles," her mother said. "Only trash like us would want to go on living."

Although she did not want to contradict her mother, Judith did not think she was trash because last night she wanted to go on living. It was sad to know that now there never would come a time when she would be grown up enough for Mr. Lerner to fall in love with. That meant that his prediction would not come to pass. God knows what else was possible when predictions made by adults who spoke with as much assurance as Mr. Lerner turned out to be wrong.

From outside there came cheers, long drawn-out cheers that grew in intensity and turned into a rhythmic chant:

"Sieg Heil, Sieg Heil, Sieg Heil."

"What is going on?" Judith asked, and seeing the fear in her parent's eyes she too became afraid.

For the remainder of that day nothing of consequence happened and there were even moments when life appeared to have remained unchanged. It was as if there continued to exist small protected corners that were spared from frost, where flowers could survive.

The next day Judith and her father walked through the Prater. They did not go too far. It was still like in the old days; they even stopped at a tobacconist's for some cigarettes. On the way home her father said, "You know, I haven't cried so much since my mother died."

From his words Judith understood that whatever had happened over the last two days was very bad: bad enough to make her father cry.

>‹

$$\rightarrow 4 \leftarrow$$

A T LAST IT WAS TIME for Judith to leave the hotel. Adjusting her hair and taking one final look at herself in the mirror, she went down into the lobby and without hesitating crossed the street and boarded the streetcar.

By sheer force of habit, she got off at the third stop.

The Kermauner house seemed hardly any different from what it was before the war. Admittedly the outside paint was peeling, and the iron fence had rusted and was badly in need of repairs; the steps however were still well swept, the brass sign on the front door had recently been polished, and aside from a cracked windowpane, the façade seemed to have been impervious to the passage of years.

As Judith climbed the stairs she once again felt the tightening in her chest, a gnawing anxiety that grew with each moment.

"Can I go over and see the Kermauners?" Judith asked. She was intent on seeing Anton. For the pain that poured out from her parents' faces was so continuous and so intense that she wanted to escape from it, if only for a few minutes.

"The Kermauners?" her father replied. "You can't be serious?"

45

"Why not?"

"They wouldn't even let you through the door. He has become a big shot; the Germans may even give him a post with the government. They are not going to be seen associating with Jews."

"Anton Kermauner is my friend."

"That doesn't matter, not one iota. Don't you understand?"

Judith did not understand, at least not at first. So she resigned herself to seeing Anton at school. There they would have enough time to talk about all that had happened over the last few days, and she would be with someone whose life had not become a tragedy.

At school, it was almost an ordinary Monday. Perhaps there was a bit more chatter and laughter but nothing very striking. The map of Austria was still in its place, the red borders of the country as unmutilated as any red border on a wall map could ever be. Judith sat down at her desk and opened it. Shortly before the bell rang, Anton came in and sat down in his seat across the aisle. He was wearing new black shorts, and a white shirt with the Nazi youth emblem embroidered on it. His blonde hair was carefully parted, and after he had straightened out his desk, he proudly tightened his new leather belt.

Mr. Prohaska got up on the platform.

"Boys and girls: as you all know, history was written this weekend, and as a result of it, Austria has finally and definitively rejoined the German homeland. Under the divinely inspired leadership of Adolf Hitler we are now able to look forward to a glorious future, a future that has been vouchsafed our Germanic-Aryan race and which is unmatched in any epoch of our country's history. As a Germanic-Austrian I am proud to live during such exhilarating days, and I know that all of you share my feelings.

"A few words about the Jews that are in our class. We must all remember the principles of hospitality practiced by our Germanic forbears. Jews, whatever their faults may be, are our guests, and we must treat them as such until it is time for them to return to their proper home. I know that you are tempted to do otherwise. I know

that you are urged on by the seething national consciousness that has been aroused within you. Yet I must stress that anyone in this class who does not behave according to the Germanic principles of hospitality will be punished by me. There will be no exceptions. However, in order to minimize the temptation, I shall ask our two Jewish guests to sit in the back of the class. Anna Redlich, would you please trade seats with Judith Berger, and Leo Rosenberg will you take the empty seat next to her."

Feeling disgraced, just as she might have had she not done her homework or had been unable to answer a question in front of the class, Judith packed up books and pencils, closed the lid of her desk, and took a seat at the back of the class. Leo Rosenberg waddled down the aisle and sat down next to her.

"We will now begin a special review of the political picture of modern Europe."

Judith looked at Leo Rosenberg. It was the first time he had been so close to her. As usual, his hands were dirty, and he was picking his nose, rolling the bright green mucus between his thumb and forefinger.

"Scum," she muttered between her teeth. "Polish scum." But the small boy on her left did not hear her.

Walking down the hallway after class, she felt a tap on her back. It was Anton.

"Judith, this must be terrible for you."

She could not reply. She felt as if she were about to dissolve into sobs, crying endlessly with her head on his shoulder. Her face remained tightly set. It would be weak to show her feelings, and she certainly would never do so in front of Anton. Her parents might cry, and it frightened her when they did, but she would be stronger than they, as strong as the Aryans.

"I am all right," she replied flatly.

"Good. Now listen, Judith, don't worry. I will always talk to you, even if you are a Jew."

They walked down the stairs. How strong he looked in his new

white shirt and stockings, Judith thought, and in his black corduroy shorts, how strong and how handsome.

In the entrance hall a workman on a ladder had removed the portrait of the former Chancellor and was in the process of replacing it with one of the Fuehrer. The discarded picture lay on its side, its back angled towards the wall. It was the portrait of an austere, learned man, with a wisp of a moustache and gray eyes that were now staring into nothingness. On the wall, underneath where the picture had hung, the paint was a milky yellow, a color that appeared to have been exposed indecently. It reminded Judith of the time when her father had come into her room and had found her standing before the mirror without panties.

"The Gestapo got him," Anton whispered to her, pointing at the picture by their feet. There was mystery and admiration in his voice. With a quick toss of his head, and another tug at his new belt, he strolled away.

On her way home, Judith passed a placard that had newly been pasted on the walls of a wood yard.

"One People, one Nation, one Leader."

The letters were drawn in bold red against the background of a large black swastika.

The stationery store, the halfway point between school and home, was closed. One of its plate-glass windows had been smashed, and large jagged fragments strewed the sidewalks. The remaining window had been smeared with a yellow Star of David. A sign hung across the door.

"Do not buy from Jewish swine."

What a thing to tell her parents, Judith thought. She had never liked Mr. Gruber, for he was gruff with her and became impatient when she stood at the counter trying to decide between the dog- and the frog-shaped pencil-sharpeners. She thought it served him right, but immediately realized that it was a wicked thought, for now all Jews had to help one another.

On opening the door of her house, Judith heard a strange wailing

sound, a keening that rose and fell in pitch and intensity. It sounded so inhuman, that she felt goose bumps across the back of her neck.

She found her mother face down on the bedroom floor, her legs drawn up against her stomach. Judith touched her but there was no response.

"What happened, please tell me, what happened? Tell me, tell me," she kept asking.

After what seemed to be an eternity, the cries subsided, and her mother rolled over onto her back. Her eyes however remained tightly closed.

"Where is Daddy?" Judith asked. "Has something happened to him?"

Silently her mother shook her head.

"Please open your eyes and tell me."

Finally Judith pried her mother's eyes open, aghast at the large rims of white that faced her.

"It's too awful," her mother moaned, "awful, awful, awful."

The story came out piecemeal. The Werners were dead. Last night, after they had given their maid the evening off, all three of them had taken cyanide.

Cyanide, there was something special about the word. Judith repeated it to herself in silence. It had a beautiful sound to it: cold and inexorable. Although Lotte Werner only rarely played in the Prater, Judith knew her quite well. She was a pert little girl with a shock of red hair, who could speak French and was always showing off with it. She would walk in the Stadtpark with her hoop and her mademoiselle, her apron lacy and starched, too proud to speak to anyone. Actually, Judith never thought that Lotte had much to be proud of. So what if she could speak French? Judith could speak English. She thought about the red-haired girl, and then about cyanide, and somehow was unable to put the two thoughts together.

>‹

She wanted to take a deep breath and compose herself before ringing the bell, but the Kermauners must have been waiting for her, for the front door opened as soon as she had arrived at the top of the steps.

"Hello, Judith!"

It was Herta Kermauner, much changed but still recognizable. Her face had grown heavy and bloated, her hair was gray now, and her hands had acquired a clumsy appearance.

"Well, Judith," she said, looking fixedly at the girl, "here we are. It has been quite a long time hasn't it?"

Before Judith had an opportunity to reply, Anton stood at his mother's side. Tall and handsome, with blonde hair and quiet blue eyes, it was the face she remembered, although he was even taller now and his features larger and their expression more subdued than when she last had seen him. Undecided how to greet her, he stepped forward with his hands extended, then retreated into the house. In the process he stumbled over the door mat.

"Good evening, Judith," he finally said. Of course his voice had changed; he was just entering adolescence when she had last spoken with him. But the inflection was the same, much like the "Good morning, Judith" with which he would greet her when he sat down in his desk next to hers.

"Good evening, Anton." She offered him her hand and he took it. "You have gotten so tall. Much taller than I remember you."

"What a marvelous tan you have," he stammered, still holding her hand. "It goes so well with your blonde hair. And your clothes; they are so elegant—no Viennese girl wears such clothes these days."

"What do you mean?"

Anton was silent. Judith knew he was groping to put thoughts into words. "They are smart, sensuous," he said, as he straightened the collar of his shirt. "Every detail enhances your beauty. You are so extraordinary, I have to remind myself that this is not a dream, that it is you and not a princess who has entered my life."

Judith did not know how to respond. It had been a long time since she was last exposed to Viennese flattery.

"Come in, please come in," Mrs. Kermauner urged. "Don't just stand outside. It is getting chilly. How wonderful it is to see you again, Judith—such an unexpected pleasure."

They entered the hallway, and Mrs. Kermauner led the way into the parlor. There was no doubt in Judith's mind: Herta Kermauner was not as elegant as Aunt Klea. Even though the stitchery on the front of her blouse was handmade, its cut was predictable. Aunt Klea would never have worn such a blouse.

"Shall we sit down?" Mrs. Kermauner suggested. "Lisl and I have been working for hours to put together something nice for you. It'll almost be like in the old days."

So it was. There was fried chicken and even though it had been prepared with margarine in place of butter, it still was very good, as were the warm potato salad and the cucumbers sprinkled with paprika that accompanied it.

Judith was surprised by the slightly sweet taste of the cucumbers. All at once, there it was—almost a vision of her mother as she stood in the dining room, her beautiful white hands smoothing down the crocheted tablecloth.

"Judith, will you carry in the silver candlesticks from the kitchen, the ones that Marushka polished this afternoon."

"Yes, Mama."

"And then come back, and I'll give you something else to do."

Judith felt Anton's eyes on her.

"You must tell me something about yourself," he said.

In a few sentences Judith provided him with a superficial sketch of her current life.

"And what about you?" she asked Anton. "What are you doing these days?"

"I am at the University."

"What are you studying?"

"He is in his second year of medicine," his mother answered for him. "And he is doing so well. I know he is on his way to becoming a professor. He has already written a paper. It is so complicated, with

chemical formulas, I can't possibly understand it."

"Oh, mother!"

"Isn't that what Professor Powolatz said to you the other day? He thinks Anton should become a researcher. Can you imagine?"

Holding her knife and fork in the European manner, Judith kept looking at Anton.

"Are you surprised to see me?" she asked him.

"Yes and no. I always knew you would come back to us."

"You knew, but I didn't." After a pause: "What do you think? Do I look anything like you expected?"

"Far better."

"Is that so?" Having said that she didn't know what else to say. Yesterday morning she was not in Anton's life. As luck would have it, at that very moment she caught him with his mouth full, looking silly and so like the Anton she remembered, that she made a face at him and giggled. He immediately knew why, and with his mouth still full started to laugh so hard that he nearly choked on the potato salad.

Judith and Anton were standing at the tram stop. Anton was chewing one of his favorite Ildefonsos, and with his mouth full laughed at something Judith had just said. As they were the only ones waiting, there was no one who might see them speaking with each other.

"You know, if my father ever finds out that I still talk to you, he'd beat me," Anton said.

"Are you afraid of him?"

"Me? Of course I am not; in fact I could report him to my Youth Leader and he'd be in bad trouble."

"You could?"

"That's right; two nights ago I heard him call Goering a fat slob."

"Oh."

"That was being disrespectful to one of our leaders, and if the authorities found out, he'd get into real trouble."

"What about me, could you get me into trouble?"

"You? Do you see this?"

He pulled a knife from the sheath attached to his belt. It was of black steel, sharply pointed, with a swastika engraved into the blade. He pointed the knife at Judith's neck.

"Do you know I could kill you, and no one would say a word."

Judith stepped back; the knife was uncomfortably close to her throat. Yet she was not afraid of Anton, for after all he was her very best friend. Besides she knew he was the kind of person who would never kill anyone.

"I know you don't mean it," she replied simply.

"Of course I mean it," Anton said. "When the police get here, all I would have to tell them is that you were a Jew and that I got angry with you when you made fun of our Fuehrer."

She had forced him to kneel in front of her and beg for a marzipan strawberry which she had thrown into his face. At that time she had been so appallingly wicked towards him that she now deserved to be punished. "Though the mills of God grind slowly," the rabbi had once said in the course of a sermon, "yet they grind exceedingly small."

Anton examined the blade, and carefully felt its edge with the ball of his thumb.

"Of course I could kill you," he reflected, "but I won't, because one day you and I will marry each other."

"Marry?"

"That's right...when we are both old enough."

Anton and Judith. Judith and Anton. Which sounded better?

The streetcar for the Inner City arrived with a bouquet of bells, and the boy replaced the knife. They both climbed in. Four stops later Anton got off. As he stood in the island waiting to cross he waved to Judith.

>‹

Herta Kermauner talked about the new milk- and meat-rationing program instituted by the Occupying Forces, then, as if drained of energy everyone fell silent. Mrs. Kermauner was the first to reveal her preoccupation.

"I wish Reinhard were here," she said with a sigh. She put down knife and fork. "The poor soul. In the dead of night he had to leave Vienna when the war was over. God knows what the Russians would have done to him had he stayed. Thank God he managed to escape into Switzerland. His friends found him a position at a boys' school just outside Zurich. Of course it is nothing compared to what he had in Vienna. Can you imagine, Judith, he had been appointed University Rector. It was such an honor. But what can we do? Anton and I visit him every few months…but we don't know whether he will ever be allowed to come back."

"Of course he will. Mother is too pessimistic," Anton explained. "We have only now started to make some efforts. After all, he has retained quite a number of friends who are high up in the government. It might take a couple of years, but in my opinion it is merely a matter of time. People forget. The important thing is that he has a clear conscience."

Judith felt for her necklace. The chain was thin but so hard that it cut into the balls of her fingers.

"And how is your conscience, Anton?" she asked with soft intensity. She felt as if she were setting him a trap.

"My conscience?" Anton repeated.

"That's right. I am curious."

"You don't understand, Judith," Mrs. Kermauner replied in her son's stead, protecting him as if he was still the young boy with the neatly combed and parted hair who sat across the aisle from Judith. "We were so deluded, all of us, it's impossible to explain."

><

March seventh, the feast of St. Reinhard, was Reinhard Kermauner's name day. As it had been for many years, it was a momentous occasion for the entire family. There would be roast goose accompanied by liver dumplings and a mushroom soufflé; and of course Lisl would bake some of her fantastic chocolate-covered puff pastry. The table would be set out festively with an assortment of family heirlooms: the best chinaware, crystal goblets, and silver cutlery, all displayed around the centerpiece of a porcelain vase filled with long-stemmed red roses.

"Is that you, Anton?"

From the kitchen Mrs. Kermauner had heard the door open and slam shut, as Anton came into the house.

"Yes," Anton said, and dashed up the stairs, two steps at a time without waiting for his mother's reply. As he did not have a good excuse for being late he quickly washed up for dinner. Lisl had laid out a fresh Hitler Youth shirt and the black velvet shorts that he wore only on special occasions. He gave himself a quick look in the mirror, parted his hair, and tried out a variety of serious and mature expressions. None of them seemed quite right.

By the time he came downstairs, Uncle Franz had arrived. He had brought his fiancée, Fräulein Erika, a slender girl with a stub nose, dark, pensive eyes, and luminous black hair trimmed square around her face. Head bowed, she was seated in the window seat; her hands were folded in her lap. She had draped a black knitted shawl around her shoulders; its fringes dropped over her ankles and curled on the floor. Erika was studying the piano. She had spent a year in Japan, and last fall she had been accepted into the master course at the Conservatory.

In the months since her engagement to Franz she had become a frequent visitor to the Kermauners. Anton found her beauty to be intensely disturbing; whenever she addressed him, even if it concerned the most trivial matters, he would stammer, giggle, or at best maintain a self-conscious silence, miserable at not being able to

respond with anything better than what he sensed to be stupid and childish remarks.

Outside daylight was fading. A sprinkle of rain dotted the sidewalk: opalescent circles that grew and joined each other to create puddles that reflected the street lamps.

"Well, well, well, my young friend," Franz addressed Anton. "How is life treating you these days?" He put down the newspaper, and got up to stand with his back against the tiled stove.

Relieved at not having to converse with Erika, Anton shook hands with his uncle.

"Now don't tell me you are going to ignore my Erika," Franz admonished him. "You'd better not; she might be disappointed in the manners of her future nephew."

When Anton had made his amends, Franz motioned him over.

"Come and sit down with your Uncle Franz. You and I never have much chance to talk these days. How is school?"

"Fine," Anton replied sullenly. Adults always asked him about school. He sat down with a sideways glance at Erika.

Franz did not miss the glance, nor was he unaware of the cause for his nephew's discomfort.

"Glad to hear that," Franz continued. "I suppose it's still the same old grind: Latin, Greek and all that, eh? Even the new regime can't help you with this sort of thing, can they?"

"No."

"And how is your social life? Anything to report to us?"

Franz smiled and turning his head took in Erika's response to his question. The girl remained serious; her eyes were half-closed and she seemed not to have heard.

Anton shook his head. There was no way he could tell Franz about Judith, not tonight at least, not with Erika sitting in the window seat, and his father about to come downstairs.

By then Anton was overwhelmed with despair. To see Franz in Erika's presence caused him to lose all sense of his own future. Who was he? What would become of him? What was he going to do with

his life? He had asked himself these questions many times before, and he always came up with a different answer. Nothing seemed quite right; all he could do was study and receive the best possible marks on his examinations. To what end? Even though at various times he had cornered Heinz or Willi with such questions, they were absolutely hopeless when it came to serious matters. Heinz would turn sarcastic and nasty, and as for Willi he would act stupid and quickly change the subject to soccer.

Judith would have been different. She had always listened to him, and they had shared a passion for defining the important ideas that were beginning to appear on their horizon: love, truth, beauty, the purpose of man's life. When Anton brought up his belief in God, she would question him intensely until he was forced to admit that he did not know and that there were times when he too doubted whether the priests had the final answer.

"I don't know either, Anton," she would say, nodding in agreement with his uncertainties, "everything is so vague and so far in the future."

Then she would tell him about her plans. She would become a writer, prepare humorous stories for the newspapers, and of course she wanted to experience the heady excitement of being in love. There was much understanding between them.

That had been before the Anschluss. Now with Judith about to leave Vienna there could be no further chats with her. He would have to wait until she returned, and these days there was no way of knowing when that would happen; after all she was a Jew.

Heinz is right, Anton told himself, as he watched Franz pick up Fräulein Erika's shawl, and place it into her lap with a show of solicitude. I should stop worrying about love and God, and other similar boring questions that will always remain out of my reach.

His mind was free of them when he was at the Youth House. Indeed, whenever he was with his troop he felt good about himself. At such times he had no doubts concerning his future, for at the Youth House he was continually being reminded that he had sworn an oath

to devote himself to the ideals set forth by Adolph Hitler and that he would lay down his life, were it necessary, for Germany and the Aryan State. It was wonderful to be filled with one goal, to be able to soar above every nagging fear and doubt. Surely, National Socialism must be the right answer for him. He would devote himself to strengthening the cause of Germany and dedicate his life to his country's glory. Before too long he would be promoted to Unit Leader, then to Group Leader and he would be invited to participate in the Party Day at Nuremberg. That would be fabulous: to march as one of innumerable thousands, sense the immense strength of indissoluble comradeship, and become enveloped by flags, lights, and songs.

It must have been Judith's fault that he ever had any uncertainties about himself. Now that he was freed of her, the path that lay ahead of him was absolutely clear: brilliant, immensely exciting. With such reassuring thoughts as these he quickly wiped out whatever feelings of misery he had felt a few minutes before.

"Do you know when we are supposed to eat?" he asked Uncle Franz.

"Pretty soon, I would imagine," Franz replied. "Your Uncle Egon should be here any minute." Herta Kermauner's brother Egon was in the import-export business and spent much of his time in Cameroon, a former German colony.

Reinhard Kermauner came down the stairs.

"Erika, Franzl, how are things with the two of you?"

For Anton, his greetings were less genial. "I was looking for you. Where have you kept yourself all afternoon?" Even though his stooped head detracted from his height, he towered over his son.

"Oh nowhere," Anton replied evasively. "When's dinner?"

"Never mind. First I want you to define for me what 'nowhere' means."

When Anton hesitated, his father became insistent.

"All right, now where were you?"

"I was in the Inner City," Anton conceded, "and I didn't realize how late it got."

Franz turned to his brother.

"Reinhard, you forget how it was when you were his age. There are things one doesn't tell one's parents...."

So Uncle Franz thinks I have a girlfriend, Anton thought, relieved by his uncle's rescue. What would happen if over dinner I would make an announcement and tell everyone about Judith? What would they do? It would wreck their evening, that's for sure. Father would be furious. He would say I was a disgrace to the family. What about Uncle Franz, would he speak up for me? Probably not. After all, he declared, not too long ago, that it was the fault of the Jews that Austria was such a poor country and that Hitler was right: they had to go, once and for all.

And how would Fräulein Erika respond? Anton glanced at her as she reclined in the window seat. She was not only beautiful, but also different from anyone else in the family. He could not take his eyes off her. Her white blouse hid two full breasts, and they moved up and down as she breathed. Judith was still flat-chested, and remembering that he felt sad and helpless.

"What do you think, Reinhard? Are the Czechs going to give us trouble?"

Franz pulled out his cigarette case and snapping it open offered it to his brother.

"Of course not," his older brother replied, taking a cigarette. "I have complete faith in our Fuehrer. You saw what he did with the Sudetenland. He planned everything so carefully, that Chamberlain and Daladier just stood there, looking foolish. The same thing will happen again. The Western Powers won't dare to fight. Czechoslovakia will become our Protectorate without one drop of blood being shed in the process."

Uncle Franz rubbed the side of his nose. He was weighing his brother's remarks.

"You are quite right," he finally agreed, "and after all that is taken care of, we can settle the question of the Corridor. That should be much easier. I can't imagine the Poles putting up much of a resis-

tance. Pigs, that is a subject they know something about, but war: hardly."

"I agree with you. Still I foresee one big problem."

"What's that?"

"Stalin. We must never trust that man; he is deceitful. I have no doubt that the Fuehrer has considered all that, and that he will provide us with a solution in due time. You see, Franz, this is why I never questioned that the Anschluss was the best thing that could have happened to Austria. You were too young to have my insight, but now, don't you admit I was right?"

"Of course I admit it. Why shouldn't I? Adolf Hitler is God-inspired. How else could he have accomplished all the things he did for Germany? And let me tell you something else: even if there should be a war, it'll be a wonderful experience for all of us, a genuine baptism of blood."

"Baptism of blood. That's all one hears these days."

Herta Kermauner had come in from the kitchen. "Here we are, about to sit down for a good Name's Day dinner, and I find my husband and brother-in-law declaiming about baptism of blood."

Erika rose and came over to Franz.

"Tell me, Fräulein Erika," Herta addressed her, "do you want Franz to participate in any 'baptism of blood'?"

Erika locked her fingers into Franz's. "Not for the whole world, I wouldn't," she replied.

Anton knew that his mother did not support the State and the Fuehrer as wholeheartedly as did his father. Judging from what he had learned at the Youth House, some of her remarks could be interpreted as being seditious, intending to downgrade the Government, and therefore punishable.

For one tantalizing moment he toyed with the idea of reporting her to the Group Leader. It would be a marvelous affirmation of his dedication to National Socialism and demonstrate to everyone that he held the State in higher regard than his parents.

Even though he knew quite well that he would not denounce his mother, the possibility that he could do so was so reassuring that, when a few minutes later, she asked him whether he had washed his hands before supper, he was able to reply civilly.

Breathing excuses, Uncle Egon arrived. He was a heavy-set blond man, with a small sharp beard and restless eyes. He was loaded with presents, which he proceeded to distribute: ebony wood carvings for Reinhard, an ivory bracelet for Herta, earrings for Erika, and a bark painting for Franz. For Anton he had an album of photographs: jungle scenes, native markets, gold mines, wild animals.

"Something to feed your imagination," he said to the boy. He was right. Books about American Indians, bloodthirsty Arab sheiks, and expeditions to the Poles were Anton's favorite bedtime reading.

At long last, the door was pushed open, and Lisl entered. In her arms was a huge tureen of dumpling soup. An intense aroma of caraway, chives, and above all, roast goose accompanied her into the dining room.

"Sit down, sit down, everyone."

"Here, Erika, I want you between Franzl and Anton."

"What a marvelous production!"

"Who will open the wine?"

Everyone took a place at the table, and while Lisl stood by the door with her head bowed, Reinhard Kermauner rose to say grace.

"Bless us, oh Lord, and these Thy gifts which through Thy bounty we are about to receive through Christ our Lord. This day bless and protect our German Reich, the Province of Ostmark, and our great and glorious leader, Adolf Hitler. Amen."

With grace having been said Franz pushed himself up from the table. A glass of white wine in his hand, he proposed a toast.

"To a dear and wonderful brother, Reinhard, and may he have many more happy name's days. Prost."

There was a chorus of "Prosts" and everyone drank the toast.

How tart the wine is, Anton thought, sipping his glass. Raspberry

lemonade is much better, that's for sure, but he was old enough now to drink wine. The important thing was not to grimace when it went down his throat.

"Another toast, another toast," Franz announced and got up a second time.

"This toast is to my nephew Anton, who has just been promoted to the Hitler Youth. Stand up Anton and take a bow. At long last you have graduated from the Jungvolk, and that deserves a toast."

Another round of "Prosts" ensued, and with all eyes upon him Anton struggled with his second glass of wine.

Finally it was time for the soup. With a sigh the boy took up the spoon. It was a good soup, with little green shreds of chives that circled the discs of yellow fat. Before long Anton had finished and was ready for the next course.

The goose was a miracle. A crisp, juicy brown skin, that crackled in one's mouth, soft meat, and to top it off, a stuffing of chestnuts, apples, and lemons. Anton succumbed to seconds and thirds.

"He must be a growing boy," Uncle Egon growled. "I hope he leaves something for the rest of us."

To be sure there was enough, and when Anton's mother poured the coffee, the men leaned back in their chairs and lit cigarettes, inhaling deeply and luxuriously.

"You know, Franz," Reinhard Kermauner declared, "we are living in truly wonderful times, and we must thank our National Socialist Party for bringing them about."

"Can I make a confession?" Franz looked around the table. "This is a good time for a confession is it not?"

"Of course, of course," Herta said, "aren't we amongst friends?"

"When you first became a member of the Party, I didn't understand why you were so certain that National Socialism was the answer for Austria. Besides, one never trusts one's older brother, even if he is a professor at the University. One always hopes he will make a fool of himself. But today I know: you were the most far-seeing of

any of us." Franz grinned. "Therefore I shall now propose a toast. To Reinhard and Adolf, the two greatest men of our time."

He was on his second bottle of wine and his words had lost some of their clarity. Glass in hand, he bent over Erika.

"Aren't you going to join us?"

She complied and raised her glass. The dancing lights of the chandelier were reflected in the crystal.

Another chorus of "Prosts" sprung up around the table, and Anton's voice was the loudest of all.

"What is it with you?" Franz whispered to Erika when he had downed his glass. It was loud enough for Anton to overhear him.

"Nothing, it's nothing." Her face had acquired a frightened cast.

"Are you sure? You don't seem yourself."

Erika shook her head and patted Franz's hand.

"I'll be all right, it just seems that people like Reinhard...." She broke off and smiled perfunctorily.

"Wasn't it a gorgeous goose," Uncle Egon said. "Herta, you are a fantastic cook."

There was pastry and more coffee in the music room.

"You will play for us, Erika," Herta Kermauner asked, "won't you, please?"

"Of course I will, but after all that wine, please don't expect too much from me."

"It really doesn't matter, not with your skills. You are so talented. I have no doubt but that you will play beautifully."

Erika sat down at the piano, stretched her knuckles, and played a few chords and scales to warm up her fingers.

"How about some Schubert?" Franz suggested. He looked through the music books on top of the piano. "Here is the Impromptu in C minor."

"I would love to play it for you, but I must warn you, it is not in my repertoire."

Nevertheless she took the book from him, opened it out on the

rack and began to play. Franz sat down next to her and turned the pages.

Anton remained in the rear of the room, his back against the wall. He was chewing a chocolate-covered Ildefonso. A fragment had become lodged in his tooth, and he worried whether that meant he would have to return to the dentist. That was a disturbing thought, and he pushed it aside, preferring to listen to Erika. How slender her neck and arms were, the color of moonlight, covered with a fine down that was like blue dust. He wondered how her arms would feel were he to stroke them, and thinking about it, he shivered.

"That was wonderful," Reinhard Kermauner said when Erika had finished. "It seems as if all the tragedy of poor Schubert's life has been distilled into this one piece."

Franz closed his eyes. "I can just imagine how he felt when he composed it. I sense an enormity of longing, of loneliness…and what a soft, tiny melody." He hummed it, and lit another cigarette.

"Now play something else, anything." It was Reinhard's turn to ask.

Erika agreed. "But this is from memory, only from my memory."

Her words had an unusual intonation; it was as if they swayed from side to side. What a strange manner of speaking, Anton thought; could it have been her year in Japan?

Then he heard the music. A soft, insistent invitation, a beckoning by a beloved woman to walk through a garden on a blue, unclouded summer day. Slowly, hand in hand, taking in the perfume that was everywhere. Just when it seemed there were no more flowers to gaze at, magic erupted: water nymphs ascended on iridescent sprays and, forming a circle in the sunlight, danced a fragile, unworldly roundelay.

"What are you playing?" Egon asked.

Erika did not reply. She tossed her head and the elfin dance continued.

"Mendelssohn, isn't it?" Franz's voice was remarkably harsh.

Erika nodded and continued.

"Stop it, will you?" Reinhard Kermauner enjoined her. "What possessed you, after such a wonderful dinner?"

"Please, Erika." Herta came up behind her and placed her hand on the girl's shoulder. "You mustn't, you know it's forbidden."

With a quick forward movement Erika dislodged Herta's hand. Defiantly she erupted with another spray of crystal notes.

Her behavior stunned Anton. Not that he sensed the music to be immoral or degenerate, the way Jewish music had been described to the boys at the Youth House, but rather that Erika would play it, knowing full well that it was proscribed. What right did she have to do so? He became angry. It was as if by playing Jewish music she no longer was the same Erika who had sat in the window seat, hands in her lap. As far as he was concerned, she had forfeited her position in the family as Franz's fiancée and had become an outlaw. For him there was only one course of action: he would show himself to his parents as mature and aware of his responsibilities as a Hitler Youth.

"Why are you playing this filthy Jewish music?" To his embarrassment his voice cracked as he spoke. When she did not reply, he came up alongside her and banged his hands on the piano keys. The instrument shrieked, but Erika ignored it. Trembling with fury, the boy pointed his finger at her.

"Stop it," he shouted. "Don't you know this music insults the Aryan race?"

"Anton, please," his mother tried to intervene. "You are addressing Erika."

"As far as I am concerned she no longer is Erika. She has defiled our house. You don't understand, you are too old to understand, but she has defiled all of us with that Jewish crap."

Erika stopped playing. She turned around on the bench and faced the family.

"I am sorry, Anton," she said softly, "but I think Mendelssohn is beautiful."

No one spoke. Beads of perspiration had collected on Anton's forehead, and his hair had become disheveled. Without another

word Erika got up and closed the piano lid. Understanding her gesture, Franz left the music room to gather her coat.

"What on earth got into you?" he asked her when he returned.

"I don't know."

"But why did you provoke the boy by playing such trash?"

Erika sighed and put on her coat. "Things are not right anymore."

"What makes you say that?"

"Because I'm afraid; all day long I am afraid."

Franz took her hand. "But you mustn't be. Don't you know I still love you?"

"Of course I do. I know it, yet I am still afraid."

"Come on, Erika, I think you are getting a trifle too melodramatic."

"Perhaps…it's just that I am even afraid to think."

Without a farewell, and without even waiting to see whether her fiancé would accompany her, she turned and left the house. When she had gone, Franz turned to his brother. Palms up, he shrugged his shoulders.

"She is so reckless," he said, "much too reckless."

Reinhard pressed his brother's hand. "Let's not talk about it now. Just take her home."

Throwing on his coat, Franz opened the door and followed Erika. The night had grown cold. A wet wind brushed through the trees, tossing their branches with brief, unpredictable gusts.

After Franz and Erika had left, Reinhard motioned to his son.

"I have to have a talk with you." He led him into his study. As such talks were rare occasions and were usually the consequence of some unpleasant event or other, the announcement made the boy uneasy. As he stood before his father's desk and regarded the innumerable rows of books that lined the wall as far as the ceiling, he sensed himself as small and fearful.

"What can he be up to?" he thought. He reassured himself that as a Hitler Youth he no longer needed to fear his father, and that

it was best to get this talk over with as quickly and as painlessly as possible.

"Sit down, Anton."

He did as he was told. Reinhard Kermauner picked up his reading glasses and turning them in his hands squinted down at his son, conscious of the latter's discomfort and anger.

"Your behavior towards Erika was totally inexcusable." He paused, as if he sensed that he had to select words that conveyed his feelings correctly and precisely.

Anton remained silent. If his father looked for remorse, he would only find pride in having accomplished a manly deed.

"Tell me, Anton, do you understand what you have done?" Reinhard Kermauner's fingers drummed on the green, ink-stained blotting paper in front of him.

The milk glass of the table lamp was also green, as was the light that it cast across the tapestried walls. The silence that gathered within the study rose to fill every available space. Somewhere in the house Lisl sang "Ach du lieber Augustin," as she was washing up the dinnerware. She sang it simply, repeating the refrain over and over. Anton hated to hear it: it was so predictable, so purposeless, why couldn't she simply work without singing?

He fingered the blotter on his side of the table and rocked it back and forth. Should he apologize to his father, and perhaps even to Erika? That was all wrong. How could he cringe before his father, when he had just become a Hitler Youth, a full member of the State, a model to his comrades and all those younger than he? He scowled. What did it matter what his father expected from him? Old men like him could not understand his feelings.

"I have sworn an oath over the flag of blood," he declared.

No sooner had he spoken these words than he felt pompous and melodramatic. He sounded exactly like Gisela Gschnitzer. At thirteen she was always ready to produce a child of her own for the Reich. Still, he had, in all reality, sworn an oath to the Fuehrer, and he had dedicated his life to the glory of the State. That meant he had

to make certain that no one, not even a member of his family, would act against the State.

When he reasoned in this manner he became delighted with the strength of his ideals and with the marvelous maturity of his words. Unmoved, his father looked up and fixed his eyes upon him.

"Listen, Anton, I was a National Socialist when you were still in diapers, and I know what National Socialism stands for a good sight better than you do. One thing it certainly does not stand for is harassing some poor girl because, after a few glasses of wine, she decides to play Mendelssohn."

"Then you condone Jewish music?"

"You are being arrogant, and I shall not stand for that. No, I do not condone Jewish music, I don't believe there is room for Jewish music in our new State, but as far as I am concerned it makes not one iota of difference whether Erika plays Mendelssohn or not. Believe me, my son, the Third Reich is strong enough to tolerate a bit of Mendelssohn."

Anton felt he was losing the argument.

"I can't stand you talking that way," he shouted. "You understand nothing, absolutely nothing. All you can do is turn something wonderful into dust, dry dust."

"I want you to lower your voice. You forget you are speaking to your father."

"I don't want to talk about it anymore." Anton jumped up and pushed his chair aside. The violence of his movement made it crash to the floor. Without another word he dashed from the room. He grabbed his jacket from the coat rack in the hallway and ran out of the house, slamming the door behind him.

Once he had gone, his mother came into the study. With a sigh, she stood up the chair and returned it to its former position.

"What are we going to do with him?" Obviously she had stood outside and overheard the argument. "I don't think the Hitler Youth is good for the boy," she continued. "It gives him such an over-inflated sense of importance. Can't you take him out?"

"How can I? I am a Party Member with a low number. I have been a member of the Party longer than most people in Austria. Besides, it is essential that he take part in building the Third Reich. We all must."

"It is just that he is so angry so much of the time. It is all right when he takes it out on the Jews, but Erika...."

"I am not worried. It's just his age. You forget, we weren't little angels when we were growing up."

He rose, a signal for them to go to bed. His wife followed.

"When do you think he'll be back?" she asked. "I want to wait up until he returns."

The following morning Erika was arrested, the consequence of Anton's denouncing her to his File Leader. Although she was released two days later, she was summarily expelled from the Conservatory.

➤✦

✢5✢

Herta kermauner took a deep breath and rang for Lisl to clear the dishes. After the woman had come and gone, she took Judith's hand and whispered: "I hardly dare ask about your parents."

Judith shook her head: "I think they were killed. Most likely they were gassed, but I never found out where or when."

"I suppose you don't really want to know," Herta said.

"In a way I would. It would help with my farewells to them. Like seeing their graves. Do you understand?" She looked at her hosts. Herta nodded in agreement. Anton's face was tight; his eyes seemed to fix on an object in the far distance. For an instant it appeared to Judith as if he were about to say something. Instead he picked up a spoon at his side and turned it back and forth in his hand.

"How awful," Mrs. Kermauner breathed sympathetically. "I will never forget them. That day when we took an outing on the Danube, the four of us, you remember that, Anton, don't you?"

"We must put the past behind us, draw a heavy line under it," Anton said. He looked neither at his mother nor at Judith.

Mrs. Kermauner adjusted the collar of her blouse. "Yes, yes, it is far better that way," she sighed. "I tell you, Judith, it has been a hard time for all of us. My brother Egon died. He was interned by the French. They also had their concentration camps, and he contracted

some strange tropical disease. And do you know, Franz is also no longer. He was killed at Stalingrad. And for that they gave him the Iron Cross. The Iron Cross: that's all we have left of him."

>‹

When Franz arrived at the Kermauners he was by himself and in uniform. Herta met him at the door.

"Franz, my, my, how smart."

Franz responded with a mock salute. "Lieutenant Kermauner, Ski Patrol, Hoch-und Deutschmeister Regiment at your service." He clicked his heels.

"Come and have some coffee with me, I am all alone. Reinhard has gone to the University for the Rector's Assembly. More social and racial education. No coffee? Of course, how could have I forgotten? But you will have a glass of cognac?"

Franz accepted the cognac and stretched out his legs. The black leather boots glistened in the lamplight.

"How wonderful it is to be here," he sighed. "Now more than ever. Everything in the barracks is so impersonal, even for us officers, that I miss the comfort that I get from you and Reinhard. You cannot imagine what barrack life is like. The man I room with is indescribable, there is no way I can talk to him. He has no education, no manners, a genuine pig-breeder. There is nothing going for him, except that he joined the Party in thirty-six, so that he knows one or two of the bigwigs. I tell you, times have changed."

Regretfully, he refilled his glass.

"And Anton," he asked, "how are things with him?"

"He is at the Youth House. He should be back before too long." She shook her head. "I no longer can understand him. Some days it is as if they have completely taken him away from me." She leaned forward. "You know," she confided, "I come from Znaim. It's a small town, or at least it was when I was a girl. So I had a strict upbringing. The respect I developed for my parents. You cannot imagine how

well grounded it is; you grew up after the war. But Anton, I don't know what they are teaching him in school and in the Hitler Youth. It's contrary to what I was given to believe is right. That boy couldn't care less about us. He's even stopped going to church, and the things he says about the priests.... When I say something to him about it, he sticks out his chin and says, 'We are the New Germany.' Sometimes I'm actually afraid of him. I might say the wrong thing about the regime, and he'll go and report me."

"Of course he wouldn't. He is not a vengeful boy. A trifle over-enthusiastic, perhaps, but not to the extent that he would report his mother. Besides, Reinhard is a Party Member...that should protect you."

Herta grew thoughtful and rang for Lisl.

"Do you realize that Lisl and I whisper when he is around?"

Lisl came in and cleared the coffee. With her out of the room, Herta rose and went over to the wardrobe.

"By the way, we still have Erika's shawl."

She took it from the hanger, its black knitted form fell limply across her arm. "She left it here when she was over the last time."

"Of course. You know, we are not seeing each other any longer."

"Franz? You didn't tell me. What brought this on?"

"She is politically encumbered. As an officer, it would never do for me to...."

"I'm so sorry. The two of you seemed so promising a couple. Couldn't you—"

"You must understand. These days one doesn't take risks, one regrets it so often. You can't conceive though how difficult it was for me. Painful, I assure you, truly painful."

"Poor Erika. She is so talented. Do you think I should ring her up?"

Franz crossed his knees and put down his brandy glass. A shadow came over his face.

"I think it's better you don't. Someone might find out, and we'd all get bad marks. Besides, I don't think she is in her apartment any longer."

"No? Where did she move to?"

"I don't rightly know."

They grew silent. When Franz spoke up, his voice was clear once more.

"Do you think Anton will be back in time for the opera? I have an extra ticket for tonight's *Meistersinger*. Standing room, but the cast is excellent."

Mrs. Kermauner took a deep breath and got up. "Let me see what Lisl has done about our dessert." Over her shoulder she added, "As you can imagine, we are short of servants."

She disappeared into the kitchen and the two young people were left to face each other across the table. "What did you do all these years?" Judith asked Anton.

"Not much." He shrugged his shoulders, "And you?"

"Let's not talk about it…not tonight."

"Mother tells me you left California to come here." Anton said. "I would never have done so. As soon as I get my degree I am going to look for a position in America. Here there is nothing. Medicine has become fossilized, and doctors just barely make a living; even a street-sweeper earns more than I will. I'm sure America is different. Don't you think I could find something there? Some sort of a job to get started with?"

His uncertainty surprised Judith. This was not how she remembered him. After the German takeover, he had become strong and uncompromising, a young man who had claimed an innate, Aryan superiority for himself.

"You would do very well in America," she replied. Conscious of being kind to him she smiled.

"I even know quite a lot of English. I am studying at night so I can become fluent."

"Remember, I tried to teach a little bit to you."

73

"'*I am your friend.*' That is a phrase I will never forget. It saved my life."

He did not elaborate, and Judith did not dare question him any further. Not that evening, at least. In a way, she behaved like a drunkard who has awakened after a night of carousing and blurred images and does not dare look for his wallet for fear that he will find it gone. Therefore instead of probing for disclosures that might well turn out to be unbearable to Anton and herself, Judith permitted Anton's past to remain obscure.

After school, Judith would walk part of the way home with Anton.

"Nothing will happen to you when you are with me," he said, and looking into his earnest blue eyes, Judith knew that this was so.

"I am learning English," she announced one day.

"You must teach me."

"I would love to. Now listen carefully." And she spoke slowly and in English. "*I am your friend.*"

"What does that mean?"

Judith told him, and Anton repeated it several times. Soon they reached the place where they usually parted ways.

"See you tomorrow," Anton said.

Herta Kermauner returned to preside at the table while Lisl served the dessert. It was extravagant and fanciful, a melee of mocha, almond paste and whipped cream. Judith put down her spoon.

"I think it is incredible that I am back in Vienna, sitting over dinner with the two of you as if the last decade had never existed."

Despite the vanilla-flavored whipped cream, a sense of discomfort smoldered within her, a feeling of unease aroused by Anton's

reply to her question as to what he had done during the Hitler years. "Not much...."

Dessert plates in their hands, they adjourned to the music room.

A feeling of separation had overcome Judith. To push it aside she chatted about her life in California, painted it in exuberant hues, with descriptions designed to arouse "Oh"s and "Ah"s in mother and son. She allowed Anton to pour cognac for her, and with a dusky voice asked him to sing some Viennese songs.

Anton went up to his room and returned with his harmonica.

"My voice is no better than it was when we were in school together," he apologized, "but during the war I learned to play the harmonica."

"Good," his mother said. "Judith and I will sing together so that no one will know who is off-key."

"How about 'Vienna, City of My Dreams'?" Judith suggested.

"Of course...."

Anton played a few arpeggios and then started in on the song. The two women joined him, and Lisl, who came to remove the plates, stayed and took up the refrain.

There were more songs, and even another glass of cognac, and then there was a serious matter to be dealt with. How to get Judith back to her hotel.

"I don't want to take a taxi. It's time I took the streetcar, like all the other Viennese."

The last streetcar, the blue one, so termed because of the light used to designate it, was due in a few minutes. There would be just enough time for Anton to walk Judith to the tram-stop.

"You must come back again soon," Mrs. Kermauner told Judith as the girl bade her farewell. "I want you to see this as your new home...do you hear?"

As Anton and Judith walked through the empty streets, her feet tapped forlornly on the cobblestones. A car drove by with dimmed lights, and then a jeep: American occupation forces.

"Your compatriots," Anton declared, pointing to the vehicles.

"They are so much more decent than the Russians. I only wish we could teach them some manners." They walked arm in arm. "Don't hurry!" he said. "We are almost there."

Without becoming aware of it they fell into step, like a couple who have been together for years and who have learned to move in unison.

"You are right, Anton," Judith said, "we must draw a line under the past. It is useless to dwell on it. Certainly it won't resurrect my parents and the rest of my family."

When they arrived at the stop, they found themselves to be early.

"It's so good to be with you," she said. She was conscious that the bond between them had reformed. "Not a day has gone by that I didn't think of you. All I had to help me think of you was one photo." And she described the photo taken on the river boat outing. Anton kissed the top of her head. "I want you to know," he said softly, "I never forgot you, not even during the war. And I didn't have a photo to help me."

1939

It was early summer and the soccer season was in full swing. Austria had defeated Admira, which that year did not come as an utter surprise, since the latter club had lost three of their star players to the Wehrmacht.

"Anyway, I tell you, Zoehrer was fantastic…what a goalie."

Anton, who was an Admira supporter, was trying to make the best of a disappointing afternoon. Heinz Uridil was triumphant. He had backed Austria, and his voice was still hoarse from cheering, especially during the second half when his team had come from behind. Willi Moser was non-committal. He was a Rapid supporter, and had only come along because his team was playing in Graz, and consequently there was nothing else for him to do.

Their arms linked, the three boys were walking home across the Prater meadows. The crowd of spectators leaving the game, thick at first, had scattered, with most of them heading in the direction of Floridsdorf, so that the boys were able to stride along rapidly. The sun had descended and its light filtered through the heavy-leafed chestnut trees that lined the meadow. Their long diagonal shadows crossed the grass.

"I'm in no hurry to get home," Anton announced. "What about you two?"

He knew Willi would be of the same mind, for Willi was always agreeable. Willi who was fat and did poorly in all aspects of Body Culture lacked friends, and therefore was always happy to be included in the company of the more popular boys such as Anton. It was different with Heinz, who might well have countered with plans of his own. This afternoon he was so filled with the triumph of seeing his team win that he didn't care what Anton proposed, for he could bask in the prestige of his team.

"What a second half," he proclaimed breathlessly after the three of them had sat down in the grass. Anton put his head back. The soil felt warm with the unspent heat of a summer's day.

"I hope the match against Hungary comes off," he said.

"Of course it will," Heinz replied. "Why shouldn't it?"

"It won't if we have a war."

"You mean against the Poles?"

"Do you guys think there will be a war?" It was Willi, and his voice was anxious. Anton was immediately aware of it.

"Sounds as if you are afraid of the war."

"No, I'm not. I'll volunteer if they'll have me."

Anton turned to Heinz, but his words were also intended for Willi.

"Did you guys know the Hitler Youth in Eisenstadt have been issued Mausers? Eleven point five caliber Mausers, and they are already doing target practice."

"Who says?"

77

"My Uncle Franz, and he is with the Hoch-und Deutschmeister."

"Well that's because they are next door to Russia."

"Have you ever shot off a pistol?" Willi did not attempt to disguise his concern.

"Of course I have," Heinz said, proudly. "Next time I go Jew baiting, I'm going to borrow my Dad's Luger."

"You mean he'll let you have it?" Anton could not imagine his father owning a pistol, let alone lending it to him.

"Of course he will. You never can tell, I might feel like plugging a Jew."

This time both Willi and Anton were impressed.

"Have you ever gone on a Jew Action before?" The latter asked.

"Of course I have. My Dad took me just after Easter."

"How was it?"

"Splendid...really splendid."

Before the Anschluss, Heinz's father had been headwaiter at the Cafe Abeles. Since the coffee house was owned by a Jew, he was given the opportunity to expropriate it from him, a reward for five years' service as an illegal National Socialist.

"Anyway, I don't think there will be a war," Anton mused. For a while the boys were silent. Anton lay back. Through half-closed eyes he could see the drifting summer evening clouds, violet feathers tinged with the light of the prolonged dusk. A group of girls strolled by. Singing, their arms around each other's waists, they marched in perfect step.

"Look at them," Heinz proclaimed. "The one on the right has gorgeous tits."

"She sure does," Willi quickly chimed in. His opinion came too promptly, and Heinz picked up on it.

"I'll bet you've never been laid."

Willi was silent. His head hung in shame.

"I've seen a girl's cunt," he finally managed.

"That's nothing, everyone has."

Anton was glad he hadn't been asked. He wondered what it was

like: arms around arms, legs around legs, dark and hot between two bodies. He should try it, but with whom? He thought of Judith, who by now must have left Vienna. What would it have been like with her? Heinz had said that Jewish women get absolutely wild; it was merely a matter of touching them in the right spot: high up on the inside of their thighs. Anton tried to conjure up Judith's face, and imagined its appearance as they were doing it, trying to feel her long blonde braids around his cheeks. She was a Jew, so he could have done it with her even if she didn't want him to. That's what Heinz had told him a few weeks back. But he still would have asked her permission, since she really wasn't like all the other Jews he had seen. She was blonde, well mannered, never gesticulated with her hands, and didn't have that peculiar way of speaking that Jews had. Yet the law said she was a Jew, and the law was right. Then again there might be exceptions. He would have to ask the Unit Leader about that. He wouldn't have to mention Judith by name, just a general question would do.

"Listen, you guys," Heinz said, "when we go into Poland we'll have so many Polish girls to fuck, you can't imagine. Besides, they'll love it. We'll give them the best fucking they ever had."

"That's right," Willi said softly.

"And if they won't let us, we'll tie them down with their legs apart, give them a few whacks with our belt, and then fuck them crazy. What do you think, Anton, are you with me?"

"Sure, but I'd want to try it with the B.D.M. as well."

"You mean, you haven't yet?"

Anton was trapped by his admission. He did not want to lie.

"I'd rather not talk about it in front of Willi."

"No, no, I don't mind," Willi protested.

"Yes, you do. You're a virgin, aren't you?" Willi was silent.

"I tell you what," Heinz proposed to Willi. "We'll get Gisela Gschnitzer to help you out. She'll straighten up your ding-dong in no time." Willi did not reply. His face turned red.

Anton had an idea. "Hey, Heinz, do you think Pepi Stegl is already fucking her?"

Heinz sat up and thought about it. His face grew dark, and in the evening light it looked as if he needed a shave.

"That Pepi, he's sly," he concluded. "I wouldn't be surprised if he were. That's why he looks so worn out in the morning."

Thoughts of school invaded Anton. "God, I nearly forgot; we've got that dumb algebra test on Wednesday."

"Shit, yes. I hate the thought of it," Heinz responded. "I also hate that jerk Neumann. I bet he's a subversive. A Social Democrat. I would not put it past him."

"Do you think so?" Willi asked. The truth was that he liked his teacher, but this seemed hardly the time to say so.

"Of course," Heinz said with assurance. "Hey, Anton, let's report that bastard to the File Leader. The Gestapo will take care of him."

"How can we? He always wears a swastika in his lapel. Besides, what can we report him for?"

"Oh, anything. Let's say we heard him talk to the Bergers, and heard him tell them that he thinks sooner or later the Communists are going to take over."

"Did he really say that?" Willi asked naively.

"Of course not, you dummy, but we can tell it to the File Leader. If we all come to him with the same story, Neumann is going to be in bad trouble."

Anton was only half listening. He was still thinking about Judith.

"By the way, Heinz," he asked, "has anyone seen the Bergers lately?"

"Those Jews! Who cares? They're probably in some concentration camp." After a pause, he added, "Do you know it'll be great having a war. I think I'll volunteer."

"You've learned how to shoot a Luger," Anton said enviously. "I've got to learn it too."

"You will, in no time. It's easy. I bet I'll have no trouble killing off a few of those dumb Polacks."

"I wonder what that feels like," Anton remarked.

"What feels like?"

"Killing someone."

"It's all right. My Dad says that after a while you don't even think about it."

It was growing chilly. The boys got up, stretched their legs, and brushed the grass off their bare calves.

"Hey, what are you going to do tonight?" Anton asked as they resumed their homeward walk.

"I guess I'll study my algebra," Heinz replied glumly.

"Yeah," Willi echoed, "boy, do I hate those equations."

"Me too," Anton said. "I better get down to it too."

What Anton did not reveal however, was that the reason that he was eager to get home was not algebra—he had finished his assignment before going to the game—but because he needed some time before dinner to write in the journal he had started a few weeks earlier.

With a clanging of bells the tram approached and came to a stop. Judith took Anton's hand and disengaged herself. Giving him a quick kiss on his cheek she got on.

<p style="text-align: center;">→6←</p>

"How come you're still staying at the hotel?" Anton asked when he telephoned Judith a few days after the dinner at his mother's house. "Weren't you going to find yourself an apartment?"

"I'm looking," Judith said, "but it's not so easy, even though I tell everyone I am American."

"Don't do that. They're going to charge you twice the amount they charge us."

"I know, but I don't see how I can hide it. My clothes betray me immediately."

Indeed Judith found that heads turned in her direction, her elegant appearance conspicuous amidst so much shabbiness. Anton offered his assistance, and either because or in spite of it, Judith was soon installed in an apartment just off the Währinger Strasse, a short distance from the University.

It was in a house that Judith remembered from one of her many walks with Marushka. One afternoon they had returned from the park, with Judith carrying the diabolo and its two wooden sticks. She had stopped in front of a four-story gray building with unusual ornate carvings on its façade, the kind of tracery that Aunt Klea said made houses in Vienna look like a wedding cake. Judith had run up

<p style="text-align: center;">82</p>

the steps to the frosted glass entrance adorned with Art Nouveau–style entwined flowers and plants. Because the house looked so inviting to her she made up her mind to go in.

"Come back!" Marushka had called out to her, as she opened the door to the foyer. "You mustn't go in there!"

Judith returned reluctantly. "I really love this building," she said. "Some day I will want to live in it."

The apartment turned out to be bright with large windows and a full view of the park. When Anton came to inspect it he approved. Standing in the hallway, hands on his hips, he even found the sparse furniture acceptable.

Judith thought otherwise.

"Of course you must be used to a Hollywood bed," he said. "Do you think you will import one?"

Judith allowed him to tease her.

"I suppose the furniture will do for the time being, but I do want to find a different chandelier for the living room."

Although she did not tell Anton—he would be sure to tease her even more—she had a very specific chandelier in mind: a blue and white glass chandelier, much like the one that had been in her parents' parlor. For several days she went from shop to shop, until at last she found what she was looking for in a small antique store in the old center of town.

Wrapped in a thick wadding of old newspapers she brought it back triumphantly, and when a few days later the janitor had installed it—his complaints about the extra work the installation involved stifled by a small wad of bills—and she turned on the light—luckily the electricity was working that evening—the blue glow emitted by the chandelier was like the prelude to a festival.

Gradually various other matters fell into place. She registered herself at the University, opened a bank account, visited the small shops in the neighborhood, and even obtained a monthly pass for the streetcar.

In superficial dealings with people Judith found it much easier to

avoid disclosing her past; for them her identity was that of a young American who had come to Vienna to study at the University.

"Your German is so good, miss, where did you learn it?"

"In California."

"You don't say! What wonderful schools they must have in your country, not like here; none of our young people can speak more than a few crumbs of English."

One afternoon, while she was on her way to the bank, she saw Aunt Klea. Of course it was not her Aunt Klea, but an elegantly dressed woman who walked briskly towards her. In response to a sudden gust of wind, the woman raised her hand to secure her pill-box hat. For an instant Judith thought that she was waving at her. She was overcome by a sudden chill and it was only after she looked closely into the woman's face that she was absolutely certain she had not met with an apparition of her murdered aunt.

One afternoon Aunt Clara came for coffee and cake. Judith quickly finished her homework in race biology and, having combed her hair in front of the mirror, joined her aunt and her mother in the parlor. Her father was still working, more so than ever.

"Would you believe it," Aunt Clara said, "Mrs. Kondratschek came to see me this afternoon. You know, they must have been card-carriers for ten years, to say the least."

"My God," Judith's mother responded. "What on earth did she have to say?"

"She told me that we had nothing to worry about. 'Nothing will happen to Jews like us. Hitler just wants to get rid of that Polish and Russian scum, and when that's done with, all of us will be better off.'"

"Do you believe her?" Judith interjected.

"Who knows, let's hope so," her aunt replied.

It was late and Aunt Clara was about to leave, when Judith's father came to join them. He took off his overcoat and washed his hands

while Judith's mother poured him coffee. Things were bad, he declared, very bad, but they had probably seen the worst of it. His practice was going well, and in the long run, what else could the Nazis do to them? Judith's mother was not assured.

"They are criminals," she whispered with her eye on the kitchen door behind which Marushka was putting the finishing touches to a strudel. "Ordinary criminals. The heroes of the twentieth century. They will kill us, just wait, they will murder all of us."

Aunt Clara disagreed, pointing out that everyone they knew said it was mainly a matter of economics, of expropriating banks and Jewish-owned industry, little more than that.

"We are Germans," she concluded. "After all is said and done, we are Germans first and only then Jews."

"Listen," Judith interrupted, "I have an idea. Why can't we all be baptized? Then we would be like everyone else. That wouldn't be too much trouble, would it?" The two women looked at Judith, and her father smiled sadly.

"You poor little girl, you don't understand...you just don't understand."

For a long time Judith did not understand why her idea was not feasible. She asked Anton, and he thought it might work; he promised to inquire about it the next time he was at mass.

In the meantime there was nothing else for Judith to do but sit in the back of class, her hands neatly on top of the desk, and listen to Mr. Prohaska lecture on the characteristics of the Aryan race. Clearly he was uncertain of his subject, for time after time he would return to the lectern and leaf through the swastika-decorated booklet that lay open there.

"They may put us into the last row," Judith whispered to Leo Rosenberg, "but we're smarter than all those Aryans."

It was the only time she spoke to him. A few weeks later he stopped coming to class.

When none of the children asked about him, she questioned her parents.

"I suppose they went to America," her father replied. "That type always manages, for they are used to packing up and moving. They came here with a bundle on their back and that's how they are leaving."

✢

The following evening Anton stopped by Judith's apartment.

"Some of us are going to the Boheme Bar. Would you like to come? Liane is singing tonight. Everyone says she is fabulous."

"I'd love to. Why don't you wait? I will wash up and throw on a sweater."

Heinz Uridil, Willi Moser, and Ursula Schmidt were waiting for them outside the bar that was located just around the corner from St. Stephen's cathedral. A bombsite with large muddy puddles was across the street. Its walls were marked with graffiti: large black swastikas that had been crossed out with red paint.

"You two remember Judith? Judith Berger," Anton said. "She has come back."

"My God, of course I do," Ursel said. "We used to play ball at the Second Rondeau."

"Do I remember you," Willi said. He was still fat and round-faced with a shock of red hair, but his voice had turned deep and he tended to lower his chin and talk into himself. "You never wanted to play with me."

"Because you always changed rules in the middle of the game."

"That's true: you did, all the time," Ursel agreed. "So you could win."

Heinz also said he remembered Judith, but Judith wasn't so certain that they had ever met. They obtained seats as close to the stage as possible and having ordered a round of beer, waited for Liane to make her appearance.

Willi was an engineering student, while Ursel was in medical school following the footsteps of her surgeon father. She was one year ahead of Anton and had just started to work in the clinics.

Heinz was in business. Exactly what type of business he was in did not become clear to Judith, except that it required that he travel a lot between Vienna and Leoben, a small city in Styria.

Judith felt Ursel's eyes on her necklace. She lifted it and showed to her.

"The Star of David," she said.

"To remind us of our past," Heinz grumbled. Under his breath he added: "We have learned to bend, rather than break."

"No," Judith said, ignoring his last remark. "I need it to remind myself of who I am." She wondered whether Heinz was indeed right when he implied that she wanted to show herself as a survivor, an obstinate reminder to Vienna of the crimes committed against the Jews. Silence took hold of the group.

"How elegant you look," Ursel finally said. "That must be a cashmere sweater." She ran a hand across the sleeve. Her fingernails were dark crimson. Judith commented on them.

"They are not as dark as they look in this light," she explained. "You see, as a medical student I have to assert my femininity."

Judith did not miss the quick glance she exchanged with Anton.

Liane was excellent: in a sensuous voice she sang bittersweet songs of love and loneliness. The smoke-filled room resounded with applause.

"What do you think of Truman?" Willi asked Judith during intermission. "Do you think he will get the Russians out of Vienna? Force them to sign the Staatsvertrag—the Austrian peace treaty?"

Judith did not know, but Heinz was certain he would. "There's one thing no one wants either here or in America: to have the Communists take over Austria."

There was more superficial chitchat: University gossip, local politics, the many inconveniences.

Finally Judith could stand it no longer. She turned to Willi.

"What did you do during the war?"

"*Nie sollst du mich befra-a-gen*, you must never ask me," he sang softly in the words of *Lohengrin*, and added with a smile, "Nothing,

thank God. I even managed to keep the Germans from drafting me."

There was another long silence. At last Ursel spoke up.

"Some of us did quite a few stupid things," she said. "And now we all have to pay for it."

Judith was about to remark that the word "stupid" hardly seemed appropriate. At that point there fortunately was a loud burst of applause and all conversation stopped as a zither player appeared on stage.

"Yours Is My Heart Alone" followed by a medley of waltzes from Lehar and Kalman operettas.

"I will walk you home," Anton said, when they were ready to leave.

"Aren't you going to emigrate?" Anton asked Judith one day after class. It was summer now, and they were walking home. It was a beautifully warm day and the pink and white chestnut candelabras were in full splendor.

"Maybe we are, but I don't think so."

"If you do, I'll miss you."

"Why is that?"

"I don't know…you're special, that's all. No one in my family knows any Jews, and here I am, with you as my best friend. It's funny isn't it?"

They were taking the long way, walking through the Prater. They passed the giant ferris wheel, where crowds of summer visitors and children were lined up for a ride, and then crossed the streetcar tracks. On the other side of the street there was a swarm of people.

"Let's not go this way, Judith," Anton said, and his voice was crisp and anxious. "The Boecklinstrasse will be better."

Judith heard him and understood that he was trying to protect her from what was happening on the other side of the street. She ignored him. It was as if she no longer wished to remain under his

protection, but had to continue on her own and become immersed in an experience that up to then she only had heard about. Of course she was afraid. She felt as she had one memorable occasion a few years earlier. It was in Italy and the family was on holiday at an ocean resort. She had learned to swim and even though she had barely mastered the basic stroke she was confident of herself. One day she struck out across the bay towards a tiny island that had aroused her interest. The distance was greater than she had expected and she tired quickly. Turning her head she saw that she was only halfway between the beach and the island. Very much afraid and constantly swallowing water she nevertheless kept on swimming mechanically and determinedly, angry that a force as inanimate and impersonal as the ocean could cause her to become afraid. Finally Mr. Lerner, who was also spending his holidays at the same resort and who chanced to see her swim away from the beach, rescued her and dragged her ashore, more dead than alive.

"That child of yours is extraordinary," he had told Judith's parents. "She does not know the meaning of fear."

Now she was experiencing the same feeling of anger, but this time it was directed against the tangle of grownups on the other side of the street who had the power to instill fear in her.

Leaving Anton with quick, determined steps, she crossed the street and joined the crowd. She found herself on the outside of a ring of people in whose center kneeled an old man. A large ugly scrub brush was in his hand, and a dirty pail of water bobbed by his side. For a moment she thought her fears had been ungrounded, for there was much laughter and cheering around her. Hands in the pocket of her apron, she watched the man clean the sidewalk.

"Swine," a lad with a shock of greasy hair screamed. With a swing of his entire body he kicked the old man. The lad must have been a good soccer player and it was a hard kick that knocked over the old man. He lay on the ground, rocking back and forth, clutching his behind. How like a puppy, or perhaps more like a teddy bear, Judith thought, and then she recognized Mr. Gruber, the owner of the

stationery store around the corner from the school. He was staring straight ahead, blankly, unaware of her or of anything but the pain in his groin. Finally he managed to get up. His white shirt was wet with large brown splotches of dirty water and perspiration and there was blood around his mouth. It was brown and caked as if he had just eaten and had forgotten to use a napkin.

"Get down, you Jewish swine," a woman called out to him in a shrill voice. "Get down and start scrubbing, or we'll cut off your balls."

With a sudden movement that set her hair flying, the woman broke away from the circle. Running towards Mr. Gruber with her hands outstretched she knocked him down again. For a moment he lay still, then he slowly got up to his knees. He must have been blinded by the fresh blood that covered his face and ran down between his eyes, for he had to grope for the brush that lay, bristles upward, just in front of him.

A burst of laughter erupted from the ring of bystanders.

"That'll show him," the woman shouted, and her mouth grew large with laughter. With a toss of her head she returned to her place. That small gesture, namely the toss of her head accompanied by an upward tilt of her chin, betrayed the woman's disguise to Judith. For the woman was no one else but Mrs. Platzer, the butcher's wife, and the mother of tall, lanky Inge Platzer.

Once Judith had penetrated the disguise it was easy for her to remember how before the Anschluss, the same woman had stood outside school, waiting for her daughter to come out. In those days she appeared heavy and immobile, weighed down by a sadness that Judith could not comprehend. When Inge came out into the street, satchel on her back, her mother moved over to her. Shyly she might touch her hair and having licked her handkerchief she might wipe away a smudge from her daughter's forehead. These attentions would make Inge uneasy, and she would look around, hoping that none of her classmates had perceived her mother's overly intimate gestures.

It was a different Mrs. Platzer now, who, grinning and happy, her hands on her hips, stood watching Mr. Gruber clean the sidewalk.

"Did you see that Jew?" She said to the man standing next to Judith. Playfully, she pushed her elbow into his ribs. "Did you see that stinking Jew? I bet it's the first time he's ever done any work." She laughed and Judith saw a row of broken yellow teeth. They gave her mouth a jagged appearance and reminded her of the wolf in Little Red Riding Hood.

Afraid that Mrs. Platzer might recognize her, she tried to thread her way to the periphery of the ring. Mrs. Platzer turned and looked at her intently. She might well have seen the fear in Judith's eyes, and she might even have remembered the girl. Judith forced herself to stare back, trusting the protection provided by her snub nose and her long blonde hair, which Marushka had combed out only that morning. With a defiant gesture, she raised her arm.

"Heil Hitler," she saluted Mrs. Platzer and quickly went her way. Only when she was in the next block did she realize that her heart was pounding and that it must have been minutes since she last took a breath.

Upon returning home she said nothing to her mother. It was as if she had ascended from the underworld and was so grateful to see the light that she did not wish to darken it with her memories.

"Anton wants to know when we are leaving," she said casually.

"I bet the Kermauners want our house," her mother replied. "They must be dying to confiscate it."

That night, lying in bed, arms wrapped around her yellow teddy bear who had lost both his eyes and for whom she might well have grown too old, she again saw Mr. Gruber as he rolled over on his back and stared blindly in front of him. She also saw Mrs. Platzer knocking the old man down, no longer sad but happy and free, her hair in abandoned disarray. How difficult it was to see Mr. Gruber as the same person who only a few months before had stood behind the counter of his store, ordering the school children to hurry up and make their purchases. And it was just as difficult to see Mrs. Platzer

as the same sad and solicitous woman who waited in front of school for Inge. Perhaps, Judith concluded, there were two worlds, one inside the other, one clean and sparkling, filled with cocoa, hot rolls, and white blossomed trees, while the other was crammed with everything ugly and unthinkable: anger, dirt, blood, and pain, a world in which the sole comfort was not to be able to see or feel.

"Whatever happens, I will never leave you," she told her teddy bear, and hugging him tightly, she fell asleep.

Judith unlocked the door of the apartment house and switched on the staircase lights.

"Good night, Anton," she said. Anton kissed the top of her head.

"Did you enjoy yourself?"

"I think so...."

"Don't worry about Heinz. His bark is worse than his bite."

"Let's hope it is."

"Good night, then. See you soon."

"Please, God."

"And sleep well."

After she had returned to her apartment, undressed, and climbed into bed, Judith found that sleep would not come to her. Too many events, too many images: the past taking over from the present.

One night not too long after she had watched Mr. Gruber's degradation, and Mrs. Platzer's emancipation, Judith awoke to see a crack of light under the door of her room. She rolled on her side to look at the clock. It was two in the morning. Her parents were never awake in the middle of the night, so something must have been amiss. Without switching on the light she groped for her slippers that she had carefully aligned by the side of her bed before going to sleep—to

do otherwise portended bad luck—and slowly opening the door so that it would not creak, she tiptoed into the hall. Leaning on the banister she could look down into the dining room. The blinds had been lowered and her parents sat under a circle of yellow light broken up by the shadows cast by the silver coffee pot and the empty cups in front of them. Their faces were turned away from Judith, so that at first she could not make out what they were saying. At one point her father got up and went to the sideboard for some cigarettes. She could hear the click of the lighter and the deep contented breath with which he inhaled. That relieved her for it implied that nothing too terrible had happened, even though her parents were still awake at such an incredibly late hour.

Her father circled the room in silence before sitting down again.

"I don't see any other alternative," he finally said. "The girl has to get out, at least for the time being."

"But she is so small," her mother protested, "she can't do it illegally."

"The way things are now, there is no future here for her."

So that is how they talk about me behind my back, Judith thought. She was resting her chin on the banister, unconcerned that she might be discovered. After all she had a right to hear what was going to happen to her.

"Then again we could wait a few more months," her father continued. "Clara thinks that Roosevelt will come up with some announcement about the Jews any day now." Clara was another one of Judith's aunts but not her favorite. She was too fat and hardly as well dressed as Aunt Klea. Besides she always talked and would never listen to what Judith had to say.

"Perhaps Clara and Theo are right," her father went on, "that it is merely a matter of holding out, that things are bound to get easier. I don't know anymore. There was a time when I agreed with them, but now? Look what happened to Gruber down the street."

"I know; let's not talk about it."

"All he did was go back and open up his store. He had a clean

slate, so there was no reason for the storm troopers to come in and kill him. 'Seething spirit of the people.' It doesn't look as if it's about to stop, does it?"

"It's not only Gruber, it's all of us. I've told you before: they're going to kill all of us."

"Now wait a minute. You are going too far. That will never happen. There are laws that protect us and you know what sticklers the Germans are about their laws."

"No, no, no! There are no laws—not for us. I don't know what'll become of us, all I know is that I shouldn't have listened to you back in March. The gas would have been better. The Lerners went, at least they had character, landed gentry they were. That's more than anyone can say about us."

"And what about her?" her father shouted. "She's got to live. Our duty is to see to that."

He pushed his chair away from the table and got up again.

"Come on," he said in a softer tone, "let's go to bed, it's way past two."

Judith scampered back into her room. She sat on the bed, took off her slippers, and carefully placed them side by side the way they had been. When her mother peered in a short time later, the girl was breathing regularly, not too deep, the way Anton had taught her to breathe in order to make people think she was asleep.

Wide awake, however, she thought about the conversation she had overheard. It would be exciting to leave Vienna and travel to somewhere far away: to Africa perhaps, or even to America, and all that absolutely on her own.

<p style="text-align:center">→7←</p>

IT WAS SUNDAY, the week before the start of classes, and Judith decided that it was time for her to pay a visit to Marushka.

Marushka lived out in Ottakring, in a tiny two-room cold-water flat. The workers' tenement complex had been built in the early thirties. It now was neglected and in ruins. One of its four wings was nothing more than a mound of rubble; the remainder had suffered much bomb- and shell-damage. Here and there a graffiti-marked wall was left standing, ridiculous in its solitude, and hillocks of debris were piled up in the courtyard, in the middle of which a few scraggly trees tried to maintain a semblance of life. Originally the walls had carried signs indicating the blocks and tenement numbers. With the years the paint had crumbled, and the printing had become indecipherable, so that there was nothing by which Judith could identify the tenements and she was obliged to seek her way by trial and error. She vaguely remembered that Marushka lived on the fourth floor, along the third staircase. She was not certain, but thought that it was located in one of the wings that had been spared. She picked out a door at random and knocked. There were footsteps, and a window at the side of the door opened.

"Yes?" The mustachioed face of one of the occupants appeared.

Behind him there was a swell of several voices. When he saw the well-dressed woman at his door, the dourness of his greeting changed instantly. "Is there anything I can help you with, Miss?"

"I am looking for Miss Marushka Urban. She lives on the third staircase. Do you know her?"

The man shook his head. "Can't say I do, but...." he added a phrase that was incomprehensible to Judith. My God, she thought, I no longer can understand this man, and he is Viennese. Unwilling to admit that the Viennese dialect was unintelligible to her, she repeated her request. He answered, faster and in even broader dialect than before. Fortunately, he pointed out the direction Judith should take, so that she was able to set off, nearly falling into a yet unfilled shell-hole.

The steps of the third staircase were broken, a few were completely missing, and an unbearably heavy odor of stale cabbage permeated the hallways. Judith felt that she had set out on a hopeless mission, and she was filled with an immense dreariness. "Who is Marushka, anyway?" she asked herself. "What does she mean to me? I have not heard from her for years; why then am I here? I cannot even understand their dialect, and everything has become foreign to me. I see it as dirty, in shambles, utterly dismal. Did I have to return for all that?" She was here now, and there was no turning back. When she and Anton saw each other the next time she would tell him about her visit.

She knocked on Marushka's door.

"Who is it?" A woman's voice responded.

"It's Judith. Judith Berger."

"Judith Berger?" There was a long pause. "Jesus, Mary, and Joseph! You've come back. Judith, my little Judith.... Just one second, I'll open the door."

She heard a scurry of footsteps, furniture being pushed around, a window being closed, and then, finally, the door opened. The person who stood there was a stranger. She was prematurely old and fat, her face was drawn and lined, and there was no trace in it of the jovial,

laughing Marushka whom Judith remembered.

"Oh my God! Judith, my little Judith! How wonderful of you to come back and see your old Rushka."

She embraced Judith; a repellent embrace that reeked of cabbage and stale sweat. Heavy and clammy folds of flesh were piled up against the girl's face, forcing her to hold her breath until at last she was able to break free.

Before too long Marushka had to leave. She cried a good bit and hugged Judith many times, making her promise to come and visit her at least once a week. Judith's father gave Marushka some money, saying that he understood that there was no alternative in that the law was clear: Jews could no longer have Aryan servants.

"You know Herr Doctor, I would like so much to stay with you," she said. "You have been so good to me, but I am afraid to, so afraid they'd do something to me if they found out. Like send me to a concentration camp."

Now that was not the first time that Judith had heard the word "concentration camp." It was such a simple word, and there was nothing terrible the way it was pronounced, yet there was so much fear attached to it. There were many words now that had fear attached to them: "the Nuremberg Laws," "Storm Troopers," "the S.S." and so forth. Why was that, Judith wondered, when the words themselves were so simple? It must be what grownups were doing with them, for other words such as "explosion" or "earthquake" already had fear built into them and were frightening when she pronounced them to herself. "Concentration camp" was different. It was a harmless sounding word; still it evoked fear. This is the way it was, and Marushka had to leave because she was afraid of the concentration camp, and because of that she was now wiping her tears with the corner of her handkerchief.

Judith gave Marushka a big hug, and when she felt the woman's

tears on her cheeks, she kept thinking about how it was that every-
one was so afraid now, for she wasn't afraid, at least not all the time.

"I am going to make some coffee for you," Marushka said, "and then
we can sit by the window and talk.... It's been such a long time! You
can't imagine the things we have gone through…and those Russians,
they're still here. God knows when they are going to leave."

There was coffee, but it was not real coffee. "Yes, if you want real
coffee, you'd have to see the American soldiers, they drink it all the
time. You are American now, aren't you Judith? I am going to say
'*Du*' to you. I can't do it any other way. What a pretty necklace you
have…you must have an admirer. What is this?"

She leaned forward, and pulled out her Star of David. "A Star,
how lovely. It is from your admirer, isn't it? Oh, America must be
wonderful. I have always wanted to see it."

Judith looked around the room. How cramped it was: a huge bed,
partly unmade, a clothes press, a washbasin. How could anyone live
in such surroundings, year after year?

The sun had come out and the shouts of boys playing soccer in
the courtyard came through the open window. One phrase was re-
peated over and over again. Judith heard it, but could not make it
out. She was too embarrassed to ask Marushka what it meant.

"The fresh air is nice, isn't it?" she said instead.

"Yes, miss. It is lovely, particularly on a humid day like this."

The coffee was bad indeed, but that was of little matter.

"What are you doing in Vienna?" Marushka asked.

"I am going to attend the University and study languages."

Judith wanted to have done with the conversation as quickly as
possible and leave, in order to get back to her apartment where there
was a large bed waiting, with a clean bright coverlet and a bathroom
with hot and cold water—at least for much of the time.

"And how is Dr. Berger, and your lovely Mama?"

"They disappeared. I am certain they died...gassed." Judith spat out the words.

"Oh that's terrible, just terrible. Your parents were such lovely people, so vivacious. It's been such a bad time for all of us. My mother died too. She had to be evacuated when the Russians came. She was old and it was too much for her. You know, we've all gone through a lot."

Judith stared at the face of the person whose thighs and buttocks were spilling over the wobbly chair alongside the window. Seeing her profile outlined against the dull light that issued through the open shutters, it seemed inconceivable that this was the same person who had helped arrange Judith's birthday parties and had made cocoa for her when she was ill, and who at one time was so dear to her. She tried to superimpose the two images: that of Marushka as she remembered her and that of the person who sat by the open window. The task was insurmountable, and the harder she tried the more depressed she became. All at once she realized that Marushka could not take her eyes off her jacket. Clearly she longed for it. She wanted Judith to give her some present, something to lighten the utter dreariness that was everywhere in her flat.

Judith offered her the jacket. After a perfunctory refusal, Marushka took it, and even though she was far too fat to fit into it, she jammed her arms through the sleeves. Judith closed her eyes. It was more than she could stand to see. When Marushka began to admire her shawl, Judith got up and took her leave. She sensed that Marushka had also retained an image in her mind: that of a small, blonde little girl, and when the Judith who visited her would not fit into that image, she was no longer Judith to her, but a rich American woman who might provide her with some of the material things that she craved.

Her farewell was peremptory, and as Judith picked her way down the dark staircase and through the tenement complex, she knew she could never see Marushka again.

Slowly, like a sleepwalker, Judith made her way towards the Inner City. How much smaller the city had become since she last had been there. Leaning on the damp iron railing she looked into the brown waters of the Vienna River.

⇥8⇤

A FEW DAYS LATER, Anton took Judith into the Vienna woods. Mingling with American and French officers they had coffee and pastries on the terrace of the Kobenzl. The transient beauty of the city, an expansive panorama of orange and violet, evoked sadness in Judith, and despair.

They talked about the old days, their classmates, and Mr. Prohaska, their teacher.

"He was always kind to me, even after the Anschluss," Judith said. "I remember he warned me about Kristallnacht."

November 9, 1938

Judith was sitting in class drawing a new map of Europe for her geography assignment when Mr. Prohaska came up to her.

"I think you had better pack your things and go home." He spoke softly, and bent his face towards her so that no one could hear what he was saying.

"You mean I should go home?"

"Yes, but don't be too noisy about it."

Judith put her colored pencils away: blue for the rivers and lakes, brown for the mountains, black for the railways, and red for the boundaries of the Third Reich. This done, she slipped out of the classroom and took off for home.

How strange it was to be out of school at this time of day. It had only happened once or twice before, when she had been ill, and then usually her ears were humming and walking was like floating on clouds. The morning light cast spectral shadows: walls were lit which she never heretofore had noticed, alleys appeared where she was unaware any had existed. When the sun came out briefly and turned a row of houses bright yellow, it seemed to her that she was walking through an unreal world, through a city such as she might find only in a dream.

She chose the long route through a corner of the Prater. The nights had already turned frosty and the chestnut trees were bare. Clouds of brown leaves swirled about her and, forgotten by the wind, floated down on the wilted grass alongside the gravel paths.

She stopped at the First Rondeau. It was deserted. The chairs had been put into the shed and in their stead companies of crows stalked about, cawing softly, as if they too were but shadows. She crossed to the other side of the parkway, from where a few yards further on she might see the lake. It too was deserted, and the black water reflected a dark sky. The canoes that covered the surface of the water during the summer had been taken away; only a solitary rowboat remained, its wood rotting. Bereft of oars, its bow was submerged in the shallows. Judith walked around the lake as far as the green wooden bridge. There was not a soul about, and the stillness of the park grew uncanny. She cut across the lawn toward the gates. All at once she shuddered, for it was as if she had died and had returned, unseen, to those places she once had frequented and which had become part of her soul. Her steps grew longer and faster and in a few minutes she stood in front of her house. She walked up the steps, and to her surprise found the door ajar. Opening it fully she entered.

"Hello there," she called out. "Guess what, I am home."

She took off her jacket and hung it on the coat rack in the hallway.

"Hello there," she repeated. Still there was no reply. The living room and dining room were empty. Trembling, she bounded up the stairs, opening one room after the other. Empty, all empty.

She went downstairs. There must be a reason why her mother was not at home. She looked for a message. There was none in the living room nor on the dining room table. Returning to the living room, she noted something that made her stand stock-still. From underneath the couch she could see the handle of her mother's handbag. She pulled it out and looked inside. There was a handkerchief, a comb, some money, and the usual odds and ends. Not a clue, she thought, to her mother's whereabouts. She snapped the bag shut. Forgetting herself for a moment, she put it over her arm and walked to the mirror. It was a shiny brown alligator bag with a gold frame and very elegant. She looked at herself in the mirror, turning slightly, so as to savor the full effect of her appearance. All at once she stopped, horrified by what she had done. Her mother had disappeared, and here she was looking at herself in the mirror carrying the handbag that her mother, for some reason or another, had dropped under the couch.

She sat on the couch and placed her mother's handbag between her feet. What if her mother had been taken away to a concentration camp? And her father too, then what would happen to her? Enveloped by fear she forced herself to think rationally. First there was the matter of food. There was money enough in the handbag to go over to her Aunt Clara's and live there. She didn't like Aunt Clara very much, but under the circumstances, what else could she do? There was always Marushka. Perhaps that was a better place for her. She might even go to school in Ottakring. Everyone said that schools in Ottakring were easy and there hardly ever was any homework.

In spite of herself, she began to cry. They were solitary tears, not intended for anyone who might stand by to stroke her hair, her wet cheeks, and comfort her.

She got up and went to the window. From where she stood she could see the line of bare trees, looking the same as they did every

fall. Their appearance was briefly reassuring, for how could anything ever happen to her parents when the trees were unchanged?

She sat down at the dining room table, took out her geography assignment, and began where she had left off in class. When it grew dark, she turned on the lights. This evening however the lights in the living room did not seem sufficiently bright, so that she had to turn on all the lights on the ground floor as well. By doing so she somehow felt less alone, and more hopeful of her parents' return.

By now it was nearly six. Father should soon be back. Six o'clock passed and before long it was seven, then seven-thirty, a quarter to eight. She became progressively more restless, got up, peered at the electric clock that relentlessly hummed away the minutes, walked over to the window to see whether her parents might not be coming up the street. There was no sign of them. Carrying his pole, the lamp lighter had come and gone, igniting the gas lamps along the street. A feeling of panic came over her as, one by one, all explanations concerning her parents' whereabouts failed. Trembling and overwhelmed by despair she concluded that the Nazis had killed them.

Once she had resigned herself to that thought, she felt a trifle less frightened; she preferred a bad certainty to any kind of uncertainty. With her parents dead there was no reason for her to remain alone in the house. She would leave, and for that night at least, would stay with the rabbi and his wife, where she could count on being welcomed. They lived but a few blocks away, and it would be simpler to go to their house than to Marushka, whose apartment was way out in Ottakring. For to get there meant taking the streetcar into the Inner City and then changing lines. She was too frightened to accomplish all that; besides the rabbi was a clever man. He would give her not only reassurance but also some sound advice.

Taking her mother's purse with her she climbed the stairs to her room. There she found her red suitcase. Putting in a few pieces of clothing and underwear, not forgetting her toothbrush and a tube of toothpaste, she packed up.

She wondered whether to lock or simply close the door. Since she

was unable to find the key, she left it slightly ajar, a small wedge only, not enough for anyone to see, but enabling her to come home whenever she needed.

Carrying her suitcase she walked down the dark streets. Soon she arrived at the rabbi's. She rang the bell. Mrs. Wolf, the rabbi's wife, opened the door. She was a round, heavily corseted woman, whose hair was usually combed back into a careful bun. Now however, strands had fallen down her face, and her blouse was partly unbuttoned, exposing the borders of her white brassiere.

"For God's sakes, what are you doing here?"

"I am Judith Berger."

"Yes, yes, I know. Come on in."

"I am looking for my parents; they have disappeared."

"Oh no...everything...everyone...."

She started to wring her hands, but thinking better of it, motioned Judith to a chair in the dining room.

"Sit down, child. Do sit down, you must be terrified."

Judith nodded, and no sooner had she sat down and placed her suitcase alongside the chair, than she began to cry softly. It felt good to do so; it was like going to the bathroom after wanting to for hours. Mrs. Wolf pulled over a chair and sat down with her. She stroked the back of the girl's hand.

"Judith, they have set fire to our synagogue."

She enunciated each word very carefully, as if their precision would clarify everything.

"Rabbi Wolf has gone over there. You know we must save at least one of the Torahs." She broke off and shook her head. "I don't know what will happen to us...I don't know."

Her voice trailed off. With a toss of her head she pushed herself up from the chair.

"Look Judith, I am getting you some cocoa, and then you and I will talk about your parents. By the way, have you had any dinner?"

"Oh yes, Mrs. Wolf," Judith lied. The woman went into the kitchen and lit the stove.

"Don't sit in there by yourself," she called out. "Come and keep me company."

Judith rose, straightened out her skirt and her school smock which in all the excitement she had forgotten to take off, and joined her.

Soon there was a cup of cocoa for Judith and some tea for Mrs. Wolf. Using a corner of the dining table, the two of them sat face to face. The cocoa was still too hot, and remembering that it was not good manners to blow on it, Judith stirred it carefully.

"They have arrested so many today," Mrs. Wolf said softly. "It's that affair in Paris, do you know about it?"

Judith shook her head.

"It doesn't matter, it's just a pretext anyway. So far they have only arrested men. Your mother is probably all right."

"But where could she be?"

"I don't know. Perhaps she went to the police headquarters to see if she could get your papa out…many women are there. Lot of good it will do. Anyway, I'm sure she'll be back."

Judith frowned. It was so hard to understand what was happening.

"What do you think they will do to my dad?"

"Try not to worry, darling. Look, your cocoa has cooled off enough; you can drink it now."

It was good cocoa, very good, not too sweet, with just a dab of whipped cream floating on the surface.

Judith was still sipping it when the door opened. It was the rabbi. Dressed as he was in ordinary clothes, she hardly recognized him. Ignoring Judith, he came over to his wife and embraced her, stroking her disheveled bun of hair.

"Everything is gone," he said in a strained voice, "everything. I couldn't even get near the temple, the flames were too hot. And the glass on the sidewalk, our beautiful stained glass, and all of them standing about laughing, as if they were at a bonfire."

He sat down next to Judith and rubbed his temples.

"Where did all this come from?" he cried. "Tell me. We took nothing from them…only our freedom."

He took note of Judith, a small girl in her school smock, her fingers around the handle of her cup of cocoa.

"It's Judith Berger, isn't it?"

The question could equally well have been addressed to his wife.

"Things are bad for us, my dear girl, extremely bad."

He turned to his wife.

"Say, Dora, have you offered her something? You know how children like to nibble at things."

Judith felt cozy sitting between the two of them and being referred to as a child. For that moment neither the burning temple nor her missing parents seemed to matter.

"No thank you," she replied. "I already have had some cocoa." Come what may, she must preserve her manners.

Without warning the door burst open, and two men in storm trooper uniforms stood in the hallway. A moment later they were in the dining room; their highly polished brown boots sank into the Persian carpet; the deep red hue of the wool was reflected in the leather with a red that was deeper yet.

"Are you Rabbi Wolf?" one of them asked.

"I am he."

"We would like you to come with us."

With a sigh, the rabbi got up from the table.

"Gentlemen, I am at your disposal. Am I allowed to pack a few things?"

"That won't be necessary."

"As you say."

Mrs. Wolf burst into loud sobs, striking the wallpaper with the palm of her hand.

"Dora, please," the rabbi admonished her, "we must control ourselves, we cannot give them the satisfaction."

As he turned to leave, he ran his hand over Judith's blonde hair. His eyes dwelled on the past.

"What lovely hair," he said bitterly. "One would guess you to be Nordic."

With a hard voice he addressed his wife: "You know Dora, I still believe that God means everything for our best. Today I am thankful to Him, for He has shown me how much more there is to His world than I had ever realized."

He quickly kissed her forehead.

"God help me," he whispered to her, "for I am so afraid."

Only after the door had slammed shut did Judith comprehend all that had happened. Mrs. Wolf had sunk into the dining room chair. She was hunched forward and cried noiselessly, her right hand rubbing up and down across her eyes.

When the phone rang, Judith's cocoa had long grown cold, and a fine skin had formed over its surface.

Mrs. Wolf pushed herself out of the chair and took the call.

"Yes, she is here," Judith heard her say, "quite all right, but worried about…. Not really…. That's what I was afraid of…. They just took him away too. It's like experiencing a nightmare, and praying to God it will end…. No, don't do that, I'll bring her over, the walk will do me good."

She hung up and came over to Judith.

"That was your mother, she is home now." She was silent for a moment. "They have arrested your father. He is at the Morzinplatz."

The Morzinplatz was the Gestapo headquarters. Judith had heard that address mentioned before, and the name made her shudder.

"Look, my little one, we must believe that God will take care of us. Otherwise everything will appear too much for us to handle on our own."

She picked up Judith's small red suitcase, and the two of them set out through a drizzly, cold November night.

When Judith awoke the following morning, there was bright sunlight in her room, and the noise of the traffic made the events of the preceding night appear unreal, causing her to wonder whether they actually had occurred, or whether she had dreamt all that she

remembered. For after all she once did have dreams in which she found herself in Hitler's Germany, and from which she would awake safe and relieved.

Her school clothes were laid out on the foot of the bed. Seeing them told her that it was just another day, that her father was back, that the Nazis had released the rabbi, and that everything was back in its proper place. She had finished dressing when her mother came in.

"You overslept, Judith, but that's all right, for today at least. I am going down to the Morzinplatz and see what can be done about your father. You had better go to school. I put a cup of cocoa for you on the table and a roll."

"Can't you stay a bit longer, and talk to me while I have breakfast?"

"All right. I don't suppose it matters when I get there."

Judith did not like to see her mother abandon her plans so readily. Sitting together over breakfast she saw her mother and herself like two children. She, Judith, was the older one, and it therefore was up to her to secure her father's release from the Gestapo. Should she go down to the Morzinplatz? She knew how to get there by streetcar, but then what? What should she say or do there? It was all so very difficult and complicated; but she knew that she was not as helpless and disorganized as her mother. Perhaps someone else might have a good plan. With the rabbi in the hands of the Nazis who could help them? Mr. Lerner was dead, and Aunt Klea and Uncle Max were in Czechoslovakia—at least they were safe there—and Marushka was much too scatterbrained. That left only Aunt Clara.

"Did you talk to Aunt Clara?" Judith suggested.

"Yes."

"And what did she say? Did she have any ideas?"

"Do you mean how to get Papa released?"

"Yes."

Her mother shook her head. "Uncle Theo went into hiding."

"He did? Where?"

"Why don't you just go to school? I'll see what I can do."

Discouraged by the conversation, Judith strapped her red satchel to her back and took off for school.

Coming down the Ennsgasse, she saw Anton ahead of her. She quickened her steps and soon caught up with him.

"Listen here," she said without any greeting, "you Nazis arrested my father and burnt down our temple. What did you do that for?"

Anton was perplexed by the abruptness of her question. A stone lay under his feet. He kicked it, then dribbled it as they walked along.

"But we didn't do these things," he finally replied. He stopped and placed his hand on Judith's wrist. "It wasn't us; it was the mob. You'll see, when everything has settled down, these things won't happen again."

"I don't believe you…I hate you!" she screamed. "You are a Nazi, and all of you are horrible and disgusting, and I wish you were dead!"

That moment she did not care if Anton took his knife from his belt and killed her. Instead the boy stopped and turned to her with sad eyes.

"Your father will be fine, Judith, I am sure of that. It won't happen again. I promise you, it won't."

His words were so soft that the girl burst into tears. He put his arm around her shoulder. "Please don't worry, everything will be all right again."

Later that morning Judith was so sleepy that much of the class work didn't make any sense to her; in fact, she must have dozed off several times before lunch. During lunch break Mr. Prohaska came over and put his hand on her shoulder.

"You look tired today," he remarked.

"Yes…they have arrested my father."

"Oh dear. Well, he is a good person, don't worry, nothing will happen to him. They are only looking for the Communists and troublemakers. In any case, why don't you go home now and get some sleep."

"Is that all right?"

"Of course it is. All we are going to do this afternoon are the sub-
junctive declensions. You'll catch up on them tomorrow."

When Judith returned home, her mother met her at the door.

"Can you imagine," she cried, "he has come back."

Judith threw her satchel down in the hallway and raced up the
stairs, two, three steps at a time.

"Daddy, my Daddy, where are you?"

Her mother followed her, more slowly.

"You can't see him right now. I drew a bath for him. That's what
he needed most."

"How wonderful! Oh everything will be all right again, I can tell."

She stood outside the bathroom.

"Are you in there, Daddy?"

"Yes, dear."

"How are you? Tell me, how are you?"

"Just fine. A little bit tired, that's all."

But when he came downstairs, she hardly could recognize him.
His cheeks and lips were swollen and bloody, there was a long red
gash down the middle of his forehead leading to the bridge of his
nose. At first Judith was repelled. Then, however, she realized that
she still loved the face despite or perhaps even because of its dis-
figurement. She hugged her father, pressing her cheeks next to his.
They felt strangely hot.

"No, darling, not so hard," he protested.

"What happened to you?"

"They did it with the edge of a helmet," her mother murmured
darkly.

"How? How?"

Her father did not answer. When Judith pressed him, he turned
away from her.

"Horrible…inhuman.…" was all he could say about it.

>‹

"Mr. Prohaska was a good man," Judith reflected. "I wonder what happened to him."

"I don't know…truly I don't."

"But you weren't any help to us—absolutely none."

"How could I have been? I was a mere boy."

"A mere boy," Judith repeated, and they both grew silent.

"There is something you must explain to me," Judith said after some time. "The night I had dinner at your home, when you walked me to the streetcar stop you said that you never ever forgot me, not even during the war. What did you mean by that?"

Anton became thoughtful. He crossed his knees, and leaned forward. Slowly a smile appeared over his face.

"It is not very easy to explain. The best I can say is that you were part of my memories of home, my childhood, of the many small and warm things I left behind: stable and invariable."

"But why me? What made you select me? I was a Jew."

"That never mattered." He paused and looked around. At the adjoining table three French officers were gesticulating with considerable abandon; their voices were lost in the wind. "Actually it did matter. The fact that you were a Jew was part of your attraction for me. You see, for as long as I can remember I have been drawn to strange and alien things. For a time, I must have been six or seven years old, I collected Abyssinian postage stamps. I would take my album to bed with me and look at the stamps: indecipherable writing, strange animals, scenes from mountains and wild jungles, and wonder what it would be like to travel to such distant, exotic lands. My uncle Egon did just that; for many years, until he was interned by the French, he ran an import-export business in Cameroon. Had it not been for the war, I might well have gone to work for him."

<p style="text-align:center">✦</p>

1939

One afternoon Judith was sitting in her window seat, lacing up her shoes in preparation for school. It was early spring, the nights were no longer bitter cold, and in the morning there was fog outside the windows. It blurred the outlines of the park and dissolved the black forms of still dark trees, so that she could imagine herself to be completely alone. She loved the fog and the feeling of isolation that it provided for her, and as she straightened out her long wool stockings and the sleeves of her sweater, she was so happy she hummed a song. She wondered how it would feel if she were to leave Vienna and travel to England or perhaps even to America. The idea of traveling by herself was so exciting that she felt guilty when she realized that she would have to leave her parents behind, unhappy, lonely and facing the dangers of the Nazi occupation. Nevertheless, the subject was a wonderful one for all kinds of daydreams.

One evening, after dinner, her father took her aside.

"I must have a very serious talk with you." Tanya had just cleared the dishes and was standing by the door listening to the conversation. Tanya, who was Marushka's replacement, was a pale, hunch-backed Jewish girl from Poland who had found herself trapped in Austria when Hitler marched in without either the means or the wit to return to her native country. She spoke only Yiddish, and Judith tried to be nice to her by speaking slowly and avoiding the Austrian dialect.

"It is a matter of your leaving Vienna," Judith's father continued.

"We want you to live," her mother who had come back into the dining room, interjected, "we don't mind dying; we have nothing left to live for anyway; but you, you have your entire life ahead of you."

"We think there is a way for you to escape," her father continued. "It will cost me much money, but then, these days money means nothing."

Judith was growing impatient. She wanted details: Where, how, when? "If it concerns me," she said firmly, "I want to know."

She was proud to speak this way; it sounded grown-up.

"Of course," her father conceded. "It seems there is a chance for you to go to Ireland. The only problem that remains to be settled is how to get you into Holland."

"Why is that so hard?"

"I don't want to talk about it, at least not at this time. There are so many uncertainties…the whole thing can still fall through."

The following Sunday afternoon he invited Judith to take a walk with him. It was cold and heavily overcast, and a bitter wind blew in from the east forcing them to bundle up as they strolled along the Danube Canal. They had little to say to each other. Judith felt her father's sadness and did not know how to dispel it. She chattered away about a book she was reading: *The Hunchback of Notre Dame*.

"Wouldn't it be awful to be so ugly," she asked him. "So ugly that no one could ever love you?"

"I think that's him," her father interrupted. "Mr. McGuire."

A slender dark-haired young man in a light tan trench coat with a turned-up collar approached them. A few steps away he stopped abruptly and turned towards the Danube Canal.

"So this is your daughter," he said. His hands gripped the iron balustrade as he gazed down into the dirty brown waters. A streetcar rumbled by.

"I want you to meet Judith," her father said. He nudged the girl to join him into looking down into the river.

"How old is she?" McGuire's German had an unusual intonation.

"Twelve, but she looks much younger than her age."

"Good."

"I can speak English," Judith interrupted. The two men ignored her.

"Twelve," McGuire repeated to himself. After a while he turned around. "I think we can manage."

"Oh thank you, thank you so much—it will be such a load off our minds."

"I can imagine. You can be sure you will hear either from me or directly from my friends in Dublin."

"How long will we have to wait?"

"I suppose it'll be a week or two, not much longer than that."

They parted and Judith could hardly wait until the man was out of earshot.

"Who was that?"she asked. "Where will he take me?"

"You sound so happy," her father said reproachfully. "Don't you realize you are going to leave home?"

Judith nodded. "But tell me, where am I going?"

"To Ireland," her father said, and that was all the information that he would impart to her.

"I too have always wanted to travel," Judith said. "But I can assure you not as a refugee, and I don't like to think that my attraction for you is that I am…exotic. If that is how you see me, there can never be any closeness between us. Or maybe you don't want closeness."

"I do want it. But you have to admit that there is something exotic about being a Jew and living in the twentieth century."

"That is not how I see it."

"What about your religion, your prayer books that read from right to left and from back to front, and all your archaic ceremonies and customs? You do admit they are strange and foreign."

"No stranger than believing in the transformation of wine into blood, and the resurrection of the dead."

"But these are mere symbols. Only our peasants take that sort of thing literally."

Judith sighed. "We tried so hard, for generations, and it looks as if we didn't succeed."

"Please explain."

"There is not much to explain. My parents, my grandparents, my entire family always considered themselves Austrians. They dressed like Austrians, spoke like Austrians, thought like Austrians. Austrians of Mosaic persuasion, that is what they termed themselves. You

know, like Austrians of Evangelic persuasion, Austrians of Lutheran persuasion. I am certain you never considered Anna Redlich, or Grete Neubauer to be strange and exotic, just because they were Protestant."

Anton smiled. "You have made an excellent point. What a persuasive debater you are!"

"For me this is not a debate. I am defending my identity."

Suddenly Anton's face flushed. Judith noticed it.

"What are you thinking off?"

"Look what I have for you," Anton said as he pulled a small black mitten from his coat pocket and held it out for Judith. Cradled in his palm it appeared so tiny it might well have belonged to a doll.

"Oh Anton," Judith said softly, "it has come back to me."

"You have come back to me," Anton corrected her.

She had been waiting for the streetcar, passing the time with a tortoise-shell kitten that was weaving itself around her legs. Having taken off her mittens, she crouched down to pet it. All at once she saw Anton standing over her. She quickly straightened out.

"It must belong to one of these houses," she said pointing to the kitten. "I have seen it several times now."

"She has such a funny white nose, almost as if she had dipped it into powdered sugar."

They laughed. The streetcar arrived. They got on and found seats next to each other.

"Can you keep a secret, a really important secret?" Judith asked.

"Of course."

"Swear to it."

"I will swear to it on the honor of our Fuehrer."

Judith wanted to object, but thought better of it.

"Right," she acceded.

"Now tell me your secret."

"I...am...going...to...leave...Vienna." Judith spelled out each word.

"No, not really? Where to?"

"You'll never guess."

"Yes I can."

"All right then, I'll give you three guesses."

"You're going to America?" Anton ventured.

"No, not that far."

"Let's see then, England?"

"No, not England."

"It must be Palestine."

"Not there either. See, you missed it."

Anton grabbed Judith's mittens that were lying in her lap.

"If you won't tell me, I'll keep your mittens."

"I'm going to Ireland."

Anton frowned. "Ireland? I have never heard of anyone going to Ireland. Are you sure?"

"Of course I am, you dummy. Now give me back my mittens."

Anton returned one of them.

"And what about the other one?"

"I'm keeping it. You'll get it back when you return to Vienna. It's a pledge. That way I know you'll come back to see me."

The streetcar arrived at the Ring, and Judith got off.

"Good-bye, Anton," she called to him when she was standing in the street.

"Good-bye, there."

As the streetcar rolled off, she could see her mitten fluttering from the window. It was good to leave it with Anton. This way there would be something of hers left in Vienna.

><

Anton looked for the waiter.

"Would you like a little bit more coffee?" he asked. "There is something I want to tell you, but I find it embarrassing."

"Please tell me. I wouldn't mind telling you something that embarrasses me. After all, we are old friends." Their cups were refilled, and Anton started out.

"For a time, there, after the war had started, I kept a diary. I suppose I saw it as a means to define my identity."

"I too kept a diary…but it never amounted to much."

"Neither did mine."

<p style="text-align:center">✦9✦</p>

Sunday, September 3rd, 1939

THE WAR HAS finally started! The last few days have been so much more exciting than I ever imagined they would be. These indeed are momentous times and I shall never forget them. I must never forget them. I am so glad that I have started to write this journal. It will be a repository of events and feelings and emotions, so that I shall always be able to look back upon them and remember them.

Today Heinz and I went down into the Inner City. The crowds were immense everywhere. Loudspeakers had been set up in the Rathausplatz, and they were blaring out the very latest news. England has declared war on us. How foolish of them. "A nation of shopkeepers." How can they ever imagine they will stop the predestined growth of our Reich?

"It's foolish of them," I shouted to Heinz, trying to make myself heard over the din. "We will wipe them out. First we will take care of Poland then we will wipe them out."

Everyone was singing and looked incredibly happy. In the afternoon we walked along the Ringstrasse. There were flags everywhere. A flight of bombers, tri-motored Junkers 52 passed overhead. A column of troop carriers filled with our soldiers drove by. Everyone stopped to wave at them. A girl ran out into the street and tossed a

<p style="text-align:center">119</p>

bunch of carnations at one of the soldiers. He reached for them but missed and the flowers fell on the pavement.

"Go get them, quick, quick," the crowd called to her. She ran between the troop carriers and retrieved the flowers. The second time she was successful. The soldier held them between his hands and kissed them and waved to her.

"I'll bet she'll get herself laid by one of them tonight," Heinz grumbled.

"I am going to volunteer next year," I said. "The Hoch-und Deutschmeister Regiment is for me."

September 6th

We have captured Krakow! I have bought a map of Europe and have mounted it in my room. The front is marked with flags. The war has lasted less than a week and we are in the heart of Poland.

Met Ursula Schmidt in the Prater yesterday. Heinz says she has slept with a different soldier each night since the war started. I wonder how he knows, for when I looked at her it seemed quite improbable; her face is that of a virgin.

We chatted as we walked along the avenue of chestnut trees. When polished, the nuts look like our mahogany furniture.

"Hans is with the Flak. At least there's a safe place to be." Ursula looked so earnest, that I think she must be sad to have her brother leave for Poland. She turned up the collar of her raincoat. It had started to drizzle, but I ignored the rain for I wanted to find out whether Heinz was right about her.

"Do you know anyone else with the Wehrmacht?"

As soon as I had asked her, I realized what a stupid question it was.

"Oh, here and there a few."

Her face was unchanged: serious and overcast, like the sky above us.

"Egon Platzer has been called up, and of course Rudi Trautmann."

I wonder what she looks like in bed. She has such dark eyes,

almost black. Do women close their eyes when they make love? I must remember to find out from Heinz.

I am furious with my father. Yesterday he told me I must complete Gymnasium before he would let me volunteer. He doesn't understand my feelings, and how much I want to take part in the War before it is over.

September 10th

It is after ten o'clock, and the new school term starts tomorrow. I shall be a Primaner, and will be allowed to smoke. This evening we were at the Western Railway Station to see off Uncle Franz. He is to take up a position along the French frontier, the Siegfried Line. He looked wonderful in his uniform.

I will never understand why my father donned his reserve uniform. He looked peculiar, even though he was a major, and I was embarrassed. What a wonderful scene, though—flags everywhere, a band playing the Radetzky March, and everyone singing "Watch on the Rhine." My mother cried, but of course women do cry on such occasions. I told her that for once I was not annoyed at her, and she smiled through her tears.

"I am not worried about Franz," she said. Franz was leaning out of the wagon window, smoking a cigarette. "Actually, that's not true," she added. "I am worried, quite a bit."

Mother has so little of the German spirit in her. We were standing around chatting with Franz when General Kaperda came into the station. At one time he and father were in the same University Bruederschaft, but now he is a member of the General Staff. Since the train was delayed, he stopped to talk to him.

"What are you doing here?" he asked.

"Seeing my brother off," my father answered. "He is going to the Western Front."

"Yes, yes," the General nodded, "well, the war won't be too hard for him on the Western Front."

He talks in the broadest Viennese dialect. I wonder how those

Germans will manage to understand him.

As we were leaving the station I saw this Jewish family huddled in the corner. God knows where they were going. Small, dark, with their suitcases between their legs. They didn't belong there, they were so foreign. I don't hate them, but they are repulsive. We must rid ourselves of them—the sooner the better.

I wonder what school will be like now that the War has started. Calculus and Latin seem unimportant these days.

Sunday, September 17th

I can't stand it when my father comes out with all that junk that the Fuehrer has swept aside ages ago.

He does not want me to go to the Taunus for the Hitler Youth gliding course. He says it will be at the expense of my studies. And then he comes out with all those old, worn-out things about the importance of learning, knowledge, etc.

"It is the first principle of education that it renews physical and moral strength." He has lost sight of this, and it drives me wild.

"Strength and duty create power, not education," I told him, and I felt like pounding out the words on his desk.

"Very clever, very original," he sneered at me. "And where did you learn that definition of National Socialism? In the gutter?"

I hate that part of me that is afraid of him.

Wednesday, September 27th

Ursel, Heinz and I are going to the Opera this Saturday. I asked her and she agreed to come. They are playing *Walküre*. I hope she likes it, even though the first act is so immensely long.

Heinz promises to take Sabine Mayer. This way I will have a chance to talk to Ursel. I told mother about her.

"Ursula Schmidt...she comes from a good family."

This means that she approves. Over dinner she tells Papa. Even he finds no objections.

"You know Ottmar Schmidt, don't you?" he asks mother. "He is

Privat Dozent—a surgeon—politically naive, but still a good man."

As far as I am concerned none of this matters. I want to see what *it* is like, and it might as well be with Ursel.

October 1st, 1939

The best thing that happened yesterday is that she agreed to go to a movie with me. In any case I will have to wait another week. Seven days, an incredibly long time.

October 8th

What a stupid evening! The movies and then walking through the blackout to Aida's for cake and cocoa. Found nothing to say to Ursula, and all she could come up with was something like:

"Don't you think Greek is better for girls to study than Latin?"

Heinz is a liar, I have no doubts about that. I bet she never even took off her panties for a man, let alone get laid. Then to make matters worse my mother waits up for me, except she won't admit it.

"Oh, it's you, Anton," in this sort of surprised voice, as I come in. "That Bergengruen...I can never put him down. Goodness, it's almost midnight."

This she says as if she has just realized what time it is, although it is obvious she hasn't taken her eyes off the clock all evening. "And how is Ursel?"

I just wanted to go to my room, to bed. Anything but talk about Ursel. "Just fine," I said and managed to escape from her.

These are remarkable times we live in, and I have vowed to live my life to the fullest.

October 11th, 1939

We have beaten back the first big French offensive. Now it will be our turn, and it should be quite a different story.

Ursel has sent me a note by way of Sabine Mayer. Did I want to hear Furtwängler with her. I returned her note saying that I would.

I wish Judith were back in Vienna. It is a funny thing, but when

she left, she was just a good friend, but now I feel differently about her. I miss her, and think about her almost every day, sometimes at quite unexpected moments. The strangest thing is that I can hardly picture her anymore. All I can remember is that she had long blonde hair, and that it was braided. Still there was something wonderful about her, something that I miss in Ursel.

October 13th

Found out last night what I suspected all along, namely that it would be possible for me to marry Judith. We were all sitting at dinner and my father was holding forth about Professor Rotter whose son Erich has just come back from Poland where he had won the Iron Cross, First Class. He was with the Tank Corps and fought at Czenstochau, where he single-handedly wiped out a whole column of Polish cavalry. It must have been immense.

"He's back in Vienna on leave and is getting married," my father says.

"How lovely. To whom?" My mama is always interested in such matters.

"You won't know her...Fritzi Winkler. For a while she was in the Conservatory with Erika. Fritzi is a Jew, can you imagine?

"A Jew, how is that possible?"

"These thing are. Rotter said that when his boy got the Iron Cross—mind you, it was at the Fuehrer's Headquarters—he asked Guderian for permission, and he received it right on the spot. Of course Fritzi will have to be sterilized, but I suppose Erich doesn't care about that."

I wonder what I would have to do...something grand and very special for the Fuehrer and the Reich. I hope the War won't be over too soon.

October 16th

"Of course they want it," Heinz tells me. "They want it just as much as we do, except none of them dare show it."

I wonder whether that includes Ursel. Judith is different though, I am certain of that.

I can't stop thinking about Judith. Of course I can't help it when I am listening to Waldstein's lectures on "Racial Politics." He is so boring. He goes on and on about the Jews, and how we have to free ourselves from them, for they are out to destroy the Reich. Why does he have to keep repeating it over and over? He must think he's got a bunch of idiots in front of him.

After school I did something I have thought of doing for some time. First I shook off Heinz who wanted us to go watch football practice at the Austria Field. Once I left him behind I walked over to the Bergers. It's been some time since I was by their house, and I had no idea whether they still lived there or whether they had left or something. But it looked just as it always had. The tablet outside still read: "Doctor Herrmann Berger, M.U.Dr." except that there now was the yellow disc next to his name. The shutters were down, and no one seemed to be around. I thought of ringing the doorbell and asking them about Judith—where she lived and all that. It sure would have been a mess if someone had seen me. So I walked around the block a couple of times, hoping to run into one of them going in or out of the house; then it would have been all right for me to talk to them. But I didn't see either of them. Maybe I'll call them on the telephone.

I just wish I had someone to talk to about all this.

October 22nd, 1939

What a wonderful autumn. Yesterday afternoon Heinz and I were at the Heurigen in Grinzing. I must learn to get drunk the way he does. He has a grand manner about it.

I wanted him to talk about being in love, but he says there is no such thing, it's all physical attraction, and only when you can't fuck the girl, you want to be in love with her. Besides, being in love is cheap southern sentimentality; the pure Aryan Nordic is above all that.

I wish I knew what is right.

October 27th

Walking down the Stuben Ring after school, Heinz and I were feeling high-spirited. We bumped into this Jewish woman and her boy. When she wouldn't get off the sidewalk for us Heinz tripped her, and I pushed her over. Seeing her sprawled out with her groceries all over the street was a marvelous feeling. It was all I could do to keep myself from kicking her. All this time her boy stood there screaming his head off. Studienrat Waldstein is right: there is freedom in action. I must think about this, for I was elated all day long, and breezed through my Calculus homework without the slightest trouble.

Heinz says that violence cleanses the blood.

October 30th, 1939

With Ursula in the Prater. A heavy dark day, but no rain. Heaps of leaves that crunch as we walk over them. I can remember how when we were still children Judith and I used to love running through them, kicking them up in the air. Once it got dark, Ursula quickly opened her blouse for me.

"Swear you saw nothing," she said. But of course I had.

November 6th

Yesterday afternoon at the Musikvereinssaal. So many men in uniform. They look fantastic and I can't help envying them. Ursel held my hands throughout the concert, and at the end of "Liebestod" she whispered to me: "Thus forever." The way she said it gave me the goose pimples. She has been wearing a bra for quite some time now, and when I put my hands on her thighs they felt deep and soft. I want to tell someone about her, but whom? Not Heinz. I can just hear him ask:

"Well, and after all that, did you get to lay her?"

Coming home with her on the streetcar, I was elated about the two of us: two Germans fated to live at a time when our race is about to fulfill the wonderful role destiny has given it. The rest of the world must be so envious of us. Yet they refuse to acknowledge our superiority until we have conquered them.

November 7th

Last night I thought about Judith. How dull and uninteresting Ursel is by comparison. I would not want to see her again, if only there were a way for me to be with Judith.

November 10th

Called the Bergers from a pay phone. Judith's mother answered. I introduced myself, but she insisted she did not know me. I told her I wanted to speak to Dr. Berger.

"He is not here," she said.

"When will he be back?"

"My dear Sir, there is no way I can tell."

"But I would like to speak with him."

"I don't know you, and I will now hang up. I can tell you are a provocateur. Goodbye."

She hung up, and I didn't have enough change to call again.

November 14th

According to Studienrat Waldstein, we Aryans are the most advanced race in the world, and we therefore must strive towards complete perfection. This will not be easy, particularly for us Viennese, for our blood has become tainted with that of many inferior races. It is necessary that we search our souls and cleanse ourselves of every bit within us that is non-Aryan. It is only after we have done so that we are ready to have children. If some of our non-Aryan traits cannot be rooted out, then it is far better for us not to have any offspring. To renounce procreation under these circumstances is also an Aryan virtue.

Obviously I am copying this from my notes. Writing it down will help me remember the lecture.

Ursel was waiting for me around the corner from school, in front of the skating rink. It was a beautiful afternoon, just getting dark, and we walked home together. I wonder about her. She never talks about politics, and sometimes she makes awfully naive remarks. I asked her whether next summer she would join the Arbeitsdienst.

"I hope I don't have to. It won't be much fun."

"But it's one way to support our State's war effort."

"I know. But I am sure they can do without me. Besides, I think it's time the war was over and done with."

I don't see it as her fault: It's her upbringing. Father says the Schmidts are politically naive.

November 16th

Two "1"s today: Latin and Calculus. Just laid them down on my father's desk, left them there for him to see.

I was working away, listening to the radio, when he came into my room with them.

"Quite good," he said, "quite in the Kermauner tradition."

That was that. He probably still thinks I'm not as smart as he is.

November 20th

In Waldstein's class today, he wanted to know whether there was anyone who had known a Jew.

Peter Ruzicka raised his hand.

"And what can you say about Jews?" Waldstein asked him.

"They are foreign and polluted, treacherous and cowardly, and they are so dirty that every time I talked to this Jew boy I had to go and wash my hands."

I thought of Judith. I too should have put up my hand, but Judith has to remain my secret, something I cannot share with anyone else.

I include her in my prayers. I know the Virgin Mary is taking care of her.

Sunday, November 26th, 1939

Something very exciting has happened. Ursel has told me her parents are going to be in Vorarlberg for a week. She said it in such a mysterious way that I immediately knew she will remain at home by herself.

"You mean you will be alone?" I asked her. Sometimes I am so stupid, I could kick myself. She nodded.

"What are we going to do?"

"Don't be so curious," she replied and pushed one of my jacket buttons with the tip of her forefinger.

In two weeks then it will happen.

December 1st

Long letter from Franz. Everyone on the Siegfried Line is bored. They are waiting for the big offensive, but in the meantime he will be home for Christmas.

December 4th, 1939

Lying awake last night, I wondered whether I am betraying Judith. If only I could see her for one single day. I tried to phone the Bergers again but no one answered. When I came home, I took the mitten out of the box where it has slept since she left Vienna, and looked at it. It is so small and fragile, and it is all I have left of her.

Tomorrow we are off to the Burgenland for Military Preparedness Camp. Beneke, who will be in charge of our group, was at Warsaw. Poland wasn't much of a war, he says, not any more difficult than maneuvers. When the time is right, we will wipe out the French Army with hardly any more trouble.

December 7th

Told Heinz about Ursel. We were lying in our camp bunks, and even though I could not see his face, I sensed that he took it seriously. He leaned down, his head outlined by the light in the corridor, and gave me an upside-down salute.

"*Hals-und Beinbruch*—All the best. By the way, don't expect too much, not the first time."

I don't remember what I said, but I do remember going to sleep wanting to dream of Judith. I didn't though.

December 8th

Yesterday I woke up furious with myself for being in love with a girl whom I haven't seen in nearly a year and who, to top it off, is a Jew. I don't even want to write about her in my journal. It's all so much childish nonsense. The reality is that I have dedicated myself to the Fuehrer and to the greatness of the Third Reich. I must therefore cleanse myself of this childishness that is unbefitting to a Hitler Youth and to a member of the Aryan race. Our mark is restraint, not self-indulgence. Ursula does not seem to know this, and I will have to teach it to her. She is so incredibly simple-minded, I can't believe she is almost thirteen.

December 13th

I don't even want to write about it. It was all wrong, disgusting, just that and no more. I can't bear looking at Ursel again, after what had happened between us. The worst is that I am unable to tell anyone, not even—no, least of all, Heinz.

Eating cake with her in the middle of the night, I nearly told her about Judith. The fact is, Judith had been with me all the time. It was terrible to think that if she knew....

If only I could regain my purity. Perhaps I should go to confession.

December 24th

Franz is home for the holidays, and our whole family is together. After dinner he and I walked through the Prater. With the blackout on, it was pitch-black and very cold, but there was enough of a moon so that we could make our way down the avenue of chestnut trees.

"I detest myself," I suddenly told him.

He stopped to look at me but I walked on ahead, so that he could not see my face.

"What is it?" he asked. "What's happened to you?"

I told him about Ursula. He put his hand on my shoulder, a stupid gesture; but still it felt great.

"Listen…it doesn't matter one bit. That's the way it happens with all of us. Some of us forget it and march on, others enlarge on it so as to make it a worthy opponent, and others yet fear it and flee its presence. Do you understand?"

I said I thought I did, and we walked on. All the time I was thinking of whether I should tell him about Judith. Finally I decided to do it. It was like jumping off the highest board at the swimming pool.

"There's much more," I said.

"Yes, what else?"

"I…I am in love."

"With Ursula?"

"No, no…not with Ursula, with someone who isn't even in Vienna, someone who left several months ago, and whom I might never see again."

"That is difficult, I will agree." His tone was lighthearted, and I got angry with him.

"Look here, you must listen to me. I haven't even told you the worst. Promise you will just listen and not think me despicable."

"Of course not. What on earth could be so bad?"

"She is a Jew. Her name is Judith Berger and she is a Jew."

"A full Jew or a half-breed?"

"A full Jew, that's why she left."

Franz was silent for what seemed to be an immensely long time. Finally he put his arm around me.

"Don't worry. Everyone goes through this sort of misery. It's part of growing up…that's all there is to it."

We walked on in silence.

Even though Franz may think being in love with Judith is merely a matter of growing up, I am still miserable so much of the time. Perhaps it all comes from too much self-indulgence. Tomorrow the whole family will go to church and pray for a speedy victory.

December 29th

Target practice in the Lobau. Cold and gray all afternoon, on the

verge of snow. How wonderful it was. The pistol seemed alive in my hand, possessed with an immense strength, like a fine animal that is controlled by my will. I came home late, feeling cleansed.

<p style="text-align:center">✦10✦</p>

"WHAT ABOUT MORE COFFEE?" Anton asked. The sun was disappearing behind the western hills of the Wienerwald, and the Cafe Kobenzl was emptying itself.

Judith nodded and he raised his hand. A waiter in tuxedo and black tie came by and refilled their cups. A wind arose from the Danube and caused the tablecloth to swell up from its metal clip fastenings.

"Some days when I wake up in the morning," Anton said, "I don't want to face the desolation that is everywhere. What a contrast to our lives before the war! Then I remind myself that we—all of us—are committed to recreating Vienna, the way it once was. When you look at our Opera you will see what a great start we have made."

"Let's strike a bargain," Judith said. "If you take me to the opera, I will take you to the synagogue for the High Holyday services. We have a synagogue in Vienna, in case you don't know."

"Of course I know: after the war, the Opera and the Synagogue had top priorities for restoration."

"So. What do you say?"

"It's a deal. I have tickets for the *Magic Flute* next week. How about it?"

"Sounds great." With a flourish they shook on it.

The following Sunday—it was a beautiful fall day and classes

were due to start in a week—Judith forced herself to make the journey to Stockerau and visit her Uncle Bernhard.

The Western Railway station was a make-shift building erected after the war under the direction of the occupation forces, quite different from the Western Railway Station Judith remembered. That was an ornate structure, replete with marble and stained-glass windows built in the second half of the nineteenth century during the reign of the Emperor Franz Joseph. The train for Stockerau left from Platform 3. Judith bought a newspaper and waited for its departure.

One summer evening Judith stood on the platform of the Western Railway Station, her parents helplessly participating in the final minutes of her departure. Her belongings had been packed into two suitcases: the little red one and a new brown leather case that was much bigger.

"It's nearly as large as Judith," Aunt Clara had said, when she had come over to the house for a tearful good-bye.

The new suitcase was very heavy, and every time Judith lifted it her armpit ached.

"Now let's go over everything again, once more," her father insisted. He came up to her and put his hand on her elbow.

"I know, I know," Judith protested. "You must think I am dumb or something."

"Don't be fresh, Judith, just listen. You are going to get off the train at Cologne, that'll be tomorrow morning, and you will wait in the station for Miss Cobourne, who will introduce herself to you." He looked around to make sure no one was within listening distance. "Remember, don't talk to anyone else, and if someone talks to you, just tell them you are waiting for your aunt to pick you up. Miss Cobourne will see to it that you get across the border into Holland, and you have your tickets from Nijmegen to London, and from London to Dublin. Just don't lose them, please."

"You haven't told me how I am going to get to Holland."

"I don't know, and I don't want to know."

"Will it be dangerous?"

"You'd like that, wouldn't you?"

They were walking up and down the railway platform; her mother was trailing behind them. Judith turned to look at her, worried that she might be crying. But she wasn't, not one bit, even though it would have been a perfectly good occasion to do so. That was the way her mother was.

"Go on, go on," she waved them on, "don't look at me. The two of you have a lot to talk about."

The last few minutes went quickly. Her father put the two suitcases into Judith's compartment and then returned for a few last words. The stationmaster called out the train, doors opened and slammed shut, and people hurried up and down the platform and disappeared behind huge puffs of steam. Suddenly her father did the unexpected.

"Come over here, Judith," he said and took her into a little nook where the two of them were sheltered by a scale. "See if you can guess your weight" read the sign across its face.

"I am going to bless you." He placed his hands upon her head.

"Travel safely my child, live happily, and do not forget your parents. Blessed be everyone that blesseth thee, and cursed be everyone that curseth thee, Amen."

His voice broke, and his mouth became twisted as he tried to hide his tears.

I must remember every one of these moments, Judith thought, after her father had ended his blessing. I must remember my parents, Vienna as it looked this evening when we took the taxi to the station, the stationmaster, the passengers, the smell of the coal, the hissing of the steam, the rumbling of the small locomotive that just went by. I must remember everything for this is a special moment in my life.

She hugged her parents, and knowing that she too would cry if she stayed any longer, climbed onto the train. No sooner had she

settled herself into her compartment than the train started to move out of the station, gliding at first, then knocking, then faster with a tick and a rumble. She raised the window to wave. As the train pulled away her parents grew smaller and less distinct in the poor light of the station. At last all she could make out were two tiny white handkerchiefs that fluttered like pinioned birds.

Morning came, and with it a glorious sunlight that glistened over the fields and across the broad river with its sheer mountain banks. Judith wiped the steamed-up windows and peered out.

"That's the Rhine," the fat man across from her announced.

He was wearing a green hat with a broad eagle feather. He had snored fitfully throughout the night.

It was exciting to see the Rhine. She had read about it, little thinking at that time that she would be traveling along its banks, twelve years of age, a refugee. She savored the word. She had seen pictures of refugees in newsreels, frightened little children walking towards the camera, with torn clothes and pathetic bundles. Now here she was, a refugee, sitting comfortably in a second-class compartment, admiring the Rhine. How wonderful it appeared in the morning sunshine. Then, as a matter of course, she felt guilty. How could she be happy when her parents were still back in Vienna?

"Where are you going?" the man in the green hat asked.

"To Cologne…to visit my aunt. I've never been there, and she has promised to show me the cathedral." Judith was amazed at how well she could lie.

"Cologne…that's a good old German city."

The man pulled a newspaper from his coat pocket and opened it. It must have been at least the third time that he had started to read the same paper, but whatever page he opened he always would nod off.

Getting off at Cologne was no problem for Judith. She placed herself and her two suitcases against a marble pillar and kept a lookout for Mrs. Cobourne. The station was packed. It was the start of the weekend, and soldiers were coming home on leave. Judith knew she

did not have to worry about soldiers: they never bothered Jews. Only the black-shirted S.S. did, and more so yet the brown-shirted Storm Troopers, the S.A. The brown shirts were the most dangerous, her father had told Judith. They were rabble, lower class, and they would beat up Jews or even kill them without the slightest provocation.

Even in the turmoil of the station Judith must have attracted attention, for two S.A. men sauntered up to her.

"Who are you?" One of them asked, snapping the belt strap across his chest.

"I am Christel Prohaska and I am waiting for my aunt," Judith answered in the broadest Viennese dialect.

"I am waiting for my aunt," the brown shirt taunted her, imitating her accent, "I bet you're from Vienna."

"Yes, sir."

"How old are you?"

"Ten," she lied.

"You're cute, but a bit too young for us. We'll have to look you up when we get down there a couple of years from now. I hear your place is full of cuties."

"I don't know, sir."

"You don't? You must be slow for your age. That's the Viennese for you, they are all a bit slow." The brown shirt who had done all the talking stroked Judith's hair.

"No racial mixture there," he said to his companion. "Pure Aryan."

Judith smiled but her insides trembled with fear and anger.

No sooner had the two S.A. men strolled off than she heard her name. She turned to face a tall, lanky woman with a sharp red nose and red cheeks. She must have been Judith's mother's age, but her hair was already gray.

"I'm Miss Cobourne," the woman introduced herself, "and you must be Judith Berger." Her German was very good, yet there was more than a trace of an accent in it.

"I can speak English," Judith offered.

"I know you can, but it will be safer for us to speak German." She picked up Judith's suitcases. "Let's leave these in the baggage room, and then we can look around the city. Our train does not leave until eight, so we have lots of time. Are you hungry?"

Judith nodded.

"Of course you must be. Children are always hungry."

Over lunch they became acquainted. Judith learned that Miss Cobourne was not English but Irish, and that she taught English at a girls' school in Cologne.

"Have you helped anybody else escape from Germany?" Judith asked.

"Hush, please, someone might hear us."

Even though no one was sitting close to their table, Miss Cobourne's nose began to twitch and, scratching it, she rose to pay the bill. "Come on, let's take a walk. There's enough time for us to look at the cathedral."

The cathedral was indeed grand; an immense crenellated stone lattice, with its many spires rising upwards, away from the world's pain and sordidness. When they were inside Judith wanted to buy a postcard.

"Don't waste your money, dear," Miss Cobourne whispered. "You'll be needing every bit of it."

After a while they emerged and crossed the square. The skies had clouded over and a heavy, warm wind had started up. Suddenly Miss Cobourne stopped and allowed Judith to walk on ahead of her.

"Go on, dear, keep on walking," she called out.

Judith did as she was told. When she reached the corner of the square she stopped. Miss Cobourne caught up with her.

"Was that your usual pace?" she asked the girl.

"What do you mean?"

"Is that the kind of steps you always make?"

"Oh yes, unless I am in a great hurry."

"Good. Now let's find somewhere quiet to sit down and talk about our plans."

A tiny park that overlooked the Rhine was just such a place. There were only two benches and both were deserted. They sat down.

"Now listen carefully," Miss Cobourne began, placing her finger on the back of Judith's hand. Miss Cobourne's hand was quite red and her nails were cracked.

"We are going to take the train to Kranenburg. That is the first stop after Kleve. It'll be quite late when we get off, and we will walk to a signpost, just outside the village. From there on you will be on your own. I will point out the path that goes through the woods, and you will follow it. At the pace you used to walk across the square just a while back, you will have to count at least 5,000 steps. Don't stop, whatever you do, and should someone try to stop you or ask you any questions just tell him '*Mijn naam is Marijka. Is dit der goede weg naar Nijmegen?*'"

"What does that mean?"

"It's Dutch, and it means 'My name is Marijka. Is this the best way to Nijmegen?' Now repeat it for me."

"*Mijn naam is Marijka. Is dit der goede weg naar Nijmegen?*"

"Good. Once more. Do you have a good memory, dear?"

"Yes, Miss Cobourne."

"Fine…everything will be all right then." She rubbed her hands together and looked over her shoulder. They were still alone.

"Now, after you have walked at least 5,000 steps, you will be in Holland, not too far from Nijmegen, and perfectly safe. In any case, Mr. Leahy will be waiting for you on the other side of the border."

"Who is Mr. Leahy?"

"He too used to live in Dublin. Now we are all working for a free and united Ireland."

"What happens after I meet Mr. Leahy?"

"Oh, it's up to him then. I suppose he'll take you into Nijmegen for the night. But that won't matter; once you are across the border everything will be fine."

"And what about my suitcases?"

"Oh you poor dear. I don't see how you possibly can carry them

all that distance. I'll take them, and I'll see whether we can get them to you in Ireland."

"But I won't have any clothes…just this."

"Right now, don't worry about your clothes, not at a time like this. Just worry that no one stops you before you cross the border."

"Will anyone stop me?"

"I hope not."

"What if?"

"Tell them what I told you to say, and hope for the best. Remember, don't talk German, whatever happens. Cry, sob, smile, just don't talk German."

"How about English?"

"My dear girl, you couldn't be that stupid."

Indeed, Judith knew it had been a stupid question, and she apologized for it.

The train for Kranenburg was nearly empty, so that it was easy for them to find a compartment to themselves.

"Anything else I should remember?" Judith asked.

"No…let's not talk about it anymore, someone might overhear us."

Miss Cobourne pulled a pocket-book out of her brown briefcase and began to read. Judith peered over at the title: Xenophon, *Anabasis*.

"Is it Greek?" she asked.

"Yes, my dear."

They chatted about the Greeks, about the Persian wars, and about many like matters that happened so long ago that, by comparison, their present journey and their present fears appeared minute and irrelevant.

At Kranenburg they were the only ones to get off the train. The stationmaster was walking along the railway platform smoking the stub end of a cigar. Seeing the girl, he removed it, and gave forth with a toothless smile. "There'll be rain tonight, I'm willing to bet on it."

"Uggh," Judith replied. It was the only word she could think of that would not betray her Viennese dialect. The stationmaster saluted them, and they hurried away. There was not too much to the village. A few poorly lit, one-story houses lined the main street. The square consisted only of the church and across from it the pub, which gave a few signs of life even at so late an hour. At the back of the pub, there was a broken-down barn. Three horses were tied to the fence that surrounded it. Their heads were lowered and they lifted their hooves sleepily. Beyond the barn the road was dark and not too easy to follow. Before Judith realized it, they were standing at the signpost. Silently, Miss Cobourne pointed to it and then to the track before them. It led across a stubbled field, and beyond that into the woods.

"Now, dear, just follow that path and, for heaven's sake, don't get mixed up with your counting…and don't make your steps too small. Here, give me your suitcases, I'll take care of them."

Judith said good-bye to the suitcases, and then to Miss Cobourne.

"Thank you so much, Miss Cobourne."

"Good luck, there."

Head down, she set out towards the black woods lying ahead. It was a dark overcast night, and she had to be careful of every step.

"Two, four, six, eight, ten…." She counted each time she moved her right foot. Never had she imagined that it would be so important to count correctly. At 1,200 steps she stopped for a rest. The underbrush crackled around her, somewhere in the distance a sleepy bird twittered, and the wind hissed through the black trees like waves breaking against the ocean shore.

I mustn't be frightened, she told herself, there are no witches here, no bears, and no wolves. What if there are? This would be just the time for them to appear. For an instant she imagined that two glowing eyes peered at her from out of the darkness. That's all childish nonsense, she told herself. Everything depends on my not being frightened, but I can't wait to finish those 5,000 steps.

Just after she had done 3,240 steps she came to a fork in the trail.

For a moment she panicked. Which fork was she to take? Miss Cobourne had not told her there would be any forks in the trail. She took the left-hand one, praying to God it would be the correct choice. It was not. After 48 steps, the path was blocked by a pile of felled trees. She retraced her steps. What number was it when she had come to the fork? Was it 3,240? What if she had the wrong number? No, it had to be 3,240. She was sure it was.

"Well, there is no one around to ask," she said, quite aloud. How strange her voice sounded in the woods, foreign, an intruder into a night world that she never had known to exist.

"Forty-two, forty-four...." she went on counting every other step mechanically. Humans can't fall asleep when they walk, she told herself. Horses can, but humans can't, horses can, but humans can't, horses can.... She had forgotten to count the last few steps. "That was twelve more: fifty-six, fifty-eight, sixty...."And so she plodded on.

Five thousand twenty, twenty-two, twenty-four...." My God, she thought with a start, I have reached 5,000. I must be in Holland. But I won't stop; my steps may have been too small.

"Judith!"

A man stood at the edge of a small clearing that lay just ahead of her.

"Mr. Leahy?"

"That's me. Come on, let's take you to Nijmegen."

"Am I in Holland?"

"Of course you are, where else?"

Judith stopped. She put her cheeks against the black belted over-coat of the man at her side, a man whose face she had scarcely made out, for the light was far too dark for that. Leaning against him, she sobbed, long, drawn-out sobs. She heard them arise from within her, and it was like seeing animals in a merry-go-round, each different, yet each returning to her in an endless circle.

The next morning Judith and Mr. Leahy sat over breakfast at the Oranjehuis Hotel in Nijmegen. The table had been laid out with black bread, cheese, herring, and a huge cup of cocoa.

"Is this really breakfast?" Judith asked. She was amazed at the quantity of food.

"How do you like Dutch cocoa?" Mr. Leahy asked her. "It's supposed to be the best in the world."

"Mmm," Judith tasted it. It was good. Indeed it was so good that it made the events of the previous night fade away, like the sugar that had dissolved into the hot, brown, creamy liquid that was steaming in front of her.

She looked at Mr. Leahy. He had finished his tea, and was knocking the ashes out of his pipe, sucking and blowing at its stem. He was a young man, with dark, intense eyes and thick brown hair that was combed straight back.

"You got up late," he told her, "so we'll have to hurry to catch the train. By the way, I've already sent a cable to your parents."

"What did you say?"

He grinned: a shy, tentative grin.

"Aunt Betty's baby girl arrived today. Everyone well."

Judith took the message with a frown. "But will they know?" she wondered.

"Of course they will. Now, don't dawdle over your cocoa, we'll have to get going."

"Where to?"

"First we take the train to Hoek van Holland, then you are going to cross the Channel to Harwich, and from there you will take the train to London. You must have all the tickets in your purse, because I don't have them."

Judith nodded. The small red purse that had been her birthday present was all that was left of her belongings.

"Now, here is the ticket for the boat-train from London to Dublin."

"Thank you."

"You know that after we get to Hoek van Holland you will be traveling all by yourself?"

"Why is that?"

143

"Because I have to stay in Holland."

"You do? Why?"

"Because I am working here to free my country."

"Ireland?"

"That's right."

Judith drank her cocoa, which by now was no longer hot, and spread a sliver of cheese across the black bread. She remembered her parents at home and wondered what they were doing that very moment.

"Tell me, Mr. Leahy, am I a refugee?"

"Sure you are, and so am I. There are many of us refugees in this mad world, all of us hoping and waiting to go back home."

"When will you go back home?"

Mr. Leahy pulled out his tobacco pouch and stuffed himself a fresh pipe. Judith noted that his thumb and forefinger were stained brown with the tobacco.

"I rightly don't know, child. What I did, they don't forget so quickly."

"What did you do?" Judith asked, her interest aroused.

Mr. Leahy pondered.

"Well, I'll tell you, I still think it was the right thing to do, but the Lord knows, I didn't intend to harm all those people. It's just that the fool thing went off before it was supposed to, and there were so many of them around." He took a deep puff. "It's like being in a war, chick, except there is no one to call it that. Anyway, finish up, so we can leave."

>‹

→11←

I T WAS A SHORT TRAIN RIDE to Stockerau. When Judith got out on
the square that faced the station, the Railway Hotel that her uncle
had owned before the Anschluss—the annexation to Nazi Germa-
ny—was immediately in front of her.

The yellow three-story building was in surprisingly good condi-
tion. Some workers were repairing the revolving door at the en-
trance, and others were laying down a new carpet in the lobby. She
went up to the desk.

"I would like to talk to Mr. Bernhard Berger."

The clerk, a young man in his twenties with glistening black hair,
looked puzzled and stared at her. Through the open doors that led
into the dining room came the noise of dishes and cutlery being laid
out for the Sunday luncheon. Judith detected the unmistakable aro-
ma of liver dumplings.

"We don't have anyone by that name here," he finally said. "Is he
supposed to check in tonight?"

Judith explained that Mr. Berger had been the one-time owner.
"Before the war...before the Anschluss."

"Ah yes, those days. All that was before my time. I tell you what I
can do, I will go back and ask Frau Wawelka. She has been working

here for I don't know how long." He disappeared and soon reappeared with a buxom, white-haired woman.

"I hear you are looking for Mr. Berger," she said and was all smiles. "You know he used to own the hotel, but of course he no longer does. It was taken over by Paul Horvath, that's the same family who owns the lumber yard down the street. But Mr. Berger is still alive. I can't tell you what a miracle it was to see him come back from the concentration camp. You wouldn't have recognized him though: all skin and bones. You must be his daughter. No…his daughter did not make it. So you must be his niece. I knew it: there is such a remarkable likeness between the two of you. Where are you coming from? Is it America? You must please tell me what it is like to live in America. Are all the ladies as smartly dressed as you?"

It took several minutes before Judith could detach herself from Mrs. Wawelka and the warm aroma of liver dumplings. Energetically swinging her arms, she walked down the main street and crossed a couple of squares until she arrived at a small, pale yellow apartment house.

She hardly recognized the grim-faced, wizened old man who opened the door.

"Uncle Bernhard," she said, and smiled. The man looked confused. "You are Mr. Bernhard Berger?"

"Yes and who are you?"

"I am Judith Berger."

"Judith." Then his memories fell into place. "Yes, yes, I am sure you will want to come in."

The small apartment was overwhelmed by heavy mahogany furniture, which like their owner must by some miracle have survived the war. Through the open window came the shout of children. A woman kept calling for someone called Susi. From across the street came the roar of a heavy truck.

When her uncle did not offer her a seat, Judith pulled a chair forward and sat down by the window. The distant low hills were covered by a green mantle of foliage.

"So here you see me," her uncle started out. "This is how I am ending my life." His hand made a circuit of the small apartment. "Have you seen anything as dreary as this?"

"But it is quite charming," Judith lied. "One can see the mountains from your window."

"How did you manage to find me?"

Judith explained.

"Wawelka," her uncle nodded, "Of course, Martha Wawelka. She was always an anti-Semite. Even before Hitler. After all the years I took care of her, she never once stood by me. You know that they took me away on Kristallnacht. I was in four concentration camps. After the war, when I came out of Mauthausen nothing was left. Sophie and Illi were gone. All I could find out about them was that they had been deported to Latvia…Riga or some place like that." He picked his nose with his little finger.

"And those people would not even give me back my hotel. The Horvaths own it now. They have been socialists from way back, and as you might expect, they were chummy with the local judges. They claimed the hotel hadn't belonged to me on March 13, 1938, they called that the key date. According to them I had declared bankruptcy a month earlier, and as a result the hotel belonged to the bank and reparations didn't apply. Of course if your parents had come through with the loan I asked from them—I assured them it would only be temporary, but they didn't want to have anything to do with it, or with me, their own flesh and blood. That is how I lost my hotel. Everybody tells me I should have appealed the judgment, but how can I? One needs money for an appeal, a lot of money, and I am a poor man. So here I am, living on my old age pension."

As he spoke his hand moved nervously over his face, touching what to him must have been well-known promontories and recesses, much as a dog might explore the corners of his neighborhood.

"You do have a lovely view of the mountains," Judith suggested. She felt that she had to say something positive.

"There were no mountains in Mauthausen."

He got up and rummaging through the sideboard found himself a cigarette.

"There is nothing left for me to do. In the evening I go to the Lenau Hotel—I swore I would never set foot in my hotel again—and I play cards. I don't even have a car anymore, even though I was the first man in this town to obtain a driver's license."

He saw that Judith's eyes were fixed on his right hand, from which the last two fingers were missing. He turned the hand over, palm upward.

"You see: I was punished…by the Nazis."

"For what?"

The old man shook his head. "I don't want to talk about it. Not today."

"How awful!" Her remark referred to much more than her uncle's mutilated hand.

"That is the way it is." He made a gesture of utter resignation: an abrupt, almost imperceptible movement, with his palms turned up, his fingers curved around nothing.

When Judith left her uncle a short time later, she was aching for a cup of coffee. She stopped at the station restaurant.

"You can't possibly just have a cup of coffee with nothing to go with it," the woman serving her said. "Look! We have these wonderful poppy-seed buchtels, really fresh, please have one. They are absolutely delicious."

Judith succumbed to the wheedling. When she paid, the woman remarked, "You must be from America."

"Yes," Judith said, for she was too exhausted to say any more. She took the tray and sat down with the coffee and the poppy-seed buchtel that she really had not wanted.

As she sipped her coffee, she knew she did not want to see Uncle Bernhard again. As it had been with Marushka, the few points where years ago he and Judith had touched each other had become erased with the passage of time.

The train that was to return her to Vienna was late. Sitting in the

waiting room, she took out her pen and started to write a letter to Ireland. "Dear Brigit," she began.

Her school was in the suburbs of Dublin. It was an old Victorian building with creaky wooden staircases, paneled walls, and a library filled with the musty smell of old books. The bookcases rose up to the soot-encrusted ceiling, and a dull light came through narrow windows whose glass was yellowed with time.

Miss O'Rourke introduced Judith to the class. Miss O'Rourke wore a black academic gown over her dress. She was quite young, and Judith thought she was fresh out of University.

"This is Judith Berger, and she is a war refugee from Austria. She speaks beautiful English."

The girls crowded around her. All of them were dressed in navy-blue smocks, with long black stockings and black loafers. They wanted to hear about Vienna, did she ever see Hitler, was anyone killed when the Germans marched in? And then they offered her presents, for she still had nothing on her but her one dress and her little red purse. Woolen scarves, a black sweater, socks, shoes that didn't want to fit, a blouse or two, even a cap appeared on her desk. There were books as well, more or less dog-eared, and a bracelet. It was Brigit Halloran who gave her the thin silver bracelet.

"Shall we be friends?" she said. "You can teach me German, and I shall help you with your Irish." Brigit was much taller, and she was the captain of the field-hockey team.

Judith agreed, and they shook hands on it.

A few weeks later—by then she was well set up in her room on the third floor of the school, which she shared with Maggie Leeson, a round-faced, chubby girl from Athlone—it was time for her to learn field hockey. Stick in hand, she ran up and down the moist grass in her own navy-blue smock, and the girls cheered when she scored her very first goal.

"You were wonderful," Brigit said admiringly. "You played better than any of us." Judith knew that this was not so and that Brigit was being kind to her because she was so far away from home.

Then there were her daily trips to the mail room, of opening small blue envelopes marked "Opened by Censor" for the war had already begun. But in a few months the letters stopped, and there were only yellow cards with minute handwriting and the postmark was no longer Vienna but Terezin. Afterwards there was nothing more, even though she continued to make her daily trips to the little cubicle just inside the entrance to the school where the mail was kept, and where a limping mustachioed veteran of the Troubles handed out the green-and-orange edged envelopes that were addressed to the other boarders and brought them news from home.

Then one evening, as she once again climbed, empty-handed, the warped and poorly lit wooden stairs to her room, suddenly and pervasively, Judith felt alone. She sat down on the top step and hunched forward, put her face between her hands, and cried.

Brigit had started her second year at the Catholic University, University College of Dublin, and had decided to take her degree in Ethics. "You will wonder why I am doing philosophy," she had written to Judith a week or so earlier. "Not that I intend to become a philosopher, but in our country it is so difficult to find a field in which women are fully accepted. Everyone expects us to find a man, get married, and have as many children as possible. All that will have to change, sooner or later. And I hope to be one of the women who will help to bring about the change."

⇥12⇤

1945

THE WAR WAS OVER, and Christmas was less than three weeks away.

It was a day of low drifting clouds. Since morning the rain had come and gone intermittently; a fine mist it had been much of the time. There even were moments when the clouds parted and marvelous patches of blue appeared, only to be covered by fresh swirls blown inland from the Irish Sea.

It was Saturday afternoon and O'Connell Bridge was thronged. A feeble daylight flattened the forms of pedestrians who hastened across the bridge, huddled against the salt-bitter wind. A tangle of double-decker omnibuses crept through the black sea of umbrellas; drained of their green color they appeared pasted over the sooty backdrop of the city. Like black and white marble statues a column of seagulls lined the bridge railings; motionless and impassive they stared at the ever-changing crowds before them.

Bundled up in their mackintoshes, Judith and Brigit crossed the Liffey and headed up O'Connell Street. There the wind would be less fierce and the fumes of the buses less close at hand. With school out at noon, they had come into the city to see the glitter of the

stores and to buy a few Christmas presents. Each of them had a pound or so to spend, and plenty of ideas on how to go about doing so. Their first stop was Clery's. With the traffic bubbling around them they stood in front of the store windows. A gay riot of color and clothes was assembled behind the glass. Streamers crossed from side to side at random, and the baubled Christmas tree was illuminated from all possible angles.

"What do you think of that taffeta blouse?" Brigit asked.

"It is lovely all right, but you should have one with more green in it. It'll suit you better."

Brigit had auburn hair and a rosy complexion. When she greeted her friends, she held out broad and freckled hands that were like those of a farm girl. This was far from so, for she was one of four children of a Wicklow solicitor, and apart from an occasional summer at their Galway cottage, she had never left the city.

"I do like this dress," Judith declared. "Wouldn't it be lovely and warm to wear?"

"How right you are. Shall we go in and try it on?"

Judith was appalled. "But I don't have the money to buy it, and neither do you."

"To be sure I don't, but it'll still be a lark trying it on."

After an hour or so Brigit bought a box of handkerchiefs and Judith a carton of chocolates. It would have to be a present for somebody, but when she bought it, she did not have anyone specific in mind.

"These'll be Kathleen's present," Brigit explained, raising the brown paper sack. "She always is losing her hankies. I'll get mother to hide it till Christmas."

Then making her voice appear important she added, "You will be coming home with me for the holidays, won't you? You can sleep in the upstairs bedroom and you and I will have Sunday to ourselves."

They rode back to school on the top of the bus.

"Do you celebrate Christmas?" Brigit asked.

It was cold and drafty and they were huddled up close. How unusual the Irish were, Judith thought, looking at the other occu-

pants of the bus, everyone asking her whether she celebrated Christmas. It seemed as if they could as little conceive of a person not celebrating Christmas as someone who did not require food or sleep. The answer she gave to Brigit was her standard reply:

"Not really, but I enjoy watching everyone else celebrate it."

"Don't you have a holiday like Christmas?" Brigit knew Judith to be Jewish, and to her being Jewish was as rare as a four-leaf clover.

"Well, there is Chanukah," Judith explained.

"Chanukah?"

"It comes at about the same time as Christmas and we light candles: one candle on the first day, two on the second and so on for eight days."

"Eight days…how wonderful. And do you get presents?"

"Sometimes, but it's not like Christmas when there are always presents."

Brigit was no longer listening. "Look, look, over there," she cried out. "I see some tinkers. What on earth would they be doing in the city? They are so strange, like they don't belong in this country."

Judith did not know too much about tinkers. To her they were like the gypsies she remembered from Vienna. Foreigners, unlike her family, who were *gebürtig*," Viennese by birth.

She carefully opened the carton containing the chocolates and removed two: one for Brigit and one for herself.

"Would you like a sweet?" she asked.

Brigit pushed the chocolate into her mouth. Judith bit off a corner of hers, deliberately, the way she would eat the Ildefonsos that her mother brought home from the Konditorei in the Inner City. Anton loved Ildefonsos; he always had one or two of them in his pocket, and would stuff one into his mouth when he thought no one was looking. But the chocolate she had bought this afternoon did not taste as good as Ildefonsos. It was far too sweet, much like a poem with a predictable rhyme.

She opened her mouth and spat the remainder into her woolen glove. It was a surprisingly vulgar gesture.

"I hate it," she cried. "I really hate it. It's not at all like the sweets my mother bought for me when I was still at home."

Brigit was puzzled by the outburst of a girl who was usually quiet and precisely mannered.

All at once, quite inexplicably, Judith broke into sobs and continued to sob in spite of all Brigit tried to do to comfort her friend.

"Brigit," Judith said abruptly, her voice hoarse from crying, "I think the Germans killed everyone—my parents, my whole family."

By now they were riding up Grafton Street, and Brigit was pressing her face against the steamed-up window to look at the stores below. She turned to Judith.

"I don't think that's possible."

"Yes…yes, it is." She too did not think it was possible that the many voices, faces, and sounds that were so much a part of her had all come to an abrupt end.

"That must be a terrible thing for you," Brigit said. "I shall say a prayer for them tomorrow," she added.

Since Judith was still sobbing, Brigit recited three quick Hail Marys in a low voice for the comfort of her friend. She was crossing herself when the bus came to a lurching halt in front of Switzer's. The brightly lit windows of the department store dispelled some of Judith's sadness. Unable to look into Brigit's face, she reached out and clutched her companion's gloved hand.

"I wonder whether we shouldn't have shopped on Grafton Street rather than at Clery's," she said. "There are much nicer things here."

Her voice was measured, but an immense wave of fear swept over her and gripped her stomach.

A few days later her fears were realized.

Mr. Simpson's law chambers was a queer disarray of unsorted papers, unopened letters, bulging folders, and briefs that needed to find a home. Rarely cleaned, flyspecked windows looked down on the

wintry decay of Marrion Square, and odors of dried rusty ink and old leather permeated the rooms. Mr. Simpson, whose remnants of sandy hair fluttered into the four winds, was utterly untroubled by his surroundings. Clearing the desk with the back of both hands, he rang for tea.

"Beastly cold this afternoon, isn't it?"

"Yes, sir," Judith agreed. Her raincoat and boots attended her in the hallway, where both were generating small independent puddles of rain and melting snow.

The servant girl came around with tea, and Mr. Simpson settled back into his chair. For a few minutes they talked about school. Mr. Simpson acknowledged that Judith's marks were exceptionally good; to be sure, if his memory served him rightly, they were better than his own had been some thirty years back.

"I have some bad news for you," he finally said. A chill rose up across Judith's back.

"My parents are dead," she quickly said.

"Yesterday morning I was finally able to obtain a list from the Red Cross. The survivors of Terezin. Your parents are not on the list."

Time congealed. Judith noted the disarray of pencils and pens on Mr. Simpson's desk.

"How about Aunt Klea?" she asked. If Aunt Klea survived, things wouldn't be quite so bad.

"What was her last name?"

"Bruckner. Klea Bruckner."

Mr. Simpson pulled out the mimeographed sheet from under some books, and searched for his reading glasses.

"Let me see," Judith said, and reached for the sheet. Her hands were trembling. By then Mr. Simpson had located his reading glasses. He scanned the list.

"There is an Otto Bruckner, and a Walter Bruckner."

"No."

Judith got up and standing behind Mr. Simpson, looked over his shoulder.

"What about Clara?" For an instant she fumbled for her last name. "Clara and Theodor Berger."

But they were not on the list either. "There is a Bernhard Berger," Mr. Simpson noted. "Is he any relation to you?"

"Bernhard Berger? Yes. He is my uncle."

"At least he is alive. We must contact him as soon as possible."

So Uncle Bernhard, who owned the bankrupt hotel in Stockerau, who always wanted to borrow money from her parents, and who would entertain Judith with his card tricks, had survived. She had never liked him, and now he was all she had left.

She returned to her chair. "I don't want you to write to him."

"Why not?"

"Because I hate him; I always hated him and his stupid little Illi."

Mr. Simpson took off his reading glasses, folded them, and searched for an appropriate place to put them.

"Would you like some more tea?" He rubbed his hands. The chambers were cold, and the logs in the fireplace gave off only a feeble glow.

"I don't want any of your bloody tea, and I don't want to talk to you."

"My dear child—"

"Do be quiet! You don't understand. You never will."

Then sobs took over. "What will happen to me? What will happen to me?" She buried her face in the crook of her arm. Her body shook.

"I never did know your parents, of course, but from what I have heard, they were decent, respectable people. Oh, it was a terrible thing that happened to so many of the Jews. A terrible thing, indeed." He permitted a moment to pass before continuing.

"Do have some tea." She pushed away the cup. Mr. Simpson got up to turn on the lights, and returned to stand behind the girl. After some hesitation he put his hand on her back, and with a caring gesture straightened out the white collar of her school smock.

"Come and have dinner with us tonight. I will call Mrs. Simpson, and she will prepare something nice."

"Thank you, thank you very much," Judith said, falling back on her manners. "That would be lovely."

"Dear Brigit," Judith wrote. "I have just visited my uncle, the only member of my family who has managed to survive the war. It was a sad visit and I do not want to see him again."

She looked up. A middle-aged man in a short gray beard, wearing a Tyrolean hat and a leather vest with bone buttons, was sitting a few tables away. A glass of beer was in front of him, and as he met Judith's gaze he smiled, much as any man would smile at an attractive girl.

"A man who is sitting a few tables away has just smiled at me," Judith continued her letter. "He is dressed in a traditional Tyrolian outfit, and looks as if he had just stepped out of a travel poster. Even so, I feel more connected to him than to my uncle. At least our momentary interchange was not weighed down with promises or expectations."

When the train finally arrived, Judith climbed on and found an empty compartment where she could finish her letter to Brigit without being disturbed.

⇥13⇤

Judith spent christmas holidays with Brigit Halloran and her family. There she was the center of attention.

Mrs. Halloran met them at the station when the two girls arrived by train in Wicklow.

"So then, you are Judy," she said, as they drove off in Mr. Halloran's black Austin. "After all that Brigit has told us about you, it's high time you paid us a visit."

Kathleen was waiting for them at the house. "Mom says you are a war orphan," she said with a ring of sensationalism. Judith thought that her arrival gave the girl a chance to experience vicariously the excitement of the war. Of course Kathleen was promptly hushed and ordered to take Judith's things up to the guest bedroom.

"Look, Michael," Mrs. Halloran announced, "Brigit's finally managed to bring Judy home for the holidays weekend. I've told you about Judy Berger, she's the Austrian refugee."

Michael Halloran extended his hand. He was a tall and slender man in a rumpled brown tweed jacket.

"Hello, Judy," Mr. Halloran said. He had a disconcerting habit of looking into the distance when speaking to someone. As a consequence people considered him absent-minded, but this was far from the case, for he was a very effective lawyer.

"Her real name is Judith," Brigit explained, "but in school we call her Judy."

"It certainly sounds a lot better," Mr. Halloran agreed. "I gather she can speak English."

"Of course she can, perfectly; she has even learned some Irish."

"If she has, she's wasting her time, just like the rest of you."

Brigit's father had become disillusioned with Irish politics and was ready to argue with anyone who chose to be his foil that Independence had been a step in the direction of economic disaster and anarchy. This time he did not get far, for his wife intervened.

"If you are set to start one of your political speeches, Michael, don't; the poor girl won't hardly know what to make of it."

With a rush and a shout the boys came down the stairs and into the parlor.

"I'm starved," Tom announced, ignoring Judith. "When's dinner?"

"Me too," Patrick chimed in. He was the youngest of the Hallorans, and for him life was a matter of catching someone's attention.

"Now look here, Pat." Brigit's mother managed to round up the slower of the two boys. "I want you to say hello to Judy. She's Brigit's friend at school, and she is from Austria."

"Where's that?" Patrick asked.

"That's where they have kangaroos, you dummy." Tom was a mine of misinformation.

"Not kangaroos," Kathleen corrected, "that's Australia. Judith's from Austria."

"Is that right, mother?" Tom asked. It would never do for him to accept his sister's words at face value.

Later that evening, over dinner, Michael Halloran questioned Judith about practical matters.

"So, Mr. Simpson handles your trust fund." He reflected on the name. "Yes, of course, that must be John Simpson; aren't his chambers on Marrion Square?"

Judith nodded.

"You know the Simpsons," Brigit's father remarked to his wife. "They have a cottage at Killiney. He's Jewish, of course, but his wife's a Galway girl."

"Not Galway. County Cork, that's where her family's from."

"Oh yes, of course; it's Youghall, isn't it?"

At the urgent request of the boys more beef was passed around the table, and close at its heels came a dish of parsley potatoes.

"You know Theresa Mooney, don't you?" Brigit's father asked after seconds had made their rounds. His question was ostensibly directed at his wife, but from the manner in which he surveyed the table, it was obvious that he preferred general attention.

"Did you know she grew up as an orphan? Her father was killed in the Troubles, killed back in 'eighteen he was, and her mother then dying of the influenza not too long after. It was a grand aunt that raised her, and a good job she did of it. Look at her now: a husband and four children. I dare say she'll not be lonely for a single day of her life."

Judith was cutting the potatoes. She stared at the parsley, small green stars in a white fold, watched them grow larger and become blurred, and before she knew it she was crying. She stabbed at the potato with her fork—repeatedly, relentlessly, almost viciously, leaving many rows of points that turned brown and oozed gravy. When the potato fell apart, she put down the fork and groped for her handkerchief.

"Judy?" Brigit's mother asked. "Are you all right?"

"Nothing, it is nothing." The girl pushed back her chair, and with an awkward twist of the body left the table.

Later that night Brigit sat on the bed in Judith's room. She had kicked off her shoes and was perched cross-legged, her back against the headboard. It was damp and chilly and she had wrapped a heavy brown woolen scarf around her shoulders.

"I don't rightly know what came over me," Judith admitted, "but it sounded so horrible to hear myself described as an orphan. It's almost as if my clothes were tattered and I was standing barefoot and alone in the snow begging for alms."

Although Judith smiled at her own description of herself, Brigit saw beyond her smile.

"What can I do to cheer you up?" Brigit asked.

"Stay here for a bit longer."

"I wouldn't want to be anywhere else."

"I wish I could explain everything to you. It's not that people say I am an orphan that upsets me."

"It is a stupid way to describe you."

"That doesn't matter. What I am so upset about is that there is something that has been dammed up inside me. Stunted...maybe that's a better term."

Brigit's green eyes narrowed and a fold appeared across her forehead. The fire flickered and lit up her face. She drew the heavy scarf around her shoulders.

"I don't think that's the right word, either," Judith said. "It's as if there is a knot inside me, an immense knot. I am afraid I will never be able to make friends again. For the rest of my life. And that I will never be happy again, the way I used to be when I was still in Vienna."

"Of course you will be. You are here with us, and you are about to start a new life, and we are all going to help you."

Using the back of her hand, Judith wiped away the tears that were streaming down her cheeks.

"I often feel this way," she said. "It's always there: at night when I wake up, weekends when I am alone at the college with only a handful of girls from the West Country, whose English I can hardly make out. I try to fight it. I study, I read...so much, you wouldn't believe it. It helps. Even when I read German. The sounds and phrases remind me of the days when I lived at home."

Her voice faltered. "Maybe now that my family is all dead I think no one will want me."

A picture of Willi Moser came to mind. None of the children wanted to play with him because he was fat and clumsy and always changed the rules of the games. Judith had always been popular, and

whatever the game, both girls and boys always scrambled to have her on their team. Now that was all gone.

She got off the bed and, having tucked the long flannel night-gown around her bare feet, crouched in front the fire.

"There is no need to worry about me, I am quite well off," she said with forced brightness. "I even get an allowance."

"How much does Mr. Simpson give you?"

"Ten shillings a week. And of course he pays for my clothes and the College tuition."

"Why, that's lovely."

"I know; it's more than enough."

In the end, with Brigit next to her, Judith could not be miserable for too long. One thing led to another, and soon they were talking about the boys at school and laughing.

"And what do you think of Frank Hearne?" Brigit asked, and tossed a few lumps of coal into the grate. The fire flared up again, and now that the wind had died down a bit, the chamber became cozy.

"Frank Hearne? I like what I have seen of him."

"He's got brains...."

"That's a good thing to have, but then I wish he'd do something about his hair."

Frank Hearne's hair was red, bright red, almost flaming, with an erratically hopeful part.

"Tell me, what are boys in Austria like?" Brigit asked. She took the pins out of her hair, and let it fall down over her shoulders.

"Oh, not too much different from the ones here. Maybe not as shy."

A memory of Anton as he bent down over the stray kitten at the streetcar stop, Anton who had taken her mitten and had promised to keep it to ensure her return to Vienna. She no longer could recall his face. She stood up, and after briefly shuffling through her suitcase produced a photo. She handed it to Brigit.

"This is Anton."

It was a small snapshot that somehow had followed her to Ireland. How many times had she looked at it, for it was the only evidence of her former life that she had salvaged. There was handwriting on its back: her mother's, fresh and unblemished by the years: "Judith and Anton on the *Linz* (1936)." She was nine at the time, and the photo had been taken on the top deck of a paddle steamer during an outing on the Danube. The two children were standing alongside a railing. Anton was wearing a beret and being almost a head taller than Judith, was looking down at her, his eyes screwed up, for he was facing the sun. Judith's blonde hair reached almost to her waist, and she wore a dark wool jacket and a pleated skirt, its hemline just above her knees. Her legs were hidden behind long white stockings, but she remembered them as they were at that time: far too skinny to be pretty.

"Oooh, isn't he tall!" Brigit turned the photo and read the inscription.

"He sat across the aisle from me at school," Judith said. "It's been six years since I last saw him. He was awfully fond of me, but I bet he doesn't remember me anymore. I wrote to him a few months ago, but I never got a reply."

"Did you have his right address?"

"I thought I did. Maybe not, or maybe he was bombed out."

She wondered what it would be like to see him again. Would they recognize each other? What would they have to say? There was so much that had happened, all those Nazi years for which she wanted him to make amends.

"Would you ever want to go back?"

"I don't know. Right now it would be horrible. There is no one left. I shouldn't say 'no one' because there is an uncle. But I never liked him. He was too self-centered, always talking about himself." Of course there was Anton. If he had survived the war.

It was nearly midnight when the fire finally died out.

"We are going to eleven o'clock Mass," Brigit reminded Judith as she slipped into her shoes in preparation for returning to her bed. "I

won't have anything to eat, since I'll be taking Communion, but the boys will, and you can have breakfast with them."

As soon as she was alone, Judith turned off the light. Now there was only the warm red glow of the fire. She curled up under the blankets, pulled them around her to ward off the cold air, and watched the embers fade. How wonderful they smelled, how snug and warm she was. In the comfort of her borrowed bed, she planned her life.

She would start University in autumn, and in four or five years she would receive her degree. Then what? It would be exciting to go out to Connemara and teach German there, or perhaps French. She might even remain in Dublin; there would be no trouble getting a position at a girl's college. She heard a rustle. Was it the settling of the embers, or was it a mouse that had crept out, now that the house had become still? Of course she would be married. Ever since she was a child she had thought of being married to Anton. Once they talked of having two children: a boy and a girl, but of course this didn't really matter. What did matter was that she would have to go back to Vienna and find him. She had to know what had happened to him; perhaps he was already married, or perhaps he had been killed in the war. After all he had been old enough to serve in the army. The thought of Anton in a German army uniform was intolerable to her. She could not reconcile her memory of him with her fear and hatred of German soldiers. It was better therefore to think of him in another way. She wondered where he was at that moment, what he was doing. Could he even be thinking of her, wondering where she was? She yawned and stretched her legs. In so doing she undid her blankets and a cold draught crept in between the sheets. She decided it was better to remain curled up, and in this position she closed her eyes. How wonderful it was to be with the Hallorans. At times it was almost like having regained her own family. She decided the boys were far too unruly and needed to be cuffed. The Hallorans were too patient with them and allowed them to get away with all sorts of naughty behavior. Suddenly, and without knowing why, she was happy.

In the morning there was a riot. The boys must have gotten up on the wrong side of the bed, and readying them in time for Mass was almost too much for the two girls. First there was a fight in the bathroom, soaps were being tossed around, and a wet sponge slithered down the hall. Breakfast was no better, and when Judith asked permission to slap the boys should another occasion demand it, Mrs. Halloran cheerfully accorded it to her.

Mr. Halloran attempted to steer the conversation into more serene topics.

"I hear you are going to start at Trinity this fall," he addressed Judith.

"Yes, sir, I hope I'll like it."

"Of course you will. Have you picked a subject?"

"That I have. I'll be reading in languages."

"Languages. That'll be a grand subject for a bright girl like you."

"Lu lu lu lu lu—" Patrick interrupted.

"Will you keep quiet, for God's sakes!" Kathleen shouted at him.

"And why should I?" came the defiant answer. At this point Tom got the giggles and dropped a piece of toast which, predictably, fell on the carpet, buttered side down. He was instantly cuffed by Brigit, and Judith in turn, feeling quite at home now, cuffed Patrick. Her action came as such a surprise to the boy that it evoked a cascade of howls.

"Serves you right," Mrs. Halloran said, "and if you don't mind, Judy will have more cuffs for you."

"Would you like to come with us to Mass?" Brigit asked Judith when things had calmed down.

"I'd love to."

"We'll sit next to each other, and I'll explain everything. Of course you mustn't believe what the priest says about the Jews. He is just reading the old text, and most of it will be in Latin anyway. And you don't have to kneel or go up for Communion, no one will notice."

"Of course you'll come," Mrs. Halloran interjected, "it'll be a pleasure to have you with us."

Indeed, Mass went well, for the boys were cowed by the presence of the girls and by the threatening glances of the verger who was walking up and down the aisle. At one point Judith managed to say a prayer for her parents, for the other members of the family, and for Anton, and having said it, she felt very warm inside.

On the way back she walked with Kathleen who held her hand.

"I'm going to be a nun when I grow up," the girl whispered to Judith, "this way I will save my soul."

Mrs. Halloran came up to them. "Did I tell you how glad I am that you are spending the holidays with us? It was about time Brigit brought you down. Now that we know each other we will have to see much more of you."

"Indeed I will come along with Brigit, if it's all right with you. School's quite empty over the holidays." Judith stopped, for it would never have done to start crying on the way home from church. Someone might think she had left too many sins behind.

⇥14⇤

I THINK ANTON LOVES ME," Judith wrote to Brigit, "but I think he does so because I have practiced on him with foul charms, as it was said of the black Othello. He perceives me as an exotic stranger who happened to have grown up with him, and for whom he yearns, just as he yearns to visit Abyssinia or Cameroon. Do you think love between a man and a woman can be grounded on this kind of yearning?

"I am sure you will also want to know how I feel about him. I love him, because I have always loved him, and because I see him as a means to my continuity. He is the skein and when I touch him I feel the threads I need to feel to repair my life. I hope you understand what I am trying to convey."

She reflected on how to best explain to Brigit her need for continuity and wondered whether everyone had such a need. If so, was it to the same extent as hers? What about those men and women who leave family and friends behind and emigrate to distant lands, cheerfully and with determination, without once looking back? Why could she not be like them?

Unable to make any progress with these thoughts, she ended her letter with a few superficialities: "Everything is so much smaller than I remember it; the streets are shorter, the houses lower, and the

people I meet have shrunk...." and as a postscript she added an invitation for Brigit to visit Vienna on her first school break.

1946

A few weeks before the Easter holidays Judith once again found herself in Mr. Simpson's chambers in response to a short note asking her for the favor of an appointment. The office was in the same state of disarray, the only difference being that the windows looked down on a Marrion Square that sparkled green in the light of a bright April afternoon.

Mr. Simpson stirred his cup of tea and took a slow, reflective sip.

"I am so glad we have a chance to talk," he finally said. "There is a most important matter that has come up, of which I, in my role as your trustee, am obliged to inform you." He added a lump of sugar to his tea.

"Last week I received a letter from a Mr. Randolph Erskine. He is American, and presumably was a fairly close friend of your late father's. Let me see now, I must have it here." He started to look for the letter, but it was obviously hopeless.

"Some other time," he mumbled, and returned to his cup of tea.

"In any case, from this letter, I gather that your father corresponded with him after he had been deported to Terezin. You know that the Germans turned Terezin into a model concentration camp, so that the Jews there were allowed to write.... Of course your parents must have been deported from there to Auschwitz, otherwise.... Well, the long and short of the matter is that your father, before he disappeared, appointed Mr. Erskine as your guardian, in the event of his and your mother's death. Mr. Erskine wrote to me, informing me of this fact, and furthermore he has offered to adopt you."

"Adopt me? What does that mean?"

"It means that he has invited you to live with him and his wife."

"Where will that be?"

"They're in California."

"California? But I don't want to go there."

"Of course you do. It'll be a wonderful opportunity you'll have, living with the Erskines. From what Mr. Erskine has written, they will do everything possible to make you regard them as your new parents. As you probably know, the weather there is fantastic. There is sunshine all year round, even in winter."

"I don't know these people. I don't understand why they would want to have me live with them." A fly buzzed against the window behind Mr. Simpson's desk. "This is all so sudden; I don't know what to do."

"I am not surprised. It must be quite a shock for you. The fact is that as soon as the semester is over they will send you a ticket, and you will leave for America. Of course you will be able to start University there."

"But I don't want to leave Dublin. I have made friends here, and I have been accepted at Trinity for this coming fall."

"My dear child, you don't seem to realize what a marvelous opportunity this will be for you. To tell the truth, I wish I were in your place, and could leave all this."

He leaned across the desk and spoke in a low voice.

"There are so few of us Jews left in Ireland, we are all strangers here. Who knows, some day.... Go, child, make a home for yourself in America. You will see it'll be the right thing for you."

"I really would prefer to stay."

Mr. Simpson shook his head. "I understand how you feel and I respect your feelings, but you see there is another matter that I had not wished to worry you about. You have used up all the money your parents transferred to Ireland. In fact, Mrs. Simpson and I have been paying your college fees for the last four months. There never was that much money in your name, and what with inflation, and the increased expenses...." He broke off and spread his hands in a gesture of helplessness.

"I can get a job while I go to University."

"My dear child! You don't understand. No one will hire a foreigner. Do you realize what our country's unemployment figures are?"

Judith confessed that she didn't. She sat on the other side of Mr. Simpson's desk while the solicitor explained that she was being terribly unrealistic if she expected to be able to find a part-time position while attending University.

That afternoon over tea, Brigit was attempting to be resourceful. She had torn a sheet of lined paper from her copybook and was calculating the future costs of Judith's college education and her living expenses. After she had totaled the figures her face darkened.

"It's a lot of money you'll be needing, Judy. Quite a bit more than I can ask my father to loan you."

"I know. I just wish I could find some kind of work. Do you think Switzers might want to take me on? Or Clery's? They must be hiring some part-time sales girls."

"I think it's worth a try. Make yourself look spiffy, and go around."

Judith agreed, and that Saturday she went around the various stores. It was a brisk, sunny day. Although Judith was dressed in her best jacket and skirt with a red cap perched at a jaunty angle, it turned out to be a useless and depressing endeavor. Most of the shops would not hire part-time girls, and the few that did wanted to see Judith's work permit. Unfortunately, according to regulations a work permit could not be provided to an immigrant like Judith who had come to Ireland on a transient visa, a document that had to be renewed twice a year.

So the matter was settled.

There only remained a blue balmy July afternoon when it was time for farewells at the pier at Dun Loaghaire. The Hallorans had come to see Judith off and had gone with her below deck to make sure that her cabin was comfortable. But Judith was thinking only of that other farewell, the one several years earlier at the Western Railway Station in Vienna, and she wept unashamedly.

"You must write to us every week," Brigit said, "and next summer you will come back, and we will hike through Connemara."

"You won't forget to write to me, will you?" begged Kathleen. "And when you get to Hollywood, do get me an autograph of Deanna Durbin."

For the boys the farewell was less interesting than being on board such a huge ship. They raced up and down the decks, and only when the gangplanks were about to be raised could they be induced to shake hands with Judith.

"It was good to have known you," Mr. Halloran said. The way he spoke seemed so final that even Brigit started to cry. So it was just as well that the ship gave forth its last, piercing whistle and the Hallorans had to go ashore. Judith remained at the railing shouting messages to them, and only later when land had receded into a green haze did she go down into her cabin. There she fell on her bunk, and face down, she sobbed herself to sleep.

✤15✦

THE MOMENT THAT Judith walked under the arches of the portico and through the immense doors that led into the foyer of the State Opera she felt as if she had entered a land of fantasy. It was a world filled with the sparkling diamonds of crystal chandeliers, the red and gold brocade of tapestries, the splendor of the pure marble flights of stairs, all in such contrast to the appallingly drab and bare existence outside the building. The men were in tuxedos or in dark suits of an elegant cut, the women in silk or rustling brocade-embellished taffeta gowns, their appearances designed to resurrect the elegance of the past century, or better yet, recall fairy tale princes and princesses.

Anton had secured two seats in the third balcony. From there the view of the stage was unobstructed, and the acoustics of the house were of such quality that the music rose up to them without being weakened or distorted.

Thus, when the orchestra struck up the overture it seemed to Judith that she again could hear the magic words of her childhood, her mother sitting on the side of her bed, reading, "Once upon a time...."

During the intermission between the first and second acts they ran into friends of Anton. Pepi Bäuml was a bearded young man with

horn-rimmed glasses who was in the same year in medical school as Anton. His companion was a narrow-faced young woman who appeared somewhat older, and was introduced as Pipsi, a name totally incongruous with her appearance.

"Don't you adore the *Zauberflöte*?" Pipsi asked Judith. Her voice and manners appeared affected. "And isn't Böhm fantastic? I have never seen him in such superb form."

Judith agreed. "Judith has just come back from California," Anton explained, without providing the couple any more details.

"I am enrolled in linguistics," Judith said.

"Under Professor Steindreher?"

It turned out that Professor Steindreher was a cousin, once removed, of Pepi's mother, and that Pepi's sister was seriously considering taking linguistics under him next year following her *matura*, her graduation from high school.

An attendant came to warn them that the second act was about to start and Judith and Anton returned to their seats.

"This is the way I would like you to see us," Anton said as they waited for the curtain to go up on the second act.

"It is enchanting," Judith admitted, "but unreal. What goes on outside is real."

Anton smiled. "You have been away too long. If we Viennese prefer to make this our reality, we can do it. It only takes a bit of imagination on our part."

Judith wanted to counter by saying that the amount of imagination called for was more than just a bit, it would have to be an act of faith as great as was required to accept the virgin birth or transubstantiation. Before she had a chance to formulate her words, the conductor returned, the house fell silent, and the orchestra started the second act.

It was a superbly produced opera, and Judith was entranced by the music, the singing, and the staging. But when the performance was over and she and Anton left to go out into the fine, misty drizzle of a cold autumn night, it seemed to her as if she had been cast out

into a world of compromises and banalities, permeated by her own painful memories.

The following Friday evening, the start of the High Holidays, it was Judith's turn to serve as hostess. Wearing a severely dark dress and the Star of David she had bought for herself in California, she met Anton on the Rotenturm Strasse. Holding hands, they walked up the narrow street on which the sole remaining Viennese synagogue was located. The houses were drab, dark, and nondescript. They passed a few small shops, most of them closed for the night, and paused in front of a run-down stationery store. In its window the owner had propped up a large idealized print of the Emperor Franz Joseph wearing a plumed helmet and mounted on a white charger. The remainder of the oddly assorted, sparse display included an outdated calendar, some account books, and, incongruously, a pyramid of variously colored rubber balls, the kind a child would take to the park to play with. What a contrast to Mr. Gruber's window, which always had been wonderfully enticing, with a grand assortment of large and small things she would invariably be tempted to buy.

With a quick movement she took Anton's arm and pulled him away.

"Did you bring a hat?" she asked as they walked up the street. He smiled and extracted a black beret from the pocket of his overcoat.

"Will this do?"

She nodded and they fell silent. What had made her bring Anton to the synagogue? It was as if she were about to strip and disclose a disfiguring and repulsive birthmark. The dregs of having been humiliated and victimized in this city.

"I have never been here," she added. "The synagogue my parents used to take me to was burnt down on Kristallnacht."

"Anything I could say would be trite and inadequate. Like trying to offer condolences to a friend who has just lost his mother."

They came to a poorly lit, undistinguished building that was

guarded by a city policeman in blue uniform and visor cap and two dark-faced, muscular young men.

"This must be it," Judith said. "Fully staffed with what look like Israeli guards." Indeed they were.

A young, deeply tanned woman searched Judith's purse, while one of the two heavy-set men patted up and down Anton's overcoat.

"This is where we separate," Judith said. "I shall sit upstairs in the gallery."

"I will pray for your family," Anton said.

"As you wish." Judith felt her words sounded harsher than she had intended.

Sitting in the balcony, Judith looked down on the sad splendor of white marble columns and floors, the immense chandeliers, and the Holy Ark embroidered in silver with the ruby of the eternal light swaying almost imperceptibly above it. The gallery seats around her and the dark wooden pews below were mostly empty. There were but a score or two of worshipers, mostly elderly men and women, and aside from Anton, she recognized no one either in the galleries or downstairs. As she listened to the incomprehensible, archaic chants of the rabbi and the murmured responses of the pitifully small congregation, it seemed as if she were looking down on a fire-charred forest, the black skeletal remnants of a once luxuriant hillside. She experienced a moment of despair. This was soon replaced by the hope that given enough time, new sprouts would germinate miraculously under the devastation: a bounty of young growth, fertilized by the heavy layer of ashes. With a feeling of exhilaration she foresaw this to be her life's work: to rebuild with joy and pride all that had been destroyed. "We Jews have always suffered, but we have always risen from the ashes."

After the services, Judith and Anton walked towards the Danube Canal. By now it was dark, and after having crossed the poorly lit Judenplatz, the square that long ago had been the center of the Jewish ghetto, they descended a short flight of steps. Hand in hand they

walked along the Franz Joseph Quai towards the Swedish Bridge. Suddenly Judith stood stock-still.

"What is it?" Anton asked.

"The store is still here."

She remembered a Sunday afternoon when she had walked with her father along the canal and they had stopped in front of a surgical supply store. Her father had told her the names of the various instruments in the store window and what they were used for.

A short distance further, as they crossed a square lined with newly planted birch trees, they noticed a black form crouched on the ground under a streetlight. Upon approaching they made out the broad rimmed hat and long black caftan of a young orthodox Jew. He was on his knees, as if praying, but it was clear to Judith that he was scooping up handfuls of dirt into a paper sac.

"What is he doing?" Anton asked in a whisper. There was an air of devotion to the man that prevented either of them from intruding on him.

"I don't know."

"It must be some ritual."

"I don't think so. I hope he won't mind if I ask him."

She went up to the young man who, hearing her approach, stood up and faced her. His eyes were hidden behind thick wire-framed glasses, and his mouth was submerged under a heavy growth of black beard.

"May I ask what you are doing?" Judith spoke in German.

The man looked at her and shook his head. Judith repeated her question in English. He nodded, probably in recognition of the Star of David around her neck.

"Yes," he said in broken English. "I collect my father's ashes. For my mother in Jerusalem. We bury them."

"Your father's ashes?"

"Here he was murdered by the Gestapo."

It was only then that Judith saw the street sign and realized that

they stood on the Morzinplatz, once the site of the Gestapo Head-
quarters. In an instant, she saw herself in the rabbi's apartment, sit-
ting in front of a cup of cocoa which, having grown cold, had a film
of milk on its surface. Again she heard the phone ring, heard Mrs.
Wolf answer, and saw her return to the room.

"They have arrested your father. He is at the Morzinplatz."

The building had been razed, but its name remained indelible.

"I understand," Judith said to the Jewish lad. "Shalom."

"Shalom," he replied and returned to his task.

She rejoined Anton, and without a word of explanation pressed
his hand. Although he had not overheard the interchange, he must
have sensed her need for closeness, for he returned her gesture and
drew her closer to him.

><

<div align="center">

→16←

</div>

A FEW DAYS AFTER Judith had taken Anton to the High Holiday services, she found a note under the door of her apartment. It was from Willi Moser.

"Can we meet for coffee or what have you? My telephone is in good order, so please give me a call."

At Judith's suggestion they met at the bar in the Sirk-Ecke, a place on the corner of the Ring across from the Opera. Judith remembered it from her excursions with her mother. From the outside the locale looked unchanged; several rows of cakes and gateaus were displayed in the windows, and the multitude of mirrors inside managed to have survived the war. It was teatime, and the place was crowded with prosperous Austrians mixed with an assortment of American officers.

"I never come here," Willi said when Judith joined him at one of the many small circular marble tables. "It is much too expensive."

"You are my guest...to make up for all the nasty things I said about you when we were kids."

"I don't remember you ever being nasty to me. All I remember is that you were beautiful with long blonde hair and that everyone wanted to play games with you."

"You have forgotten how I used to make fun of you for being fat.

One time you got so mad at me you wanted to hit me. But you were so slow about it that I had time to get out of the way. That's when you lost your balance and fell down on the gravel right in front of a bicycle."

"What happened?"

"Don't you remember?"

"I swear I don't."

"The rider had to swerve to avoid running over you. He cursed you, and you screamed and cried, and we all laughed because you looked terribly silly lying on the ground, face down. Oh, we were just awful."

"That's children for you."

There was a pause between them.

"How are you doing?" Willi asked.

"I am beginning to enjoy myself. Although I must say I find it strange to be listening to German lectures. The sentences are so much longer, and their meaning isn't as apparent to me as when I attended University in California. It is even worse when I try to take notes or write in German. It's such an effort for me to put down my ideas."

"It'll all come back to you before you know it." He proceeded to tell her about his work.

As a girl Judith had considered Willi to be stupid, but she now realized that this was far from true. In a few well-chosen, concise sentences he told Judith how he came to specialize in hydraulic and irrigation engineering. He explained some of the newer methods to her, the ones that were being imported into the country from America, and how before long they would revolutionize the field.

After they had placed their orders, he brought up the Nazi years. Judith saw it as a means for him to quickly bring into the open whatever resentment she might hold against him.

"Most of us have developed an amnesia for a good part of our lives," he said and smiled. "Forgetfulness has become very convenient to us. We don't have to confront our conscience."

"What about you? How bad is your amnesia?"

"I have nothing to be an amnesiac about. That's the truth. I kept my nose clean. Please don't think of me as a hero. I simply was lucky. What with my father being a Christian-Democrat and a retired Army officer, my family didn't have to make any difficult decisions either."

Coffee and a tray of cream-filled tarts appeared as if by magic. As Willi was selecting his pastry, Judith noted that the elbows in his sweater were threadbare.

"I want to do something useful and significant," he said. "For the past few years the outside shaped our lives, now it is up to us. When I have finished, I intend to work a few years in India. Or maybe in Israel. I hear that you Jews are starting to make the desert bloom." He brushed a lock of red hair from his face.

"It sounds very exciting," Judith said, but the phrase "you Jews" singed her insides. Once again she was made to feel a distance between herself and her old friends.

"What about you? Do you want to go back to America?"

"I don't think so. This is my home; it always has been."

"Are you sure?"

Judith bristled at his question.

"How dare you question me! I was born here. If it hadn't been for Hitler, I never would have left."

"Please, excuse me, Judith. I understand, but right now if I had my choice, I'd move to America; instantly, like that!" He snapped his fingers. "Vienna has become fossilized, we are clinging to the nineteenth century. We haven't come to terms with the atomic bomb, the population explosion, our pollution of water and air. Wait and see: you'll find it a lovely place to visit, but not to live in. What a contrast to California! I see it as a land of sunshine and flowers."

1946

One morning Judith awoke to see the sun throw bright trembling discs across the ceiling of her bedroom.

"The sun is out today," she told herself. "The weather must be fine."

Then she reminded herself that where she now was the weather was always fine, and when she got out of bed and walked to the window, the patches of light on the floor warmed her bare feet. She drew the shades and looked out. The garden below was a veritable box of jewels. The hibiscus were like crimson flares, laurel shimmered in a subdued and mottled light along the stone wall, and all around her, colors sparkled with every conceivable hue. At the bottom of the garden the row of orange trees carried their fruit like an unpredictable garland of iridescent gold. For a moment she stood still, curtain-pull in hand, and took stock of herself: who she was and where she was. Indeed each morning she had to verify that she was real and that all she had seen and experienced since she had left Europe was not a dream. As a test, she dropped the curtain-pull, and to her reassurance, it did not float up to the ceiling, but swung back and forth in a cascade of sunlight.

"Let me see now, what is there for me to do today?" It was Saturday, and she was caught up with her class work for the coming week.

Filled with the promise of a free weekend, she went to the closet and opened it. A few heavy wool dresses hung inside, a reminder of the mist and rain she had left behind, which like her mantle of European habits she was now determined to shed. To do so was difficult, even though to all appearances she was carrying it off well. She had learned to address the Erskines as "Mother" and "Father," and had taught herself to abandon the lilted English that she had acquired so diligently while in Dublin. She had even learned to drive a car, for this was a city where a pedestrian was viewed with suspicion.

"How hot it is already this morning," she thought, rifling through her clothes. "Here it is October and I am still in my summer things."

She stood in front of the mirror and combed out her hair, letting it fall down in long, sparkling slithers. One hundred strokes. That is what Mrs. Erskine had advised her to do every morning.

"My hair is so much lighter here than in Dublin," she sighed, as she looked into the mirror. "It must be all that sunshine." She turned her head and gave her chin a slight lift. Several new pimples above her temple drove her to despair. There was no use denying to herself that she looked awkward and uninteresting. She adjusted the sleeves of the blouse which she had selected for the day. It was powder blue, very expensive, with a simple but stylish cut. Mrs. Erskine had bought it for her on the spur of the moment a few days ago.

"It was on sale," she had said. "I couldn't resist getting it for you."

It had not even been her birthday or some special occasion. So Judith had thanked her, but as always, she felt herself so deeply and irrevocably in debt to the Erskines that there seemed to be no way she could ever pay back their kindness in full. Or was it the other way around? Should they have to be grateful to her for coming out to California and living with them against her wishes? Rather than dealing with this question, she turned from the mirror and went downstairs for breakfast.

Mrs. Erskine was sitting at the breakfast table, drinking coffee and studying the paper.

"Judy, you look absolutely fantastic this morning," she declared. "Too bad Randy isn't here to see you."

"Did he leave already?"

"He had to pop over to his office to catch up with his work. God knows, the days aren't long enough for him."

Randolph Erskine was a stockbroker and his work permeated the house. Not only had a room been set aside for it, an inner sanctum of financial brochures, stock reports and charts, but like a brood of multiplying mice, these spread into all the other parts of the house. Company statements cluttered the Erskines' bedroom, the living room, and on one occasion had even found their way onto Judith's bed, from where she retrieved them, carried them gingerly down the

stairs as she would a litter of kittens, and returned them to their rightful place.

Judith busied herself with breakfast. The doors of the breakfast room opened out onto the garden and a swimming pool shaded by immense large-leafed plants. Elephant ears, Judith reminded herself, while sipping coffee.

"I didn't realize the blouse would be so becoming to you," Mrs. Erskine told her. "Picking that color was a stroke of luck. You like it, don't you?"

Judith fingered the neckline and nodded. Then, as she tucked away a strand of hair, she felt a new pimple.

"Sure, I do," she mumbled, and reached for the toast.

"Don't you even want some cereal?" Mrs. Erskine asked. "It's good for you, full of vitamins."

"I know. I have tried it but I can't get used to the flavor."

"I hope you will; everyone I know loves it."

"Okay," Judith said. How she loved to say "okay." The two sylla-bles were capable of such a range of feeling. "Okay, tomorrow morn-ing I'll have some."

After a few minutes of silence, Mrs. Erskine looked up at Judith.

"You know, Judy, there's something important I've got to tell you. I hope you won't mind if I call it to your attention. It's the way you speak. I can tell you're trying, but every once in a while you seem to forget. You've got to get rid of your sing-song and talk like everyone else. I don't want the other girls to pick on you as a foreigner."

She reached over and patted Judith's wrist. "I know you'll work on it; I'm sure it's just a matter of time. Now, tell me, what are you going to do today?"

"I don't know. I might do some exploring."

"Exploring...what do you mean?"

There was no way Judith could explain what she meant by explor-ing. The fact was that she had no fixed plans in mind except to wan-der around the city. Of course there was no way to do so on foot. She

who had been accustomed to ramble through a goodly part of Dublin on a single afternoon now felt as in a dream: beset by distances so immense that it was as if she was rooted to the spot.

"Can I borrow your car for a few hours?"

"Of course you can. You might want to put in some gas though. I won't need it; I'll be home most of the day. My dressmaker will be here before too long, and after she and I have finished, I'll go lie by the pool and work on my tan."

How simple life was in America, Judith thought, how simple and serene. Yet woven through this tapestry of ease she sensed a dark thread that surfaced repeatedly and unexpectedly and distorted the pattern, turned it ugly, and caused her to long for the world that she had left behind. At night as she lay in her bed and listened to the cicadas in the garden below her windows, Judith managed to define what marred the portrait of sunshine, blue pools, and lush encircling foliage. It was a pentimento of a land driven by a lust for change, by a desire to prove that everyone could succeed at anything.

She must learn to conform to this credo. Even though she was a stranger in California and, aside from her new and somewhat artificial connection to the Erskines, had no one else with whom to share her thoughts, she knew she would readily be accepted once she had been converted to the faith of the country.

The memory of how she had been perfectly willing to convert to Christianity to save herself and her family from the Nazis—for after all, the Bergers were so assimilated that there was little difference between their lives and those led by Viennese Christians—gave her the necessary impetus to adapt herself to this newest demand. The new assimilation was more difficult, for it required a change in her goals and priorities. She would have to decide what was important and what was irrelevant. That for instance, it meant more in terms of her success in life if she were to complete a term paper on time and hand it in together with three book reports for extra credit than if she spent hours on end with her friends in futile discussions of Christianity, Marxism, or the nature of the universe.

In the process of undergoing this transformation she managed to retain her perceptions and could still view her new homeland without distortions. She comprehended the unreality and impermanence that was everywhere she looked, and saw the chasm between appearance and essence of the persons she met.

The handsome young man who serviced her car and filled it with gasoline told Judith, after asking her where she came from, that he had come out from Iowa and was not really a gas station attendant but was in Los Angeles to find a part in the movies. Similarly the girl who served at the drive-in was not a real waitress, but was working there to save up money to open a beauty parlor.

Judith asked Mrs. Erskine about everyone's need to succeed and become someone else.

"Don't you see, Judy, that's what's so great about our country. We all are able to make something of ourselves. It's so much easier to do it here than in Europe, where they have so many barriers."

"What about the people who don't make it? I'd feel sorry for them."

"I do," Helen Erskine agreed. A look of pity came over her face. "But remember, hon, the only reason people don't succeed in our country is because they don't try hard enough."

Judith absorbed all that knowledge and tried to make it her own, just as in Dublin she had tried to absorb a difficult theorem in geometry. She concluded that it was not easy to become an American and for quite some time she felt herself in purgatory: able neither to continue her old life nor to start a new one. She was like a joey, the immature kangaroo that needs to remain in his mother's pouch for several months in order to be protected from the outside world. In her case, she chose to protect herself with an appearance of polite yet haughty indifference, a posture that hindered her from making friends at the University. For to become popular required that she relinquish her reserve and practice the many superficial intimacies of whose rules she was uncertain.

"You shouldn't call me Miss Windham," the girl who sat next to

her in French class advised Judith. "I am Caroline, and everyone calls me Maggie."

She complied, much as she learned to say "Hi," "What'cha doing?," and "I've gotta go" to everyone, but to pronounce these phrases and use them correctly was hardly sufficient to acquire friends. At times she despaired of her isolation. She would stand in front of the mirror and try out a posture, a careless laugh, or a toss of the head which she felt was very American. But even after she had learned these mannerisms, she still was unable to reach out to other young men and women and genuinely act and speak like them. The problem was that Judith lacked a basic knowledge of their lives. It was just as well that she was an attractive girl, with a good figure and (pimples not withstanding) a beautiful face framed by blonde hair and highlighted by her shimmering black eyes. Young men were drawn to her and, undeterred by her standoffishness and foreign mannerisms, they engaged her in chitchat and conversation and frequently wanted to see more of her.

"Would you care to look at the paper?" Mrs. Erskine asked. She offered it to Judith.

"Oh, thank you."

Now that the war was over she had lost all interest in the news. There would never be any headlines to tell her that her parents had been found alive, and everything else was of little consequence. She turned the pages perfunctorily and put them down.

"I guess I'll be off," she said. "If I start much later, it'll get too hot."

She gave Mrs. Erskine a kiss on the cheek. It went with calling her "Mother." Having done so, she was free to leave.

She started up the car and drove into the hills. There, pasted against the first range of mountains, a landmark stood out, a set of immense white letters: HOLLYWOOD. From the distance, obscured by the yellow haze that hung over the city, the letters seemed flimsily attached to their blue and green background. They had a certain makeshift appearance, yet at the same time they provided a rallying

point for the disarrayed and multicolored houses at their base.

Judith drove as far as possible, then stopped the car and locked it. Prompted by a need to approach the letters, to touch them, and with their help perhaps to understand the city, she set out to climb the remaining distance. She picked her way between dried sage and wild rosemary, scrambled across gullies carved into the loose sandstone by last winter's rain, followed a track, then lost it, felt the soil crumble under her shoes, until a few hundred yards below her goal she found the path blocked by an enormous letter lying face down on the ground. Still attached to the wooden framework, its twisted and rusty form had stained the surrounding scrub oak, so that the whole configuration resembled a huge, prehistoric animal, one that had wandered across the hillside when the landscape was still lush and primitive, then, beset by disease or enemies, had withered and perished there.

Carefully, Judith stepped around the metal and continued her climb. At last, a trifle out of breath, she arrived at the foot of the letters. They were huge sheets of sun-warmed metal, painted white and reinforced on the back with wooden scaffolding. She walked to the base of the third O. There the ground was flat and free of shrubs. She sat down and with her arms clasped around her knees looked down on the city. What a sight it was: an expanse of houses, their rooftops reflecting the dazzling hot sunlight, innumerable straight and endless streets, countless trees, and here and there the brave blue outline of a swimming pool. The whole picture was as if covered by a muslin veil, blurred and blue in the center, its margins a faintly shimmering gold.

It was a strange, vast and eerily silent panorama. Despite the many traces of human existence Judith felt the city to be empty and uninhabited. For unlike Vienna when viewed from its surrounding mountains, it lacked the many small and intimate sounds and movements, the sudden wind-borne noises of taxi horns, overloaded streetcars, and lackadaisically unpunctual church bells. As hard as she might search, she could not make out any of the tiny irregular,

tree-studded squares into which one could retreat for relief from the oppressive metropolis. It was a city without repose, with no place to invite her soul.

"God, what am I going to do with myself?"

A hot wind arose. It carried a strange spicy aroma from the brush-covered hillside and blew through Judith's hair.

It was then that the seed of an idea entered her and germinated rapidly under the warm sun. In a few months she would be twenty, and the Erskines had planned a special birthday for her, with a present of her choice. What would they say if she were to ask for a year in Vienna at the University? She would continue to study languages there, and when the year was up, who knows? She might even manage to stay and support herself on her own.

A sense of happiness surged up within her. If everything worked out, and there was no reason why it should not, she would soon be able to return to Austria. Once back in Vienna she would find Anton, and with his help she would set out to resume her former life.

She got up, bestowed a farewell glance at the city below, and started her descent.

Willi smiled. "Your coffee is getting cold."

"I am sorry."

"You have been thinking...."

"Yes...about California. The life I left behind."

"And...?"

"I concluded that when you say there is no future for you in this city, you are too pessimistic."

"Am I, now? Have you ever read *The Last Days of Mankind*? Parts of the play are set right here, in and outside this restaurant."

Judith had not, and Willi explained. "Karl Kraus was a Viennese visionary. He abhorred banality, proclaimed it as the consummate evil, and predicted that one day banality would take over the country.

He was right, and it is happening this very moment." He paused to take a bite from the cream pastry. "It is a profound play."

"I would love to see it."

"You never will. It would take at least five evenings to perform it. That's how long it is. Directors have tried to abbreviate it, but no one has succeeded."

"I must read it then."

"You should. I will loan you my copy if you promise to return it."

They finished their coffees and got up to leave.

"By the way," Willi said, as they stood outside the restaurant, "do you remember Leo Rosenberg?"

"Yes. He had dark, stringy hair that was always in a mess, and his nails were dirty." She smiled because she failed to add that he was the only other Jew in her class.

"I saw him a few weeks ago."

"You mean he is alive?"

"I generally don't socialize with ghosts. At least not to my knowledge. He emigrated to America with his family, and he is here for a meeting of the Atomic Energy Commission. Apparently, he has made quite a name for himself as a physicist."

"At his age?"

"They say if you are a physicist you'd better make your mark before twenty-five, or you never will."

"So Rosenberg is alive...." she mused.

"And well. He is staying at the Hotel Bristol. The AEC is paying all his expenses."

Although she did not say so, Judith had no desire to see him.

The converse was not the case, and a few days later she received a letter from Dr. Leo Rosenberg on the stationery of the Hotel Bristol.

"Dear Judith. I heard you made it. Call me and let's meet for drinks. Leo."

She did call him, and one evening, shortly thereafter, they met at the bar of the Hotel Bristol. Leo's hair was still black and stringy, but

his hands were clean and, wearing a navy-blue blazer and charcoal slacks, he did not look one bit shabby.

"So what on earth made you come back here?" he asked Judith. "It is absolutely incomprehensible to me how a Jew can live in this city. I can't stand all their waltz and schmaltz. Those Austrians are the worst anti-Semites, far worse than the Germans. Remember, Hitler was an Austrian."

"So why did you come back?"

"The only reason I am here is because the United Nations appointed me as their consultant."

He tried to explain his work to Judith. It was something to do with neutrinos, the elementary particles with zero electrical charge. Apparently his Ph.D. thesis on neutrinos had made quite an international stir.

"And how are your parents?" he asked.

"They disappeared. They probably died at Auschwitz."

"Those bastards! I could kill each and everyone of them!"

"The tragedy is not that they died; the laws of nature dictate that parents die before their children. It is how they died that is so horrible: degraded, stripped of everything that made life meaningful to them. In a way I would like to confirm the details of their deaths; it would help me close out a part of my life...my childhood. Once I have done that I would never want to think about it again. What about your family?"

Leo's parents were well and living in the outskirts of Chicago. His father had become an accountant for Sears. There also was a younger sister who had just started college.

"Your people were survivors," Judith said. "Ours weren't."

"I guess we were. So what are you doing these days?"

Judith told him, remaining aloof. "We are proud people," her mother once said to her. "For we know how special we are."

She knew her parents had died because they preferred death to a rootless life.

"Well, they're sure generous to you."

"I am the daughter they always wanted to have."

Not knowing how to respond Terry took her hand. She felt his attempt at coming close to her and smiled. "I am sorry," she said. "Birthdays are always difficult for me, especially an important one like this."

Terry nodded. "Let's go to the bar."

"What a grand idea. My glass is empty."

Before the evening was over she was utterly drunk. Not caring what the Erskines or anyone else might say, she pulled Terry behind a clump of banana trees and necked furiously with him.

At one point in the evening Anton jumped on a chair and called for silence.

"I want to propose a toast to our hostess, Judith Berger. Thank you for such a wonderful party, Judith, and let me assure you from the very bottom of my heart that it's good to have you back in Vienna."

There were cheers, and Judith, overcome by emotion and by the several glasses of blue Veltliner she had already consumed, burst into tears.

"Speech, speech," Willi urged and everyone chimed in.

Judith rose. Her feet were a trifle wobbly, for indeed, the Veltliner was taking its toll. "Many thanks to you, Anton," she said, "and to all of you for coming here and being my friends."

But that was not what she had planned to say. Had she been sober she might have said something about being happy that she had reestablished the links that bound her to Vienna. She also might have said something to the effect that seeing her former classmates had made her aware of the passage of time, and that she was no longer a small girl, but a young woman who had embarked on her life.

Everyone applauded, and when she sat down, Willi and Anton embraced her. Glasses were refilled and more toasts were drunk. At

one point in the evening—it was past midnight, and most of the guests had already gone—Heinz came over and sat down next to Judith. They were in the kitchen. On the table next to them were plates with a few sparse leftovers. The Homeland Calendar that Judith had hung up occupied much of the small amount of wall space between shelves and cupboards. This month's picture was an autumn scene from the Ziller Tal: fall foliage, an Alpine village with sharply pitched roofs, and in the distance, majestic snow-covered mountains.

"That's a great party you made for us, Judith," Heinz said.

"Thanks. I loved preparing it."

"And I love your outfit. Absolutely charming. It's from America, isn't it? Rich, immense, powerful America." Heinz was quite drunk and he started to ramble. "You may not remember but there was a time when Viennese fashion was the best in the world, better than Berlin, better than Paris, but now…now we have nothing. Nothing except unemployment and the occupation. Everyone spies on everyone else, everyone is afraid of their own past. You cannot imagine what those Russians are like. I was coming back from Leoben this afternoon, and they stopped me outside of Vienna and searched my car. God knows what they were looking for. I tell you, those Communists are animals."

"Not any worse than the Nazis."

"There you go again. Look, Judith, the war is over. You people won, although God knows it is far from being the evening of all days. I'll grant you we made blunders, major blunders, and they were our undoing."

"Do you consider killing six million Jews a blunder?"

"Get off it! Our German people were fighting a war, the most brutal war in the history of mankind. You have no idea what the Eastern Front was like. Sure we put you Jews to work, but we all had to work, except we were used to hard work and you were not."

"What about the gas chambers?"

"There were no gas chambers. That was all propaganda concocted by the Americans, with quite a bit of help from you people."

Judith was enraged. The wine took away her control. She jumped up and stood over Heinz.

"And how many Jews did you kill, Heinz? Come on, give me an estimate. Ten, twenty? Five hundred?" She felt Anton's hand on her shoulder.

"Judith, please control yourself."

"I don't want to control myself! I can't swallow all that poison."

"We agreed the other day that the past is past. We drew a thick line under it. Didn't we?" Without waiting for Judith's response he turned to Heinz. "Heinz, please make yourself scarce. If you can't walk down the stairs on your own, get Willi to help you."

Giving out a loudly defiant belch, Heinz got to his feet. "At your service, Herr Kermauner." He came up with a mock salute. "Perhaps it's time you disclosed your role in the Final Solution to this Jewish Miss." He weaved to the door and slammed it shut behind him. Judith's face was in red blotches. She was far too angry to cry or to ask Anton to explain the meaning behind Heinz's parting words.

"Look here, Judith, Heinz is trash, lower class. If you had asked my opinion I would have told you not to invite him. Do you know what his father was before the Anschluss? A waiter in a small coffee house in the Leopoldstadt. He hated Jews because he felt exploited by them."

Judith sat down on one of the kitchen chairs. She pulled Anton over to her, and he bent down and kissed the top of her head. "Don't be upset," he said. "Everything will be all right. You will learn to ignore people like Heinz. They don't matter, believe me, they don't."

Judith burrowed her head into Anton's chest; the rough, warm texture of his sweater was like a consolation.

"Yes, yes," she said. "Yes, yes."

➤←

→18←

PROFESSOR SANDOR PETOFY was lecturing on the origins of the Germanic languages. He stressed the interrelation between the Proto-Indo-Aryan languages and the subsequently evolving Gothic, Icelandic, and High and Low German. By comparing the evolution of words, particularly their consonants, he established for his listeners the process by which Indo-Aryan changed over the centuries into its descendants, the Germanic languages on the one hand, and the Celtic, Greek, and Baltic languages on the other.

In large letters he wrote "INDO-ARYAN" on the top of the board, and connected it with arrows to Gothic and Icelandic on the left side, and Celtic, Greek, and Baltic on the right.

As Judith took notes she reminded herself that the concepts of Aryan race and language had not disappeared, they had been transplanted from the political rallies and the streets into the lecture halls. They were safer there, without doubt, and less conducive to violence. She laid down her pen, and allowing the words of the lecturer to drift away, she thought about the link between language and violence. Language could incite violence, but could also prevent it.

After the lecture Judith wandered into the corridor, books under her arm. It was a warm day in late autumn and the windows were open. With her elbows propped on the sill, she looked down on the

Ring, taking in the remaining clusters of red foliage, the noise of the early afternoon traffic, the clanging of the streetcars, and the long lines of people waiting for tickets at the Burg Theater on the other side of the avenue.

"They're back again," a man said behind her back.

"I didn't realize." It was a woman who responded.

"Of course they are. Haven't you seen them? Right now it's just a handful, but before long they'll be here in droves. Pity Hitler didn't take care of the whole lot of them. His Final Solution wasn't final enough."

"There's no use fretting about it."

"You're right, there isn't, certainly not out in the open. They'd report us to the Occupation Authorities. But just wait: in a year or so we'll have Vienna to ourselves again, and then we'll be able to take care of them."

Chills blew down Judith's back. She did not dare turn, for if she did, she might recognize the two speakers. Their voices were ordinary, matter of fact, not filled with hysterical violence, and they were conversing in reasonable tones, much as one might discuss the various means of exterminating pesky flies, or rats in the basement.

Judith looked down into the street. Nothing had changed. A streetcar stopped in front of the University, people got off and on. The branches of the trees swayed in the wind. A scattering of leaves floated to the pavement. This was how it had happened to her parents, this was how they were murdered, not with insane hatred, but for logical, sanitary reasons. Now those same ordinary, logical people, unseen and hidden behind smiles and polite phrases, were waiting for the opportunity to complete their task.

Her initial reaction was one of anger. She wanted to turn and confront the two speakers and spit it into their faces: "I am a Jew." What good would it do? There might be some shuffling, some poorly worded, contemptuous explanations, and everything would remain the same. To engage them in a dialogue would have been as useless as if she were to assure a paranoid that there were no glass

fragments in his bread, that there could not possibly be any glass fragments in his bread. A sense of hopelessness swept over her, a gloom against which she was poorly armed. She felt bereft, then remembered Anton. He would listen to her fears; he had to understand them, for she sensed—in fact she knew—that he loved her. She looked at her watch. They had arranged to meet in half an hour at a small coffee house a few blocks from the University.

When Anton saw Judith enter, he put down the newspaper and got up, all smiles. Bubbling over with excitement, he ordered two coffees and a tray of pastries. Before she could compose herself to the point of being able to say anything to him, he was describing his laboratory experiments in biochemical pharmacology. They had gone so well this afternoon—everything had been "klipp, klapp," he said—that he had been able to finish his assays before anyone else in his class. He had arrived at the cafe much earlier than he had planned.

"I really enjoyed waiting for you," he said. "Your image is still so fresh to me that whenever I tell myself I am about to meet Judith, I am uncertain whether the Judith who will come through the revolving door will be a girl or a woman; my sister or my girlfriend."

All at once he saw how upset she was.

"Good heavens, what's happened to you? You look absolutely terrible...."

"Anton, I have to talk to you," Judith said, ignoring the coffee and pastry that were being set out in front of her. "I feel absolutely devastated."

"Please tell me."

"I can't go back to the University. I don't want to go back there. It's those people...everything is still the same. I don't know what to do."

Anton reached out and held both of Judith's hands.

"Judith, you still have not told me what happened."

"I don't know where to start. It's a conversation I overheard. Between two students. I heard them. They're waiting for the Occupation to end, then they'll kill the remainder of us."

"What do you mean?"

"That's what they said. They want to kill us Jews…the few, pitiful remnants who escaped the gas chambers…they want to make it a clean sweep."

"Are you sure?"

"Absolutely." She elaborated on the conversation she had overheard.

"I can't believe it! They must be some crazy fanatics, neo-Nazis. We will find out their names and report them."

"Anton, listen, I haven't told you the worst. They didn't sound one bit crazy. They were so ordinary, just like the other students at the University…like you and me. Oh my God." She freed her hands from his and buried her face into them.

Anton leaned over and stroked her hair. "Judith, listen, those people don't matter."

"That's exactly what you said about Heinz. That he was lower class, after all what can you expect from the son of a waiter. But these are students at the University, the University of Vienna. You can't write them off as trash."

"They are still proletariat, in spite of their education."

"I don't believe it; I can't believe it!"

"Look, Judith, let's be calm about this incident. These people are not going to do a thing to you. It won't happen; I swear it will never happen again."

"How do you know?"

"I just know."

Judith looked up at him. Her face became fixed. "That's exactly what you told me when I was a girl: that nothing would happen to me, that it was merely the proletariat who was beating us up in the streets and burning down our synagogues. It might have been the proletariat at first, the impassioned soul of the people. You remember that phrase, don't you, Anton—what an apt phrase to excuse the worst excesses—but later murder became organized and efficient, and ordinary, passionless people took charge. They kept meticulous

records and noted down every detail. Names, ages, professions of their victims, their addresses, and of course at the end, the pressure, temperature and the amount and duration of gas required to kill a chamber full of people. An entire country conspired to commit these crimes, and there was not a soul who spoke out against them. Not you, not your mother, certainly not your father, nor any of my former classmates...."

"You are unfair to us. There were German tanks in the street, everywhere."

"German tanks," Judith repeated disdainfully.

"Yes, German tanks, the German army. Tell me, Judith, be honest now, tell me would you have defied the Nazis if you knew with absolute certainty that it would have cost your life, and that furthermore, it would have been in vain? Listen, back in 'forty-three, there were some students who organized themselves into an Underground, passed out leaflets, called for the end of the war, the assassination of Hitler. Do you know what happened to them? They were found out, all of them, and they died the most awful, cruel deaths—the gas chamber would have been an act of mercy for them—and their parents were sent to the concentration camps. It was a brave gesture, I'll grant you that, but it was utterly useless."

"And if everyone had done the same?"

"The University would have been turned into another Lidice: flattened to the ground and ploughed up. Not a student would have survived."

Judith became silent. She stared at the tablecloth in front of her. It was an old cloth, freshly laundered and starched, but with cigarette burns and holes here and there. She picked up her cup; the coffee had become cold.

"I need another cup of coffee," Judith said. "Order me some, will you?"

"Of course, of course. Right away. And what about your pastry?"

"I can't."

More coffee arrived and the waiter spooned out the whipped

cream. It floated on the hot, black liquid, dispersed, and then remained as a soft white cap, cold and sweet.

"There is something I learned during the war." His voice trailed off. "It's one thing to be a hero, but it's still another to be a fool."

Anton did not realize how many good friends he had until they all came to the Eastern Railway Station to see him off. First of all, there was Heinz who was to leave for Italy any day. He sported a wisp of a moustache and looked smart in his new uniform. Willi Moser, by contrast, looked fat and self-conscious. He was due to be called up within a month and he didn't like it one bit. Of the girls there was Ursula, of course, who had arrived with Sabine Mayer, both dressed up "the way we want Anton to remember us." Even Lisl had managed a half-day's leave from the *Arbeitsdienst*, the Workers Corps, in the Burgenland to come into Vienna for the send-off. She arrived with a package wrapped in an old newspaper. It was goose liver, Burgenland-style, the best that could be had in war or peace. She handed it to Anton.

"For your journey. It goes well with black bread, and it'll keep."

Her voice was matter of fact, but there were tears in her eyes. Anton was glad to see her, knowing that in her presence his mother would not dare embarrass him with prolonged embraces, and poorly stifled sobs. Reinhard Kermauner appeared self-possessed. He stood erect on the platform, hands locked behind his back, and lectured to the young people on the pros and cons of the provisional part-time University program.

"In any University curriculum there are always non-essentials," he told them, "and these we can sacrifice during our present crisis." His words came out so solidly that the young people were almost deceived into believing that elimination of the non-essentials in the University curriculum was foremost in his mind.

"I know I shouldn't worry about Anton," Herta whispered to Lisl.

"Where he'll be stationed there won't be any fighting...but still...."

"I know, ma'am. It's only natural; my mother always worries about me, even though I am only in the Burgenland; it's as if this war is everywhere, and one can never tell where something might happen. Why only two weeks ago the English came over Eisenstadt and bombed the railway station."

"All of us have become soldiers, Lisl."

Anton overheard his mother's remark and instantly was embarrassed. Farewells are too sentimental, he thought; the best thing is to pick up one's bags and just go. Everything else is mush, weakness, un-Aryan weakness.

"Well, aren't you going to give him a little kiss?" Sabine poked Ursula's ribs and giggled. Ursula gave her a short, puzzled look and then too burst into laughter. Their arms around each other's waists, the two girls turned full circle, laughing, their blonde heads clumped together like a bouquet of marigolds.

"We are going to get them," Heinz told Anton, slapping him on the back, "we'll show them what it's all about."

Willi was less enthusiastic. "I hope it's all going to be over with before too long. One real solid victory, and they'll sit down with us and talk."

"You didn't forget to pack the plum cake, did you?" Herta Kermauner asked Anton, pulling at his sleeve to get his attention.

"Of course not, you've already asked me a dozen times."

"I want you to try and eat regularly...and don't drink too much. I know it'll be a temptation out there."

"Listen, Anton, can we have a few words in private?"

With his head Reinhard Kermauner pointed towards the further end of the platform. "We only have a few more minutes and this is important."

As the two of them moved away from the group the train hissed and emitted an immense cloud of steam.

"Can you tell me the time?"

A gaunt, unshaven, blond soldier stood before them. Anton's fa-

ther unbuttoned his overcoat and pulled out his gold watch from the vest pocket. He opened it with a click.

"Eight thirty-five," he announced.

How many times have I seen this gesture of my father's, Anton thought. How deliberately he performs it, how ceremoniously, even now.

"Much obliged. Heil Hitler." The unshaven soldier moved away.

"Heil Hitler," Reinhard Kermauner responded. "He's a Saxon," he added for his son's benefit. "One can't miss the accent." The two of them retired to a quiet corner. With a shrug of his shoulders, Reinhard Kermauner adjusted the lapels of his son's uniform.

"Listen, Anton. I want you to promise me one thing before you go. It's important, not only to you or to me, but also to the ideals for which we are all fighting."

"Yes?" He is embarrassed, Anton thought, embarrassed by what he is about to tell me.

"I am sure you realize there has been a lot of talk about what is happening on the Eastern Front. Without doubt much of it is enemy propaganda, but still, there may be a kernel of truth. In any case I want you to promise me that, wherever you may be, and in whatever situation you may find yourself, you will remember that a German soldier does not disgrace his uniform. Do you understand? We are all involved in an immense struggle, and its intensity stimulates all sorts of excesses. But we have a great cause, and we cannot and must not defile it."

A fleck of soot settled on Reinhard Kermauner's nose. He pulled out a handkerchief and wiped it off, inspecting the white cloth closely, as if needing to assure himself that the soot had not damaged the weave.

Anton remained silent.

"You don't have to answer, Anton. Just tell me whether you agree."

"I do."

"Good. Then we can go back to them."

"Oh Anton," Sabine shouted as he approached, "don't forget to write to me…you promised." She already was conducting a busy correspondence with soldiers in France, Italy, and on the Eastern Front, and she enjoyed the tranquillity of sitting over her desk at night with the blackout curtains drawn, composing her letters, weighing out words of love and caring destined for so many different parts of the globe. Each letter received a part of herself; the quantity, be it large or small, depended on the recipient's needs and on the quality of the letter Sabine had last received from him.

With Ursula it was different. Anton was her first great love, and she was so involved in tasting the drama of the moment she was unable to compete with Sabine.

At last the loudspeakers announced the departure of the train. A harsh voice recited an endless list of cities, starting with the familiar: "Fischamend, Pressburg…," proceeding to the distant "Ostrau, Prerau…," and ending with strangely remote places that carried fierce, unyielding names: "Radon, Baranovici, Mogilev.…"

The steam hissed. Immense billows rose from underneath the wheels and filled the station, and after a clanging of doors that reverberated like echoes of approaching thunder, it was time for Anton to leave. He performed a few quick and impartial embraces and, that having been taken care of, swung his two bags over his shoulder and climbed aboard. Of course the window seat had been reserved for him. After all, Reinhard Kermauner had not been an illegal National Socialist for more than eight years without acquiring some influence.

Anton placed the bags in the overhead rack, took off his coat and cap, folded the latter carefully, and put it into the pocket of his coat. This done he tried to push down the window. But the bolts would not yield even though he strained and shook them. Through the dirty and fly-stained glass he could see the blurred figures of those whom he was leaving behind. Ursula was standing on tiptoe, intent on giving him a parting message. From her open and distorted mouth he surmised that she was shouting, but he could not hear a word. He shrugged his shoulders and laughingly shook his head.

Undeterred, she continued her conversation by signs. Did he have the letter paper she gave him? Of course he did, and of course he would write to her, often, very often. It was as if he had been placed into an aquarium, mute and behind glass, a submarine world into which those outside could see, but from which he no longer was able to communicate.

The compartment was full. A dark-haired young man sat facing Anton; his face was wry and it was highlighted by a pair of bushy eyebrows that possessed a life of their own. Two soldiers occupied the outside seats. They were leaning back against the compartment walls, their eyes closed. Tank Corps, Anton told himself, as he surveyed his companions for the journey to the East. Then he remembered that he should muster thoughts that were appropriate for such a momentous occasion: "The culmination of my dedicated service to Fuehrer and Fatherland...," "Joining the ranks of those who with their lives...." But instead he became distracted by his boots, which he had laced too tightly, and he wondered whether he should not try again to find a way of opening the window.

At long last the train began to move out of the station. Pressing his face against the window Anton waved to the little kernel of people that he was leaving behind. Helplessly he saw them grow more and more indistinct and then disappear as the train entered a tunnel. He leaned back in his seat and closed his eyes. Two nights, possibly even three. How immensely large the Reich had become, almost as large as the Empire of Charles V, on whose realm the sun never set. He regaled himself with a sense of pride for having been vouchsafed to participate in these momentous times, even though the war had still not been won, and already had claimed the life of Uncle Franz and so many others. All at once he found himself thinking about Judith. It had been weeks since he had last thought of her. He welcomed the return of her image, as one welcomes a soothing friend, and he longed to have her sit across from him in place of the wry-faced fellow with his bushy eyebrows. They would have so much to tell each other. The years had changed him, he knew that, and now

the war. When it was all over, he would go to Ireland and try to find her.

He was still thinking about her when, with an abrupt jerk, the train came to a halt. It was too early for them to have arrived in Schwechat, and besides they were still in the tunnel. A minute passed in complete silence. In the corridor the steam heater hissed, and someone was snoring in an adjoining compartment. Several more minutes went by and then the train lights flickered, grew dim, and went out. They were left in absolute darkness.

"For God's sakes, now what?" a voice with a Berlin accent complained.

"That's Austrian sloppiness for you." The voice came from the seat next to the corridor. "Every time we come down here something goes wrong."

"I'm going to see what's happened." The soldier with the wry face lit a match. In its light huge shadows swung back and forth against the ceiling of the compartment. Protecting the flame with his cupped hand, he got up and climbed over the two pairs of legs belonging to the Tank Corps men. He opened the compartment door and leaned out into the corridor. The blast of air blew out the light.

"Oh fuck it!" The wry-faced man tried to light another match, but standing where he did the flame died out as quickly as it had been lit.

"Don't waste all the matches," Anton admonished him. To his surprise he heard himself talk like his mother.

"Nothing works around here," one of the Tank Corps men complained. "Listen, buddy," he called out to the wry-faced man, "come back. I'm sure we'll get going in another minute."

But the train did not move. The time passed in utter silence. Someone sighed, and one of the Tank Corps men lit a cigarette. Without warning there was a burst of shouts and with a loud clang the door rolled open.

"Anyone for some Schnapps," a huge voice bellowed at them. "Come on, everybody, let's have a drink."

"Shit on that," the wry-faced man responded. "Why don't you go elsewhere to get drunk?"

"Fuck you, buddy." With another crash the compartment door rolled back and closed. Down the corridor Anton could hear the next compartment door being rolled open.

"Where are you two going?" the wry-faced man asked the soldiers from the Tank Corps.

"Crimea."

"Crimea. I suppose you don't have too bad a time down there." Then as an afterthought he added, "I bet we're having an air raid."

"Why do you say that?" Anton asked.

"Why do I say that? I say that because even you Austrians can't be that sloppy."

"An air raid. We'll be here all night."

"That's right, fellow, don't worry, it doesn't matter. So you'll get at the Russians one day later. D'you think they'll miss you?"

"I don't know."

"Well I do, and I'll tell you they won't, not one bit. The only thing that matters anymore is that we get through this war alive and all in one piece."

To Anton these remarks sounded defeatist, the kind his mother would make. He decided to change the subject.

"Where are you going?" he asked.

"Where am I going?" the wry-faced man echoed. "To a fucking hell-hole, that's where I'm going."

Anton wished that he could see the face that had just said that. He strained his eyes, but of course it was all pitch-black around him, with only the faint red glimmer of the Tank Corps man's cigarette. He felt disembodied and removed from everything that made him who he was. Talking became automatic, a series of reflexes that he came up with, and that no longer had anything to do with his true self.

"So you don't think Gomel is a fucking hell-hole?" the wry-faced man challenged Anton. "This spring it was Belgorod, and now it's

Gomel. Two fucking hell-holes. What a God awful place to die in."
His voice trailed off.

The darkness around Anton grew heavy, ponderous, and oppressive. He could hear the two soldiers from the Tank Corps whisper to each other, but to him it seemed that they were all being suffocated by the black void that surrounded them. Suddenly he knew he had to get out of the compartment. It was as if by performing that movement, by that simple act of volition, he would be able to preserve himself.

"Excuse me," he mumbled to the wry-faced man and got up. In the process of groping his way to the compartment door, his hand touched the other's knee. He felt something cold and metallic underneath the trousers, two rods that stretched out along either side of the leg. Surprised by this sensation, he jumped back. A quick shiver passed over his nape. He tried to return to his seat. In the process he stumbled and fell face down to the compartment floor. His leg was doubled underneath him and he was unable to get up. As his hand groped for the edge of the seat, he felt something small and soft lodged between his fingers. For an instant it seemed like a dead mouse, but then he was able to identify it as a cigar butt.

"My God," he thought, "I must get out of here. I will die if I don't get out."

"What the hell are you doing on the floor?" the wry-faced man called out to Anton. "Why can't you just sit still and take it easy?"

One of the men from the Tank Corps joined in. "My God, what a bunch of dumb kids we're getting into the Wehrmacht, and we're supposed to win the war with them."

Anton could feel a hand tugging at his wrist and helping him into his seat.

With a sigh he closed his eyes—not that it made any difference—and waited, his mind completely empty. Time passed; he may even have dozed off. At last the lights flickered on, and soundlessly the train moved out of the tunnel.

Soon there was Fischamend. Anton remembered Fischamend

from before the war. He had gone there with his parents for a week-end on the Danube; the river was so much broader there than at Vienna. Then too, many years before that, there had been an earth-quake in Vienna, and the papers had said that the fault was located at Fischamend.

The station was almost totally empty. Two forlorn girls, not at all pretty and wearing Red Cross armbands, pushed a wagon with cof-fee along the platform. Anton hated coffee. It left a strange dead feeling on his tongue. Besides, there was no way of opening the win-dow to ask them for some. The man with the wry face got up, stepped over the two pairs of legs belonging to the men from the Tank Corps, and left the compartment. Halfway out, he turned back to Anton.

"Coffee?"

Anton shook his head.

"That's all they've got."

"All right, I'll try some."

As he had expected, the coffee was terrible. It had ersatz milk in it, and was lukewarm and obscenely sweet. Nevertheless, Anton gulped down several mouthfuls.

After Fischamend, the train passed through a flat, ghostly land-scape. Here and there one could see a few clumps of trees, black against black, their forms rushing back to Vienna, as if something immense and nameless had put them to flight. An occasional horse, its black unmoving outline isolated under the moonless sky, the shape of a rare low-roofed farmhouse, wells, the poles of their pump handles grotesquely oblique like abandoned gallows, raced by in silence.

With the taste of the coffee grounds, Anton experienced a feeling that was completely new to him. It was one of intense loneliness and fear. Fear that enveloped him like the billows of steam he had watched in the station before leaving, fear that rose to fill every cor-ner of his compartment, every compartment of the train, fear that clung to him and to everyone on the train, fear that settled on his

clothes and across his face, fear that moved down his back and into his legs and paralyzed him, who sat erect in his seat, a metal coffee cup in his hand. He sensed himself being carried away from everything that he had ever experienced towards something new, unknown and dreadful. He wanted to cry for help, or at the very least, to tap the man sitting across from him smoking a cigarette. He wanted to tell him that he had suddenly become afraid. But of course that would have been totally impossible.

"Coward," he arraigned himself. "Stupid coward."

"The German soldier seeks war as his country's salvation, and embraces death on the battlefield as his greatest possible destiny."

Studienrat Waldstein's words reassured him. He repeated them to himself, over and over again, much as he had, as a boy, repeated his Hail Marys and the Lord's Prayer. In this manner he fell asleep.

He awoke to a gray morning. The man with the wry face was still smoking, and the two men from the Tank Corps had piled their knapsacks one on top of the other to form a table between them. They were playing cards with half-open eyes and heavy mechanical gestures. Anton looked outside. It was a flat, dull landscape: an endless succession of fields and farmhouses, with a mauve line of woods in the distance. They passed a little crossing. A man with a rucksack on his back, wheeling a bicycle, stood by the barrier. For an instant Anton could see his face, deeply lined, bitter and tired.

"We have already left Pressburg," the man with the wry face said.

"So this must be Slovakia," Anton responded. For him the country meant immense forests and gypsies: cheating, deceitful people. In the morning light he felt dirty and uncomfortable. He had to find a toilet. His hands were grimy and there were thick black lines under his fingernails. He rose from his seat and pushed his way into the corridor.

Three Air Force men were standing outside the compartment leaning out of the half-open window. Around them there was a rush of rattling and gasps of soot- and smoke-filled air.

"Would you believe it, she refused to tell me her last name."

"Forget it then."

"I know I should, but how am I going to find her again?"

"So you won't. There'll always be others. Let's just make sure we get back alive."

The Air Force man leaned out of the window. He spat thickly and in a long arch.

The door of the toilet would only open partway. Pushing his head in, Anton could see a soldier stretched out on the floor inside. His feet were wedged against the door, his back was propped against the wall of the toilet. As Anton tried to move the man's legs, he raised his head.

"Pigs...fucking pigs!"

"Can you get up, so I can use the toilet?" Anton asked. Of course it was hopeless.

"No son of a bitch will get me back there...shit on that." Anton tugged at the man. Obviously he was dead drunk.

"Fuck you, buddy," the soldier drawled. "Why don't you take off too? If we all took off, there wouldn't be no war."

Stepping out of the doorway, Anton turned to the Air Force men.

"I wonder whether you could help me. There is a man in the toilet."

"I wonder whether you could help me...." one of them repeated, imitating Anton's dialect. "Aren't we being polite, so typically Viennese." He lapsed into song: "*Wien, Wien, nur du allein, kannst stets die Stadt meiner Träume sein*—Vienna, Vienna, you alone can be the city of my dreams...." The others joined him in his laughter.

"I suppose you are looking for the coffeehouse. Well, I must regret to inform you that this train does not carry a coffeehouse."

"Fucking Germans," Anton muttered to himself and headed back to his compartment, lurching from side to side with the swaying of the train.

The countryside remained unchanged. Hills, small villages with low whitewashed houses, each cluster surveyed by a church whose steeple reflected the full morning light like cast iron. At Prerau the

men from the Tank Corps left the train. Loaded with khaki sacks, two privates struggled into the compartment. Neither of them seemed much older than Anton.

"What is Gomel like?" Anton asked the wry-faced man, who had woken up and had pulled a salami and a loaf of bread from his sack.

"Want some?" He offered Anton a slice of salami on the blade of his knife. He returned to the boy's question.

"Thank God, it's been pretty quiet there lately, although the partisans are beginning to give us a lot of trouble." He chewed and shook his head. "God, how I hate those bastards. They're like lice: no sooner does it get dark than they crawl out. One day we kill a dozen, and the next day there are two dozen more. No one knows what to do about them."

He motioned to Anton with his forefinger and bent down, his mouth close to the boy's ear.

"Do you know what they do to one of us when they capture him? he whispered. "They cut off his balls, and his prick, and then they string him upside down, so that he bleeds to death."

Anton shivered. "But why can't we kill them off?" he asked.

The wry-faced man shook his head sadly. "You didn't hear me. We kill ten, twenty, fifty of them, we round up an entire village and make an example of everyone in it, but it doesn't do any good; there are always more. I tell you, as far as I am concerned, I'd just as soon have this war over with." He paused, and thoughtfully cut himself another slice of salami. "By the way, where are you going?"

Anton told him.

"I hear it's not such a bad place, once you get used to it. But I'll say it again: I wish this fucking war was over. I don't care how it ends."

"But we have practically won it."

"Maybe, but some days I can't see the end of it all. Perhaps it's because I've been in Russia far too long."

Villages and towns passed by, undistinguished, with strange names that were pronounced between one's teeth and in the back of one's throat. The rain started and stopped, and at one time the train

came to a halt just outside a fairly large town. It remained there long enough for Anton to feel as if he could share its life. A woman in a black wool kerchief going to the back of her house to take in the washing that was hanging on the line, a barn door opening and closing, school children skipping, hand in hand, down to the train siding, followed by a dog that wagged its tail at them. Common sights that made Anton long for the life he had left behind.

"I will never see this village again," he told himself, "and even Vienna, its life there is going on without me, the days pass in preordained ways, while ahead of me there is only the unknown."

When night came once more they were in the mountains. The two privates had started to play cards, and judging from the pile of banknotes at their sides, the stakes were incredibly high.

The wry-faced man began to talk about women. Anton listened attentively, too attentively, for the man stopped in the middle of his story and grinned.

"Say, have you ever been with a woman?"

Anton was proud to be able to nod affirmatively. But the wry-faced man was not convinced.

"You sure?" he asked, but then he resumed recounting his adventures with a Bavarian girl. It all took place during the summer before last, when he was on leave from Belgium.

"Those were the days," he sighed. "That was before Stalingrad, and before all those fucking air raids started." He went on a bit. A few minutes later Anton fell asleep.

Shortly after dawn he was awakened by the wry-faced man slapping his shoulders.

"Hey, buddy, wake up, this is your station."

Half-asleep, Anton grabbed his bags, and in the blurred light stumbled out of the train. Before him was a low brick archway. "Auschwitz–Birkenau" the sign read, and above it in bold letters: "Freedom Through Work."

The cold morning air awakened Anton. He tossed his bags over his shoulder and adjusted his fatigue cap.

At the far end of the platform he encountered an S.S. Officer. He saluted smartly, and with a click of his heels announced himself: "Heil Hitler! Private Anton Kermauner reporting for duty, sir."

"So you learned not to be a fool," Judith said. "And your father, Anton, what was he?"

Anton's face turned sallow, as if its youth had been washed away.

"We must forgive him. He could not have foreseen the demons his philosophy would unleash. He saw Hitler as the man who would revitalize not only Germany but the entire world, would sweep away the malaise, and make life meaningful to those desperate masses for whom each day was a drudgery. So he sold his soul to him. Can you forgive a disillusioned old man?"

"Can I? Or should I? Which is it?"

Silently he spread his hands, palms up, towards the tear-stained young woman who slowly shook her head.

"So then, you are telling me that there is nothing more to be said, nothing more I can do about it," she said. "If I cannot forgive, then I have to forget, and when the occasion demands it, I have to turn deaf and blind."

"Life is one compromise after another."

"Is that how you see it?"

"Yes. We are imperfect men and women living for all too short a time in an imperfect and uncertain world."

"A part of me would like to accept your compromise. Another part screams and struggles against it."

Anton reached for her hands, and drew them towards him.

"I have known those two Judiths for many years now," he said, "and I love both of them, believe me."

"I love you too," she said simply. "All my life I have loved no one but you."

He leaned forward, placed his fingers on her cheek, and kissed

her, a long kiss which to an impartial observer would hardly have appeared as brotherly.

"Let's not talk about it anymore," he finally said.

Judith looked at him. Strands of blonde hair fell down his forehead. That is how he had looked when he sat across the aisle from her at school. She permitted herself to be overcome by the comfort of her memories.

"All right. I'll try to forget," she replied. "I know I have to or I could not stay here one more day."

When they left the coffeehouse it was dark and the streetlights had been lit. A fine rain was falling, little more than a mist. With their arms around each other, they slowly walked down the Ring. Anton steered the course to a *Wirtshaus* in one of the narrow side streets. There they shared a simple dinner: hot sausages with dark bread and beer. The pub was crowded and a covey of men stood at the bar, exchanging loud, abrupt phrases in heavy Viennese dialect. At one point they turned to look at Anton and Judith. There was a moment of silence, then a burst of coarse laughter. Judith looked around the establishment, afraid that all eyes were on her. But the days when her elegant clothes stood out amidst the drably dressed women of the city were over; the outfits she selected for her classes were inexpensive and intentionally subdued.

The group of men at the bar burst into a song:

"Im Prater blühn wieder die Bäume..."

"In the Prater the trees bloom once again..."

"Keep quiet, Toni, will you," one of them said in a loud voice. "You are so off-key you sound castrated."

"Oh, shut up!" A burst of guffaws came from the bar. At the adjoining table a heavy elderly woman in a green and black-braided Tyrolese hat looked at Judith, giggled, and leaning sideways, said something to the two men sitting on either side that Judith could not make out. Then as if upon signal, the three of them joined into the song, swaying in their chairs in time to the tune:

"Im Grinzing blüht wieder der Wein..."

"In Grinzing, once again blooms the wine…"

Anton smiled at the interchange.

"Our typical Viennese," he said. "They don't care what has happened to Austria. The Occupation, unemployment, our lack of incentive, it's all the same to them. They have their beer and their sausage and they are happy. At worst they'll grumble a bit. All of us Viennese are born grumblers."

"I know," said Judith in a bitter tone. "That's what my father used to tell me: they are grumblers, but they have hearts of gold." All at once she was overcome with horror. She turned to Anton.

"Ordinary people like those people over there—the bureaucrats, the small officials, the record keepers—they were the most guilty. Much more guilty than those who committed crimes though hatred or passion."

"You promised me you would try not to think about any of this."

"I am sorry. There are times when I can't help it."

"You are forgiven," Anton said.

✦19✦

ALL THROUGH WINTER Anton received regular food parcels from Vienna. Usually there was liverwurst in them, several sticks of hard salami, cheese, pastry, and even a few bars of chocolate, most of them not nearly as good as before the war, but still quite tolerable.

With these delicacies spread out on his bunk, Anton invited Paul and Helmut to join him. Paul's family lived in Doebling, the most fashionable suburb of Vienna, and they regularly sent him one or two bottles of wine. Helmut, who was quartered in the adjoining barracks, came from Linz. The previous summer his family had been transported into the Saar where his father was working in a steel factory. After they had been bombed out they had stopped sending packages to him. Nevertheless, Helmut always managed to secure for himself an extra pack of cigarettes, so that he too could contribute to a reasonably pleasant evening.

"When this is all over," Helmut said, a few weeks before Christmas, "I am going to take you both to the Adlon and treat you to a dinner the likes of which you have never seen: Champagne, caviar, and the most fantastic wines you can imagine."

He bent over the stick of salami on the bunk and sliced it with his pocketknife. Thinly, so as to make it last longer, one slice of salami for each slice of black bread. The black bread at Auschwitz was

excellent and was baked fresh every other day. Since it was so close to Christmas, Paul had received three bottles of wine, and everyone was drinking more than usual.

"This place is beginning to get me down," Helmut complained. "At first I thought I'd get used to it…but it doesn't look as if I will."

"What I don't understand is why we don't simply shoot them as soon as they get off the transports," Paul wondered. "None of them are doing anything useful around here."

"It would be simpler, wouldn't it?" Anton agreed. "You know, it's all beyond me." He reached for the bottle of wine and refilled his cup.

"Wait until tomorrow," Paul admonished him. "You'll have the worst hangover you've ever had."

"I can't have any more," Helmut announced, looking at his watch. "I'm scheduled to help with roll call." He sighed. "I tell you guys, is it cold out there. Every morning we lose one or two dozen of them." He shrugged his shoulders and gathered up his cigarettes. "But what can one do? I just wish this fucking war were over."

"By the way," Paul asked the other two, "what do you think of Mueller?"

Mueller was the new S.S. Group Commander. He had arrived but a few days before, and although no one had dared discuss him up to then, the wine was loosening everyone's tongue.

"You know what I think of him," Helmut replied. Anton became worried about the tenor of the conversation and looked over his shoulder. At the far end of the barracks a group of soldiers sat in front of the radio. The music was so loud that there was little chance of being overheard.

"He is a bastard," Helmut whispered, "a dirty bastard…don't you guys agree?"

Anton nodded, and he remembered his father's parting admonition. Yesterday for no apparent reason, Mueller had set his dog on a woman. Half-dead from starvation she had no chance. Her screams had been drowned out by the growls of the dog.

"It's no way to fight a war," he said, equally softly, and took a large swallow of wine. He looked at his cup, and without emptying it, placed it on the windowsill behind his bunk.

"But what can one do?" Anton continued, lifting his eyebrows. No one replied. He turned and reached for the harmonica under his pillow. Since arriving at Auschwitz he had learned to play it passably well, practicing much of his spare time.

"Hey, you guys, I'm going to take a walk."

He threw on his fur-lined jacket, laced up his boots, and left the barracks. Outside it was cold and still: a moonless winter night. Behind a high and immensely long barbed-wire fence lay rows of low barracks, each topped by beads of dim, forlorn lights. On Anton's right the railway station was outlined by a row of searchlights: fiery, white ribbons that washed its walls and cut through the night. Further on, towards the outer limits of the camp, he could make out the red glow of the crematorium; small flames flashed up briefly from its chimneys like a tethered animal writhing to escape into the night sky.

It was cold all right. Stamping his feet Anton walked down the stony-hard path that led from his barracks towards one of the gates in the barbed-wire fence. When he went as far as he could, he pulled the harmonica from his jacket and began to play "Träumerei," a dreamy and longing melody, as little at home at Auschwitz as he was.

"Schumann."

A man's voice came across to him from the other side of the fence. Anton looked up. The searchlights were making their rounds, crossing each other and lighting up the electrified wire so that it glistened with a life of its own.

Before Anton had time to make out any more than the outlines of the prisoner who had addressed him, the lights moved away.

"Can you play something else?" the man asked. Anton complied with Schubert's "Serenade."

"Softly, fleeting, through the evening, seek my songs for thee...."

While Anton played the voice on the other side hummed the

tune. The searchlights returned along their pre-ordained route, crossing and re-crossing the fence which separated the two men.

"Sometimes, for just a moment or two, one can forget," the voice said after Anton had finished. Too cold to remain in one place for long, Anton stamped his feet and knocked the moisture out of the harmonica.

"The war is hard on all of us," he replied, pocketing the instrument.

He knew there was much more that he should say. At first, the right words would not come to him. He knew the man behind the electric barbed-wire fence suffered, and that in all likelihood he was doomed and would soon die and become part of the flames that tore at the sky above the camp. But he too was unhappy at Auschwitz, and he too faced the likelihood of death. These facts were immense and unalterable.

"Are you afraid?" he asked the man.

"All the time. Not of dying…of pain. I am afraid of being tortured." There was a pause, and Anton heard the shuffling of feet on the other side of the fence. Then the voice said: "You are young. What about you?"

"Soon after I arrived I decided my time here didn't matter, that it was no part of my life. Does that make any sense?"

"Certainly. You have managed to separate what you feel and do and say here at Auschwitz from what you would feel and do and say at home."

"That's right. And it helps being totally removed from my normal surroundings and from the things that formed me—"

"Your conscience."

"Yes. My conscience." He remembered his father's parting admonition. "The habits that used to guide my decisions."

"So you see yourself as unaccountable and reprieved from all responsibility?"

"For the time being, at least. Until I return home."

"Where is that, if I may ask?"

"Vienna."

"Ah, yes. A beautiful city. God willing, I might be able to see it once more."

Shaking his head, Anton walked away from the electric fence. He was uneasy. It was as if an important part of himself was imprisoned, a part that he feared to set free. With slow steps he returned to the barracks. The frozen ground crackled under his boots, while in the distance a high-pitched drawn-out whistle pierced the night. Another transport train had arrived at the railway station.

Back in the heated barracks, Anton sat down on his bunk and unlaced his boots. One boot was off when he stopped.

"Hey, Paul," he called to his companion who had been sitting on the edge of his bunk writing a letter, "listen, I must tell you something."

Paul put down his pen and looked up.

"Yes?"

"You know, I was just over there by the fence, playing my harmonica, and...." He stopped, unable to put into words what he had experienced a short time before.

"Yes?" Paul repeated, waiting for Anton to continue.

"Oh, I don't know...I don't know what I want to say...."

Anton's voice trailed off, and he resumed his other boot.

"If you don't know what you want to say," Paul grumbled, "don't bother me." And with this he resumed his letter.

✦20✦

"Sooner or later, all of us Viennese will have to confront our past: truthfully and unretouched. Until we do so, we will not be able to obtain absolution."

Willi and Judith were sitting over beer at the Steindl, a small *Wirtshaus* in the vicinity of the University, and Judith had just finished recounting the conversation she had overheard between the two students.

"Look at Germany," Willi continued. "They have made a clean breast of their nation's schizophrenic personality. They are attempting to undo, to whatever extent it is possible to undo, the harm that they have caused, and they are teaching an unvarnished history to the young generation with the moral: never again. Not us Austrians. We prefer to believe that we were the victims of German aggression, and that whatever crimes were committed during the Nazi years were solely the fault of Germans." He paused, took a long draught of beer, and wiped the foam from his upper lip with his forefinger. "As if we Austrians didn't enjoy locking steps with our Germanic brethren. It made us feel bigger, more important, more powerful."

He must have enjoyed the sound of his last sentence, for he looked expectantly at Judith, who nodded in appreciation.

"Have you ever confronted an Austrian with a few of the so-called excesses that were committed in this country during those seven years?"

"No."

"Of course you haven't," Willi said. "Well, I have, on several occasions. At first my Austrian friend will be all smiles, much as if I had belched, or had been guilty of some other social indiscretion. Then, when I persist, he will try to change the subject to something innocuous and less unpleasant. Finally, after everything else fails, and I still persist in my questioning him, he will become nasty and belligerent. He will accuse me of being a Communist or some type of pervert. He might even raise his fists and threaten to let me have it. No, we Austrians prefer to spend our days in a rosy fairytale world of bonbons and waltzes." He sighed and brushed back a shock of red hair. "What are we going to do with ourselves? We are a bizarre bunch of people, especially us Viennese. I wish to God we would grow up."

He stared into his mug, then turned to Judith. "Of course, all this intellectualizing doesn't help you one bit."

"What does help?"

"I'll tell you what helps: try to remember that you have friends in this city. Real friends upon whom you can rely: Anton, me, perhaps even Ursel and Grete. We have opened our circle for you, and we will never again expel you. That you can be sure of." He got up. "Would you like another beer?"

"I think so."

"Good. Remember, this is my treat."

He went to the bar and thrusting his elbows on the counter ordered two mugs of beer.

That night Judith had the most vivid dream. She was in a column of people, men and women, and she was walking in an immense dark plain with her hands tied behind her back. Her mother and father were in front of her, she could see only their backs. She did not know where everyone was marching; all she knew was that she was about

to be killed. She tried to break out of the column, but two men on either side would not permit her. She stopped, and the people in back pushed her forward. As she stumbled and fell, unable to use her pinioned hands to break her fall, she screamed and awoke.

→21←

C OULD YOU PLEASE explain what is going on between you and Judith?"

It was Ursel, and she was sitting with Anton in the cafeteria of the University Clinic for Internal Medicine. Anton had just come from a lecture on Pharmacology and had stopped off at the clinic to visit with Ursel, who was in the process of writing up the medical history of a patient who was being admitted to the hospital. It was a complicated case, she told Anton, a middle-aged man with simultaneous liver, kidney, and heart failure, and she tried to clarify for him the reasoning that lay behind the various provisional diagnoses. Seemingly out of nowhere she came up with her question.

"She is the sister I never had," Anton replied gravely, but he knew that his response was a trifle too facile for Ursel's liking.

"If she is your sister, then who am I?"

"My lover."

"Your lover, whom you take to bed whenever the opportunity presents itself. With unpredictable results." She laughed, then added. "I worry about you. I think you are on the verge of falling in love with her. You know of course that if you do, it will be all over between us. Remember it is always easier to turn a sister into a lover than a lover into a sister."

She stopped and waited for Anton to respond. He, in turn, reflected on the advantages and disadvantages of being honest with Ursel.

"At least tell me what you find so attractive about her? If it's her long blonde hair, I promise I will let my hair grow out, even though it will take me much longer to get ready in the morning."

"Of course it's not her hair."

"Then what is it? Those soft, wistful eyes? Generations of persecution suffered and endured?"

"You have a point there. In a way I expect her to have a unique wisdom and insight which can only come from suffering. But there is more to it than that."

Anton reflected. A white-gowned waitress with a slightly soiled white cloth wrapped around her hair placed a tray in front of two physicians at the other end of the cafeteria; judging from their scrub suits, they were surgeons who had just come out of the operating theater. What Anton was attempting to put into words was the mystery that he felt whenever he was in Judith's presence. He said so to Ursel.

"Are you telling me that it is this mystery of hers which makes her so attractive to you?"

"Could be."

"So then, you have a mysterious and sexually attractive sister—prospects of joyous incest."

"Come on, Ursel, you are making fun of me."

"I am trying to keep things on the light side, because if I didn't I might burst into tears right here, in front of those surgeons. Look, we've known each other since we were children. I hate to sound mundane, but I would like you to tell me what the future holds in store for us."

An image of a well-defined and circumscribed future with Ursel arose within Anton. They would be two physicians practicing in Vienna, or perhaps he would go into research, as Professor Powolatz had suggested to him, and Ursel would open an office in internal

medicine. Since both came from good families and had good con-
nections they should have all the staples of a good, comfortable life: a
beautifully furnished villa in Döbling, an interesting circle of friends,
vacations in Italy, Greece, or America. Many would have relished
such a future, but not Anton.

"We could have a good life," Ursel said, echoing his thoughts.

"I don't think this is what I want."

"What do you want?"

"I prefer risks, uncertainties. An opportunity to prove myself.
This may sound bizarre to you, but I don't think I deserve a safe and
contented future." With a couple of bites, he finished the pastry on
his plate. "You see, I can't get rid of my past. Like a wizened old
gnome it keeps popping up whenever I am most happy."

"Even when you are with me?"

"Particularly when I am with you."

"That explains it." She laughed and put her hand on Anton's
wrist. "Don't you know: *Glücklich ist, wer vergisst, was nicht mehr zu
ändern ist*," she recited. Happy he who can be resigned to grim reali-
ty.... "You cannot go around in sackcloth and ashes for the rest of
your life because of the small role you played during the war. Every
day I run into people who did far worse things than you did. Like
Heinz. I am certain the man eats well, sleeps well, and is quite unfet-
tered in bed."

"Heinz is a piece of trash."

"That might be the case, but in my opinion you have a conscience
which is much too finely honed for your own good."

"I need to make amends."

"To whom? The Jews?"

"Perhaps."

"Is that why you took Judith to the opera, and went with her to
the synagogue? Is that your way of making amends?" Her mouth
tightened and two vertical creases appeared between her eyes.

"I don't know." And in truth, he didn't.

"Then think about it. Better sooner than later."

Anton promised he would, but at that moment it was easier for him to talk to Ursel about the various diseases that can cause liver, kidney, and heart to fail.

A few nights later, Anton was in Ursel's apartment waiting for her return. She was on call in the clinic emergency department and had phoned to let him know that she would be late, and that he did not have to wait for her but could have dinner on his own. When she finally arrived it was nearly midnight, and she looked tired and bedraggled.

"How did it go?" Anton asked. Ursel tossed her jacket on the bed.

"We were swamped: a couple of men with heart attacks, and then they had an old woman who had been run over by a streetcar. She was absolutely mangled, but I think she will make it. Have you eaten?"

"No. I wanted to wait for you."

"That's nice. I'll wash up while you open a bottle of wine, and then I'll prepare something quick for the two of us."

Later, over a simple meal of hot sausages, black bread, and a bottle of red wine, Ursel looked more relaxed.

"I am working my ass off," she said, "but I am enjoying it. For one, I am quite good at what I am doing. I suppose I have my father to thank for that: the right set of genes. Then also, I have the assurance that I am doing some good. Wait until you start your clinical years; it's a great feeling."

Anton nodded. Ursel read the abstraction in his face. "Na, Anton, what's on your mind?"

"Nothing much."

"Come on. Fill up your glass and tell me."

So Anton had another glass and tried to put his thoughts into a sufficient order to be delivered to Ursel. That wasn't easy.

"There's a phrase that keeps going around in my head. A phrase that is like a verdict. 'The bureaucrats, the small officials, the record keepers, they were the most guilty.'"

"What did you say?"

Anton repeated the phrase.

"Oh, for God's sakes! Where did you hear that?"

"That's what Judith says."

"She would! That woman is beginning to get on my nerves. I can empathize with all that she has experienced, but she is impossible. Depressing. I wish you wouldn't see so much of her." She refilled her glass and Anton's.

"She has so few friends. She needs me."

"Yes, yes…I suppose she does. I wonder whether it is good for her to stay in Vienna. She should go back to America, or maybe to Israel. You know I just heard that the Freis are going to emigrate to Israel."

Dr. Frei was a Jewish physician who had been a good friend of Ursel's father. Before the Anschluss he had played the cello in a quartet with him—Brahms and Schubert. When Hitler took over, he and his family managed to escape to Sweden, where they were interned for the duration of the war.

"Perhaps we should introduce her to the Freis before they leave Vienna. It would do her a lot of good if she were to establish some Jewish connections."

Anton did not respond. Ursel made Judith appear as if she had contracted an illness that needed treatment. "Look," she said, "I am ready to go to bed. Would you like to join me?" Glass in hand she got up. Anton remained at the table; his chin rested on the palm of his hand.

"I still see his eyes," he said.

"Whose eyes?"

"The boy I killed. I feel as if at that moment I killed whatever was good and innocent in me."

"Stop it, Anton, you are being overly dramatic!"

"I never told you about the boy."

"Of course you did. Quite some time ago. Please, stop rummaging and put all that aside. It's over and done with."

"There is more."

"I know. You have a bad conscience about that pianist."

"Erika."

"You were a child; and you were intensely jealous of your uncle."

"I destroyed her life."

"Nonsense. She is probably somewhere in America, playing her little heart out."

"We don't know that. She disappeared."

"That was the best thing for her to do in those days."

Anton remained silent. He stared at his empty glass.

"There is something else."

"Tell me."

"I wish I could. I don't have the strength to. It just sits and smolders within me."

"Come on, come on, you can tell me. I swear I won't repeat it to anyone."

Anton shook his head, and despite urgings on the part of Ursel remained silently hunched over the table.

"I don't know what I can do for you," he murmured to himself.

"What did you say?"

"Nothing."

Ursel went to the wardrobe, undressed, then extended her bare arms towards him. "Please, darling. I want you. It will be sweet between us."

Anton took note of her pale, languorous body in the same way as he took note of the mosaic of books that crowded the bookshelves of pine boards and brick, the framed picture of Alpine mountains surrounding the Hallstätter See, and the slightly open window through which he heard the hiss of the sparse traffic on the rainy cobblestones of the Alser Strasse. He downed the wine, undressed, and climbed into bed next to Ursel.

They held each other, and that was that.

The winter was long and bitter, and the news from the front became increasingly desperate. Retreat followed retreat, so that the men

found it easier not to mention the war, even though it weighed on their minds much of the time.

Paul had become openly pessimistic.

"The only way we'll get out of here will be to be sent to the front," he complained to Anton. "As for me, I don't think I'll be as resolute as the Fuehrer would like me to be."

Anton no longer thought about the war. In fact he had ceased to think about many things that at one time had been important to him. Without being aware of it, he had stopped writing home. It was not until he received a desperate telegram from his parents that he realized that at least two months had gone by without a letter from him. He had also stopped thinking about Heinz, or Ursel, or about any of the persons who had filled up the canvas of his life in Vienna. They were gone now; in their place there were the trivialities, the annoyances, and above all a constant fear.

In the prison camp typhus had become rampant, and by spring, when the epidemic had not subsided, the number of suicides increased by leaps and bounds. Each morning columns of bodies were found stretched out along the electric barbed-wire fence. To prevent this from continuing, a ditch was ordered to be dug around the camp. With guns slung over their shoulders, Anton and Helmut supervised the work.

Dressed in their flimsy and ridiculous blue-and-white-striped uniforms, the prisoners moved through their tasks, working so slowly that it seemed their bodies had congealed in the sub-zero weather.

"Time means nothing to them," Anton muttered through his teeth, and prodded the laggards with the butt of his gun.

"I don't see why the fuck they have to dig that ditch," Helmut said. "If they want to kill themselves, let them do it with or without a ditch."

Helmut was in a bad mood. Ever since he had improved his typing he had managed to be assigned to one of the compound offices. Today, however, the high priority of the new ditch pre-empted his usual task and forced him to work with the prisoners.

"Goddammit," he called out to Anton, "I hope I don't catch typhus. They should gas the lot of them, that'll take care of the epidemic." He swung his gun at the *Kapo*. "Come on, you swine, you make those bastards work faster or I'll cut your balls off."

The *Kapo* responded by swinging his club at the hindmost prisoners, but even the dull thud of his blows did not help matters. All it managed to do was to bring out a succession of groans.

All at once there was an outburst of crying, a child's voice—long, whimpering cries, each higher pitched than the preceding. Anton turned to find a small dark-haired boy sitting alongside a mound of mud. His hands were dirty and he was rubbing his eyes.

He walked over to him and bent down.

"Hey there, little guy, what's the matter?"

But the child continued to wail implacably; his cries prevented a single word of explanation. Anton motioned Helmut over. The *Kapos* could supervise the work detail on their own; this was more important. But Helmut was no more successful than Anton at finding out what made the child cry.

The wails became louder and louder and threatened to dissolve what little strength was left in the thin, pale body. When they turned into a barrage of shrieks, Anton became angry.

"For God's sakes," he shouted at the child, "now shut up, and tell me what's wrong."

But there were more shrieks. Two wheelbarrows pushed and pulled by women prisoners rolled by. None of them turned, for wails and shrieks were commonplace within the confines of the electric wire.

"If you don't shut up, I'll slap you," Anton shouted at the boy.

When his words had no effect he bent down and shook the frail form. The force of his movements caused his woolen scarf to slip off his shoulders into the mud. As he bent down to retrieve it he was suddenly filled with an immense and overwhelming hatred of the shrieking child, the mud, the disease, the starvation, and the suffering into which he had become immersed. With a few quick movements he wrapped his shawl around the boy's neck. He pulled the

ends tightly, and noted with gratification that the shrieks ceased and that even the wails grew softer although they did not stop completely. Again and again he tugged at the ends of the scarf. A deep, surprisingly deep, gurgle came from the child's mouth, then a small trickle of blood and saliva. Without warning, the thin form fell backwards into the mound of mud. Losing all sense of time Anton continued to pull at the ends of the scarf.

"'All right, Anton, you can let him go now. You've fixed him for good, that's certain."

Helmut said nothing more. In fact, he scarcely gave the dead boy more than a glance. Anton unwrapped his shawl and lifted the body. Lying between his hands it appeared little changed from before—a trifle more crumpled perhaps, but the material felt the same: soft, warm, blue and green stripes woven against a black background. He kept staring at it, feeling its comfort and softness between his fingers. Helmut patted his companion's shoulder.

"Listen, buddy, don't worry. Just a Jew kid. He would have had to go anyway."

Anton folded the shawl. Even though it had clouded over and the wind had started up again, he could not bear putting it back round his neck. Instead he stuffed it into the pocket of his overcoat.

"I'm sure you're right," he replied. "Some Jew kid...."

"Come on, now, let's see what those bastards are doing. Without us over them they are probably sitting on their asses."

Indeed there had been little progress, and at the rate with which work was proceeding, it would take the prisoners at least two more weeks to finish.

That Sunday, Anton attended mass. It was the first time he had done so in three years. The small hall was only sparsely filled, and afterwards the priest had sufficient time to listen to his confession.

"Father, I have sinned...."

Sitting in the dark wooden box, Anton told him about the wailing boy, and how it had come about that he had strangled him. When he had finished, the priest spoke softly:

235

"Tell me, my son, is there anything else you need to confess?"

"No, Father."

"Good." The priest made the sign of the cross over him. "Remember, my son, when we do good, we do so because of ourselves. When we commit evil, we do so in spite of ourselves."

Rising, he blessed Anton in the name of the Father, the Son, and the Holy Ghost.

That evening Anton wrote a letter to his parents. It was the first in over a month. "Dear Papa and Mama," he began. "I am very well and our days go by uneventfully, one after the other. So far we have seen little of spring."

He was unable to continue. He found it impossible to set down meaningless words, phrases that ignored the reality he perceived. He assured himself that it didn't matter anyway, for were he to describe everything he saw and did, the letter would certainly be intercepted by the censor, and he would be in serious trouble.

He put down his pen and tore up what he had started. What a relief it was to play the harmonica. Over the last few months he had become so proficient that the S.S. men came by to listen. The evening wore on and with the assistance of Paul's wine everyone became drunk. Shortly after nine, Schuller dropped in. He was in a jovial mood and sat down on Anton's bunk.

Encouraged by his presence and by the enthusiasm of his not inconsiderable audience, Anton played through his entire repertoire.

"*Es wird ein Wein sein, und wir wern nimmer sein, es wird schöne Maderln geben, und wir wern nimmer leben,*" Anton played. "There will be wine, and we shall not be here, there will be pretty maidens, and we shall not be alive." Schuller turned to another S.S. officer.

"Those Viennese," he laughed, "they are so unashamedly sentimental."

Ursel stretched in her sleep and reached for Anton. Her hands were

cold. Anton got out of bed and closed the windows. The rain had stopped and the street noises had subsided. Dressed in nothing but his shorts, he sat at the kitchen table, head between his hands.

In spring Anton was assigned to the convoy registry. He had a small table set up on the railway platform, behind which he sat, registering arrivals. The table was old and its legs were uneven, so that it would rock back and forth as he was writing. He stuffed a wad of folded newspaper under one leg, then under another, to no avail. Whatever he tried, the table wobbled obstinately, so that there was nothing left for him to do but become resigned to it and proceed with his work. In front of him there stretched an immense line of deportees from all over Europe. His duty was to question them and to obtain from them the information required to complete the registry. The deportees were starved, exhausted, ill, dying. Some were still determined to retain their identity; others had resigned themselves to becoming disembodied voices. For some the German language was yet another barbed wire that held them imprisoned, for others it was their mother tongue that had turned against them.

"Your name, please," Anton said.

"Moritz Weinberg."

"Moritz Israel Weinberg," Anton corrected.

"That's right, I keep forgetting."

"Where from?"

"Krakow."

"Krakow," Anton repeated. "Your age and profession?"

As he wrote down the responses, Anton kept reminding himself that his demeanor must remain irreproachable, and that his work must be done to perfection. It was a matter of filling his mind with every conceivable detail, with irrelevancies upon which he could dwell, which he could enlarge to fill his entire horizon and block out everything else. There it was again, that confounded wobble. Anton

winced as he wrote down the deportee's Krakow address. What if he were to ask one of the S.S. men for a new table? There must be a better one somewhere in the camp. It was maddening.

Anton looked up. The line was immense: this morning he would be registering arrivals until well after noon. He forced his handwriting to remain neat; the characters stayed well-formed hour after hour. A gust of wind folded the page and smudged the ink. He must do something to weigh down the other page. A stone perhaps. Actually, what he really needed was a paperweight. Perhaps he could ask for one at the Central Office.

He hardly ever looked at the person who stood in front of the table holding onto what was left of his belongings. Only when a suitcase hit one of the table legs and set it rocking did Anton become aware that he was not alone. Sometimes, however, and often it was only by accident, he saw the person who stood in front of him, could even smell his perspiration or the stench of urine and feces that clung to his clothes. He would then quickly reassure himself of the chasm that separated that individual from himself by reminding himself that the face across the table did not count, that it was not a German face, not that of an Aryan but that of the enemy. Indeed, for what other reason would that person be at Auschwitz, waiting in line, standing on the opposite side of his table?

"Next," he called out. "Your name, please."

The hissing of steam from the recently arrived locomotive drowned out the reply.

"May I have your name again."

"Rosa Sara Dreifuss."

Sometimes the shouts of the S.S. men behind Anton interrupted registration.

Gunther was on duty that day, and he was uncivilized.

"You fucking, filthy pig, I'll show you why you're here."

Without looking up from his book, Anton could hear Gunther's whip, a deep whistle, and a heavy wet splash that elicited a cascade of shrieks and sobs.

"Left, fuck you, left, I said—right, right."

Left was to the crematorium, right to the barracks behind the electric fence.

"Left, yes, that's what I said, you don't look like you're good for anything."

Again there was the whip; Gunther loved to use the whip, and it forced another eruption of screams.

The noise caused Anton to make a mistake, and he corrected it, using the ink eraser. His work must be irreproachable, he repeated to himself, absolutely irreproachable.

Then there was the cold, crystal-clear morning when fresh snow covered the barrack roofs and draped them so festively that they acquired a strange beauty: black and white, a study in India ink.

Anton was sitting behind his small, wobbly table when the transport from Terezin unloaded. Multi-colored droplets of humanity, stumbling, falling, pushing their way from out of the barred cattle cars, being forced into a line along the platform that led towards Anton.

"Your name, please."

That day it was Schuller who was sorting out the arrivals.

"Let's hurry," he called over to Anton. "I want to be done by noon."

The camp was overcrowded anyway, so most of the arrivals would be loaded into the small squat trucks that waited for them at the end of the platform and took them to the crematorium.

"Left, left, left," Schuller directed, but unlike Gunther he was a decent man and hardly ever used the whip.

"Your name, please."

The sun had come out, and cast a weak, milky light across the immense snowy plain. The ground glistened, and icicles dangled from the edge of the corrugated iron roof.

"Berger, Dr. Herrmann Berger…I am sorry, Dr. Herrmann Israel Berger."

"Where from?"

"Vienna."

"Your age and profession?"

"Forty-nine, physician."

A chill ripped into Anton and he looked up. In front of him, haggard but still erect, his face sunken, gray and unshaven, stood Judith's father. A leather briefcase bearing his initials embossed in gold was under his arm. Behind him, huddled in a shawl that Anton recognized, for she had carried it with her that day he and Judith had their Danube outing on the *Linz*, stood Judith's mother.

"For God's sake, what are you doing here?" Anton asked.

"We have come here as guests of the Third Reich," Judith's father replied bitterly.

Anton reached for the pistol that lay on the table. The handle was cold and hard, seemingly implacable. He felt there was something he had to say or do.

"We have had a cold winter," he finally managed.

"For us, it doesn't matter anymore," Judith's father replied.

Judith's mother coughed. A few isolated coughs at first, then more and more rapid, like bursts from an automatic pistol.

"How are you, Mrs. Berger?" Anton asked.

Judith's mother shook her head. She opened her mouth wide, as if about to scream.

"Dreadful, dreadful, so dreadful." The words came out in a whisper, softly enough to be drowned out by Schuller's commands: "Left, left, left, left …."

"I don't know what I can do for you," Anton said.

Judith's father shook his head.

"I understand…completely. Tell me, Anton, what will happen to us?"

Anton was spared an answer.

"Come on, Kermauner," Schuller called over to him. "What's holding you up? We don't have time for a little chat."

Anton motioned the Bergers to move on. Putting his arm around his wife, Judith's father walked up to Schuller.

"Left," the S.S. Officer called out to Judith's mother, and then motioning to Judith's father who stood before him smartly, head erect, "Right."

"No, *Herr Officier*. I want to stay with my wife."

"As you wish. Left, then, left."

Anton saw the Bergers being loaded into the small black truck. The tailgate was lifted by the *Kapos* and they disappeared.

"Your name, please...."

That night the red glow over the camp lasted well past midnight. It was reflected by the fresh snow, dull red now, as if the ground itself were a layer of smoldering coals.

Over breakfast he and Paul discussed the war. Paul thought defeat was inevitable; Anton remained hopeful that Germany would win. After all, how could the country be defeated by inferior races.

"You don't have faith, Paul," he chided his companion. "You wait: in the end everything will turn out all right."

That night, after he returned to bed and lay next to Ursel, Anton dreamt about Judith. The two of them were in Vienna looking for Judith's house. They went up one street and down another, totally lost. People, houses, streets had changed; everything was unfamiliar to him. It was cold, and so dark that he could not make out Judith's face.

"It doesn't matter, Anton," she finally said. "Don't you know it doesn't matter?" Her voice was soft and reassuring.

When he awoke he felt as if he had wept in his sleep. He turned to Ursel. She was gone. She must have left early for her morning surgical clinic.

⋆22⋆

S OMETIME AROUND the onset of the Christmas season Judith start-
ed to interrogate the faces of the people she encountered. What
had they done during the seven years of the Nazi regime?

Mrs. Wagner, the owner of the shop where Judith liked to buy
fruit and vegetables was overly polite to her. She was a heavyset
woman in her fifties, with a lined face and gray hair which she kept
tucked under a red-and-white checkered cap.

Silent bystander or active participant?

Judith decided that the woman's polite smiles hid a malignant bit-
terness and that consequently she had been an active participant, like
one of those shrilly shouting women who had knocked down Mr.
Gruber and who with a laugh had threatened to cut his balls off. She
might even have participated when he was later beaten to death by
the brown shirts.

Once Judith had come to that conclusion she no longer could
shop at Mrs. Wagner's, but had to find herself another less conve-
nient store. Its owner, judging from his dour face and from the cross
and the photo of the church at Mariazell that hung on the back wall,
was a devout Catholic and probably had been a silent bystander.

So it went with all the other people Judith had contact with. Pro-
fessor Sandor Petofy was undoubtedly an active participant, proba-

bly less outspoken than Reinhard Kermauner, or he too would have had to go into exile, but like him a strong proponent of an Aryan Third Reich with a leader dedicated to liberating the German people from Jewish oppression. As for the extermination of the Jews, the most ancient and most dangerous enemies of the German race, he probably viewed that as a metaphysical proposition which he supported when amongst friends but which for diplomatic reasons he never endorsed in writing or in his lectures.

She stopped attending his lectures, and at length dropped his course.

She told Anton about her interrogations, as she termed them, during one of their sporadic meals at the Kistl, one of several cozy pubs not too far from the University.

"I am worried about you," Anton said. "You should not have dropped Petofy's course. It won't look good on your record."

"I could not face that man any longer. I am surprised the authorities have permitted him to continue to teach at the University."

"How do you know what his position was during the Hitler years? He might have been a Socialist, or even a Liberal."

"I know he was a Nazi, probably even an illegal Nazi like your father. Every gesture of his tells me that."

"Let's order another beer," Anton said. Judith knew he did not want to talk about his father. She had brought up Reinhard Kermauner's political past to test his son's determination to avoid confronting it.

When beer arrived, Anton questioned Judith about America. Judith smiled, the ruse was so obvious. For reasons she did not fully comprehend, he preferred her to be far away, the small blonde girl of his childhood, rather than a woman of flesh and blood sitting across a table from him.

"Tell me, what is it like to live in California?" he asked.

"I have been asked that so many times, that I have a ready-made answer. The weather there is always fine, and the gardens are like jewel boxes."

Judith was unused to the strong black beer, and it was rapidly going to her head.

"And you really don't want to go back?"

"Would you like me to?"

"Of course not. I am merely thinking about what might be best for you. Have you considered what you will do after you have received your degree?"

"My degree...."

She tried to think clearly, for after all this was an important question that deserved a well thought-out reply.

"To be sure, I don't want to go back. I don't belong to all that sunshine. It makes me wilt. Every part of me wilts."

She laughed. "Besides, if I go back, I might turn into plastic or into one of those immense, chrome-plated cars that roam up and down the boulevards, condemned to do so for all eternity. I don't think I'd like that one bit. I would prefer to turn into wood, even if it's a bit wormy." She rapped her knuckles against the table. There were ring marks on it, and a whole host of initials inscribed in indelible ink.

"Listen, listen how good that sounds," she said. "It's real. It looks like a table, and it is a table, and that's all there is to it."

Anton shook his head. After yet another beer the patrons at the pub became hazy. Soon the entire pub became hazy for Judith; even Anton who sat across from her no longer appeared sharply defined.

"At least in Vienna one can shut out the present," she said, "if that is how one is inclined. That's not possible in America. There the present intrudes upon people, warps them, and ultimately destroys the little morsel of humanity that is within all of us. That's how I see it." She raised her voice and raised her glass with a flamboyant gesture. Hearing herself speak she knew she sounded drunk, but she also knew that it did not matter whether she was drunk or sober; she was in a pub. It was like walking naked in a sauna; people expected it.

"Anton, I want to tell you something. Something very important. Are you listening? I have been to a land where everything is possible. I have been there and I didn't like it...not one bit."

Anton was patient and kind with her, and when, unaccountably, she burst into tears, he stroked her hand and cheeks and called her his *Schatzl*.

When they left the pub it was late, and she was uncertain of her legs. Her body felt as if it floated over the cobblestoned streets.

"Where are we going?" she asked, holding onto Anton's arm and making a mental note that her speech was slurred.

"I am taking you home. I worry you might not find your way."

"Of course I will…. Remember I was born and grew up here, just like you."

"That's right."

"I think you want to seduce me. Well, tonight I could well be seducible." She laughed, but then she suddenly stopped. Anton went on ahead, but seeing her stay behind he turned.

The sidewalk was narrow, scarcely wide enough for two pedestrians to walk abreast. Judith stepped into a doorway. Cold, dank air met her, centuries old. It was like the entrance to a vault.

"I think you don't love me," she said darkly when Anton returned and took her hand. "I know you don't love me. You are really in love with Ursel because she wants you to sleep with her."

"Good heavens, Judith, why do you say that?"

"Because I know it…not once have you told me that you loved me."

"Of course I love you. I have loved you ever since you were a little girl…all the time, even during the War. Why, you saved my life."

"I saved your life. How?"

"It's a long story."

"I don't care. You must tell me right now, this minute, how did I save your life?"

"Take my arm, and I'll tell you." Anton coaxed her out of the doorway and carefully, as if he had to test each sentence before uttering it out loud, told her as they walked through the dark streets. Not the complete story, but only those parts that he dared divulge to her.

✹

Over the ensuing weeks, orders came and went, the radio was filled with the most conflicting news, and groups of soldiers left. Some did so with as much military order as they could manage, others went on a rampage of killing and looting before departing. As for Anton, he tried to maintain as much regularity in his days as possible.

One morning when he reported for duty, there was only Schuller. Mueller had disappeared, and Gunther had been murdered by the *Kapos*.

"None of you have to stay here any longer," Schuller said. "You best take that half-truck and try to make it back to Germany. It will be easier for you without me."

"What about you?"

"I don't know whether I'll be able to make it. The Russians are looking for me."

Anton waited for him to say more. When there was nothing else, he saluted.

"*Heil Hitler!*"

"*Heil Hitler!*" Schuller responded with a smile.

Anton had always known that Schuller was a decent man.

That is how it came about that the following morning, as soon as there was enough light, Paul started up the half-truck. Anton got in next to him, and Helmut climbed into the rear.

"It will be better if we take the side roads," Paul announced. "The last thing I'd want is to have some fucking Russian plane spot us."

By then there was no longer a front line. Russian troops and partisans were everywhere, often decimating the broken up and retreating German units. Auschwitz had been evacuated, Poland had been abandoned, even the German parts of Silesia had been lost, and what was left of the army was now in Czechoslovakia, no one knowing where they might safely stop their retreat.

The sun came out from behind a skein of broken clouds. Milky and

soft, its light enveloped the copse of birch trees under which the three soldiers had spent the night. Their shadows were as yet uncertain.

"Let's go," Helmut shouted from the back of the truck. "What are we waiting for?"

"Just trying to see how much gas we've got left."

Paul bent his head down over the gas gauge. Tangled and unruly, his brown hair peered out from under the rim of his hat.

"Don't worry," Helmut called to him. "We can always commandeer some when we get low." He patted his gun. "This at least still works."

The truck started up with a jerk and moved out into the muddy road.

"I think we are on the right road for Katowitz," Anton said.

They passed rows of barren and partly flooded fields. In the distance lay a scattering of white farmhouses. Peering out of the window of the truck, Anton pointed to a formation of planes that had just appeared over the range of hills on his right. "Look at those swine. They're back again."

"Perhaps they're ours," Helmut demurred.

"Hell no, not anymore they aren't."

They entered a village. Two rows of low-walled houses lined the road. The windows and doors were barred; there was not a sign of life. The sharply steepled church was set back from the street facing a tiny square. A cart containing half-empty sacks stood abandoned in one of its corners. With its slanted pole it leaned against the trunk of a tree. It was as if it had rolled away from the road and had come to rest there, waiting for life to return to the village, and with it someone to reclaim it. An old truck had been parked on the far side of the square. Its sides were wooden, chipped, and makeshift, and its fenders were long gone. It too had the appearance of having been abandoned.

"Let's stop and siphon off the gas," Anton suggested.

This was an excellent idea and they pulled up alongside. While Helmut stood guard, Paul and Anton drained off what little gasoline

was left in the tank. In the process Anton swallowed some. He spat it out, but its taste, sweet and heavy, remained in his mouth.

"I hope I don't get sick from it," he thought. "That's the last thing I would want at this time."

The whole task took less than ten minutes. No sooner were they done with it—in fact, Helmut had already climbed back onto the truck—than the door of one of the houses facing the square opened. It was one of the least unprepossessing in the village. The walls looked as if they had been whitewashed not too long ago, and there were geranium plants in the windows. Anton could see the woman clearly as she came out. She was no longer young; a white kerchief was wrapped around her hair in a peasant manner, and her billowing skirt nearly reached the ground.

For a moment she stood on the threshold surveying the square, the dirty gray D.K.W., and the three German soldiers. Slowly, as if carrying an immense weight, she raised her right arm. She was a tall woman, and when she made her hand into a fist, it reached to the transom.

"*Svina, svina, zkazenà,*" she shouted at the soldiers; the pitch of her voice rose with the force of her hatred. Her arm fell to her side; she turned and quickly disappeared into the house. The door closed with a slam. A flock of pigeons that had strutted on the steps of the church fluttered up, circled, and soon becalmed, settled into their former places.

"What did she say?" Paul asked.

"I don't know, but I'm going to get her for it," Helmut shouted. With a swing of his body he pulled the gun from his shoulder. Anton had been standing by the side of the truck. He came over to Helmut who was aiming at the window of the house.

"Jesus, Helmut, what are you doing? We'll have the whole village on our necks."

"Get away from me. I'll show her something she'll remember."

"Let's go, let's go," Paul called out from the cab. He started the engine. Anton jumped in next to him and with a jerk that threw Hel-

mut off balance, the truck pulled into the road and raced off. Looking back, Anton no longer could see the village. It had disappeared behind billows of dust, and for a moment it seemed to him that all that had happened over the past few minutes, in fact even over the last couple of months, was but a dream, through which he was moving without a will of his own, compelled by his destiny.

"Are we still going to Katowitz?" Helmut shouted over the noise of the motor.

"What do you think?" Anton asked Paul. "Do you think we'll be able to find headquarters there?"

"What's the difference?" Paul replied. "I'd just as soon go home."

"We can't do that anymore." Anton shrugged his shoulders. "The Russians are probably there by now."

"That's one thing I won't do," Helmut interjected from the back of the truck. "I am not going to surrender to the fucking Russians. To the Americans, yes, but not to the Russians. They are savages."

"Where do you think the Americans are?" Anton asked.

"God knows, perhaps in Prague."

It had started to rain, soft desultory streaks across the windshield. The wipers did not work, and they had to stop to clean off the caked-up dust, which had cut down on their visibility. The truck entered a forest. Tall, dark, lanky pines blocked off what little light was left.

"I worry about the partisans," Anton mused aloud. He glanced at Paul, who was gripping the steering wheel, lips tightly pressed together. Two dark lines ran from the corners of his mouth to outline his black stubbled chin. Seeing Paul, who was two years older than he, so obviously afraid, made the fear that was already within him grow larger.

"Jesus, Paul, how could all this have happened to us?"

"Can't be helped," Paul replied brusquely. Nevertheless he speeded up the D.K.W.

"Hey, Helmut, keep an eye out for partisans," he shouted, his head partway out of the window.

"Yeah, and what else do you want me to do?"

Nevertheless Helmut took down his gun and held it in his lap.

By late afternoon they were between open fields again. The rain gathered in strength, and Helmut draped his overcoat over his head.

"Listen here, you guys, how about stopping and trading places. I don't want to be the only one to get sopping wet."

Before anyone could reply, there was a resounding crash from underneath the truck. The vehicle veered off the road, twisted on its axis, turned sideways, backwards, then finally with another crash fell upon its side. For a short while the engine roared on, as if unconcerned by what had happened.

"Jesus, Mary, and Joseph," Paul cried, "are you all right?"

Anton's nose was bleeding, but he had suffered from nosebleeds since childhood, so this was nothing of consequence.

"I'm all right," he said, licking the sweet blood off his upper lip. "What about Helmut?"

Helmut lay between the unploughed furrows of the adjoining field. He had been thrown from the truck and in the process had been struck over the head by the butt of his gun. Drawing his knees together he sat up and rubbed his temple. "Jesus, you guys, what happened?" he asked the others when they had climbed out of the truck.

"Such a shitty car," Paul cursed, bending over the D.K.W. "It's the front axle, the fucking thing broke on us."

"Now what?" Helmut asked, wiping the mud off his face.

"I don't know," Paul said, "I wouldn't have the slightest idea how to fix the damn thing."

"How far do we have to Katowitz?" Anton asked.

"How the hell should I know?" Paul replied. "Probably some fifty kilometers."

"That's eight to ten hours on foot. I guess we'll just have to do it."

For Anton it was as if reaching Katowitz had become the sole aim of his life. If he got there everything would be all right again, his life would fall into one piece and would regain the meaning it once had. Ten hours or not, he would walk on, looking neither right nor left,

like a child in a fairy tale walking through an enchanted forest. It seemed incredible to him that there once had been a time when he lay in his bed, propped up on an arm, and read fairy tales. The Snow Queen. It had been his favorite and Judith's as well. He thought about her for the first time in months. If she could see him now she would insist he walk on to Katowitz. How would she have said it? He could not imagine her words. After all, it had been such a long time since he had last heard them.

"Let's go," he said to the others. His voice was determined.

"Not me," Paul responded. "I'm staying right here."

"Me too," Helmut said. He looked at his gun. It appeared unscathed.

"But what about the partisans? They'll get you."

"I'm no fucking German," Helmut replied. "I am Austrian...*Jsem Rakousky*," he repeated in halting Czech, "from Vienna."

"I think that's the best," Paul concurred. "Listen, let's get rid of this fucking thing." He tore the swastika off his coat and with a swing of his arm sent it flying into the field: a small black circle describing a long trajectory against the dark sky. Helmut followed suit, as did Anton.

"Now let's see," Paul said, "where's our flag?" He climbed back into the cab of the truck, and after some searching came up with it.

"Anyone have a hanky?"

Helmut offered his. Paul ripped the swastika off the flag and using its red background, the handkerchief, and two safety pins, put a new flag together. Red-white-red: the Austrian emblem. He twisted the antenna upright, and tied the flag to it.

"They're not going to kill any Austrians," he said reassuringly.

Anton shook his head. "I'm sure you're right, but I'm going to take off anyway. I want to get to Katowitz."

"Fuck Katowitz. You're crazy," Helmut declared. "You stay with us. The three of us will be okay. Nothing wrong with the Czechs. My grandmother was from Brno, and boy, did she know how to make liver dumplings."

Rejecting Helmut's offer of his gun, Anton set off, marching down the road without once turning back to look at the truck that lay in the ditch like a black, monstrous beetle rotting in the rain, or at the two small figures huddled around it awaiting the end of their war.

"Left, right, left, right, hayfoot, strawfoot…" Anton mumbled to himself. His nose had stopped bleeding and now it was the cold rain that ran down his hair and across his face. He welcomed it in the expectation of the green fertile odors that would arise from the fields once the rain had ceased and the sun emerged. His hair was sopping wet and matted, and the thin, cold trickles of water ran down his neck and into his shirt. He smiled and breathed deeply. It was a wonderful sensation. The past was gone: forgotten. It was as if the rain had washed everything clean, leaving the world fresh and pure, ready to have his new life inscribed upon it.

He marched on. The last light faded, and when it became dark and he no longer was able to find his way, he sat down with his back against a tree. He pulled off his knapsack and searched in it for food. Nothing much was left. A small piece of Emmenthaler cheese, warmed by the heat of his back, and two squares of Ildefonso chocolates, the remnants of the last parcel his mother had sent while he was still at Auschwitz. He ate the cheese, and in spite of the rain and cold, he fell asleep.

When he awoke it was already daylight. His watch had stopped during the night, and he was forced to guess at the time. It was still raining, but now it was a mere drizzle. Nevertheless his clothes and the knapsack were completely soaked. Mechanically, he urinated, retied his shoelaces, straightened out his socks, and tightened his belt. No breakfast again, he thought, but his mind quickly returned to the marching he had to do before he would reach Katowitz.

"Left, right, left, right," he told himself, "hayfoot, strawfoot, hayfoot, strawfoot…."

Later that afternoon he fell in with Ulrich, a Bavarian from the 17th Panzer Division.

"Where are you headed for, buddy?" Ulrich asked.

"Katowitz," Anton replied. He no longer wanted to talk. But Ulrich was chatty.

"Where are you from?"

"Vienna."

"Oh, my God, a Viennese," he laughed. "I didn't deserve that. If I had known, I would have surrendered to the Russians." Anton did not reply, and Ulrich interpreted the silence as hurt feelings.

"Didn't mean it, buddy. Vienna is charming, and the girls…Wow! But all that's too late now. None of us are going to see the end of this business." Head bent down, Ulrich continued: "It's all over with us: treachery, treachery everywhere. Our Fuehrer never wanted this to happen, but those Jews, they turned England and America against us."

Ulrich carried an automatic pistol. He patted it and looked up at Anton.

"As for me, I'll die with this in my hand. It's cleaner that way… clean, no lies. One dies like a true Aryan, fighting to the end."

They walked through a couple of hamlets. The same whitewashed low houses, black roofs, chimneys devoid of smoke, deserted.

When it became too dark for them to continue, they found a barn in which to spend the night. The small amount of hay was a comfort to Anton, and he stretched out on it and opened his knapsack.

Only the two pieces of Ildefonso were left. Since he had no intentions of offering one to the Bavarian, he quickly swallowed both. The taste of the almond paste reminded him of an evening, more than six years ago, the evening of his father's Name Day, when Erika had played Mendelssohn. He had reported her for doing so. All that had been in another life, a life that had to be washed out of his mind. Once that was done it was only a matter of seeing himself through to the end of the war.

The Bavarian thought otherwise.

"We're done for," he said.

"Do you really think so?"

"Of course I do. There is treachery everywhere. Our Army is riddled with defeatists. They don't realize that history is harsh but just."

"What do you think will happen to us?"

"You and I don't matter. We will die, but by dying we shall set an example to our sons and daughters, a glorious example, like those Spartans did who died rather than yield."

The Bavarian frightened Anton. He shook his head.

"I don't know any longer what's right or wrong," he said.

Ulrich sat up and looked intently at him.

"You too, then," he replied harshly. "You too have been infected." He paused. "Listen, Anton, we Germans are destined to become the pinnacle of the human race. That trash out there, they don't matter. Today they may have more tanks and more planes and more men than we, but they are diseased, riddled with weaknesses, and their time will come, as sure as I am here in this barn with you."

"But I keep wondering: Could we have been wrong? Could we have been listening to fairy tales? After all, we know there never was a Sleeping Beauty."

"Wrong?" Ulrich gave forth with a brief laugh. "We are so right, so totally right. I know we are, because I feel it in here." He tapped his chest, "Right in here."

Anton was not convinced.

"But if we are wrong, what then? Do you know what we did? We committed crimes that were so horrible, I can't believe they really happened. And I took part in them, I killed helpless people: starving, sick, defenseless men, women…children."

He pressed his hands against his temples.

"You know," he continued, "the priest at Auschwitz absolved me. But he too is only human.…"

The Bavarian shook his head. "Don't waver, my friend, don't waver. What we did was for the good of the Aryan race, for the future of Germany. Even though we will not live much longer, we will be vin-

dicated in the end. Truth will conquer, remember that."

"But I don't know what is true and what is false. I don't know and I despair that I shall never know, for if we were wrong...."

Anton was unable to finish. It was as if a chasm lay before him and that to finish his thought meant to cast himself into it.

"I don't want to die," he finally cried out, "but how will I live with myself?"

There was only one answer. It was the one that had come to him the day before as he was marching through the rain-streaked fields: to forget. The Bavarian was already asleep, and bone-tired as he was, Anton quickly joined him.

The rumble of a truck woke him. It was barely daylight. He jumped up from the hay and peered between the slats of the barn. A column of dusty green trucks was going along the road heading east.

He roused Ulrich.

"Quick, quick, they're here."

"Who is?"

"I don't know, but they're not ours."

"For God's sake!"

Without another word the Bavarian jumped up and grabbed his pistol. Opening the door just a trifle, he pushed out the barrel.

"What are you doing?" Anton cried. "You're crazy!"

But he spoke too late. Ulrich fired a round at the truck, and reaching for the ammunition in the side pocket of his pant legs, re-loaded his pistol.

Outside there was a screeching of brakes. There were shouts and then an immense searing flash. A huge unearthly force pushed Anton down into the ground and into himself. When it was all over, he was lying next to a store puppet whose head was missing and whose trunk had been painted a grotesque red. Above him was a gray sky and it was still drizzling.

"It is still drizzling," Anton told himself, "and I am still alive."

He reached into his pocket and pulled out his handkerchief. It

was stained with chocolate, and one corner was marked by brown circles of congealed blood.

"That's right," Anton thought, "that's from when I had one of my nosebleeds."

There was a twig at his feet, and he tied the handkerchief to it and waved it through the barn door which, lacking a roof to keep it upright, tilted at a completely unreal angle. The fluttering handkerchief elicited some more shouts, but then it was still around him.

Anton got up and having pushed down the barn door, went outside holding the stick and the handkerchief in front of him. A truck and a jeep stood in the road: Americans. All at once the English phrase that Judith had taught him many years ago returned to him.

"I am your friend," he called out to the vehicles. "Friend, friend...."

"To this day," Anton concluded, "I am certain that had I not remembered that little phrase you taught me in fourth grade I wouldn't be here."

"I too had to walk through the woods at night," Judith reflected. That was when she told him of her escape to Holland. When she finished there were tears in her eyes.

"I love you," Anton said. "I never stopped loving you."

"All right, all right," Judith stopped and looked firmly at him. "So then you love me. So I am the sister you never had. But you go to bed with Ursel. Is it fun, going to bed with Ursel? Tell me. I want to know."

When Anton refused to answer, she kept questioning him. Her language became unashamedly wanton, and she enjoyed hearing herself use words that she had never used before. A picture of Uncle Bernhard flashed before her. He was sitting in their parlor about to tell a risqué joke, and her father was interrupting him: "Please, Bernhard, not in front of the children." She put her arm around Anton's

waist and they walked on. When they arrived at her apartment house she took the key out of her purse and handed it to him.

"Here, but don't turn on the lights. We can find our way up the stairs without them."

Once they were in her room, she took off her coat.

"So then," she said, sitting down on the bed, "here we are."

"Yes, here we are, finally."

He leaned down and kissed her.

"Wait," she said pushing him away gently, "I must have some wine. There is an open bottle on the dresser. Will you be a gentleman and pour me a glass? And help yourself." He poured her a glass and sat down next to her. She downed her glass and embraced him.

How firm he felt, she marveled to herself, how wonderfully firm. She took his hands and interlocked her fingers with his.

"We are so much alike: two bodies that complement each other: yin and yang," she said. "Yet for a time there we were pulled apart. All because you were a Nazi, and I was a Jew."

When Anton protested she smiled. Taking his hand she placed it on her throat. She felt his fingers run down her neck along the edge of the blouse. She shivered, again and again, a continuous quivering like leaves in a sunlit breeze.

Anton must have sensed it for he continued to stroke her neck.

"You are not cold, are you?" he asked.

"No, no, absolutely not." He kissed the top of her head and caressed her shoulder; his fingers crossed and recrossed the fine gold chain bearing the Star of David.

"I want you," she whispered. "I've always wanted you."

He did not answer; instead he kissed her on the mouth. She allowed him to force her down on the bed with the weight of his body.

"Are you going to rape me, Anton?"

"Of course not, darling."

"But I want you to rape me. Imagine that you are still in the Nazi Army and I am a Jewish girl. You have total power over me. Total power; you can do anything you want to, because you are a Nazi and

I am a Jewish woman."

"Please don't talk that way. It is horrible."

"I will let you do anything that Ursel refuses you."

With half-open eyes she watched him unbutton her blouse. In the dim light of the room his body took on an ivory hue. She closed her eyes and felt him pull off her skirt, and only from the warmth of his hands on her thighs did she realize how cold she was.

"I am so cold," she whispered. "Please help me get under the covers."

Undressed, he sat over her and ran his fingers across her face, her lips and her breasts.

"Tell me what you are going to do to me."

"I am going to kiss your breasts."

She looked up at him.

"Do you like them?" she asked.

"They are perfect."

"They are not too small?"

"Not one bit; they are precious."

He bent down and kissed her nipples.

"I am still cold. Why don't you come under the covers with me?"

With his arms around her it was soft and warm between them. How good it was to have no more thoughts, she was telling herself, no memories, only to feel each moment as it evolved, allow it to form in its destined fullness, and acquiesce to its power. They interlocked mouths and thighs, and as her hands gripped his hips a primitive rhythm took charge of her and drove her onwards to where there was no will.

Afterwards, in the peace and stillness that floated over her, she heard his heart pound softly, in unison with hers, racing on, like hers, but where to?

*

A few evenings later, she wrote to Brigit.

"Something unique and simple has happened to me, and I have

258

Anton to thank for it." She went on to relate the events of the night, at least as many of them as she could recall and was not too embarrassed to put down on paper. "If I were to become pregnant, it would bind him to me, and it would reaffirm my links with my home and my past."

She had not seen Brigit for so long, it was like writing into a diary.

→23←

I T WAS SUNDAY afternoon in the Vienna woods. A crisp fall day: beautiful, clear sunshine, the leaves in their last autumn splendor. Like a flock of unseen birds, the sound of church bells rose from the city below. Hand in hand Judith and Anton climbed the path that crossed the lowest range of hills and wound upwards between vineyards, a few small houses, and copses of newly planted trees. The view of the city was magnificent: a gray sea of houses framed by the silver curves of the Danube and the Danube Canal.

"The Germans mined all these hills," Anton said, pointing to both sides of the path. "Lot of good it did them."

"It's all so different from how I remember it," Judith remarked. "So many of the old trees are gone."

"The Russians cut them down to give their artillery a clean sweep of the city."

They walked on in silence. How happy I am, thought Judith, as she kept her eyes on the small stones under her feet. Everything has become resolved for me. My life centers on Anton. The two of us will be content with each other for the rest of our lives. Nothing else will matter. I don't want to look any further than his face, listen to anything but his voice, feel anything more than the closeness of his body. He is all for me, he is everything. This is the way it should be.

Hitler, the War, they were only an interlude, a few years that I will forget. I belong here with him. I have never belonged anywhere else, and never loved anyone else.

She stopped and tugged on Anton's arm.

"A kiss, if you please, Herr Kermauner." Anton kissed her and for a long time she felt the warmth of his face on hers.

"You know," Anton said, when they finally walked on, "there was a time when all we soldiers wanted was to have the war over and done with." His face grew earnest, and his fingers interlocked with Judith's. "The last few years were awful for all of us. As a matter of fact, when the Americans released me, I decided I would become a vegetarian. It was like a penance I imposed on myself."

"But you're no longer...are you?"

"No. I thought it was inadequate. Anyway, I only brought it up to show you how I felt about the war. You know, I may talk about going to America, about making a career for myself and all that, but in reality it's much easier for me to stay in Vienna. Things will get better with us ultimately. We won't have big houses, any of us, or big cars, but we will have contentment, or at least as much of it as is possible in this vale of tears."

They crossed a meadow. On the other side the path became muddy. Anton helped Judith, but despite that her shoes and stockings became soiled.

"It'll get better in a short while; over there it's all old growth."

Indeed the road turned rocky, and before long they were between tall broad trees.

"This is how I remember it," Judith remarked, "and somewhere along there I would always hear a cuckoo."

"Not in the fall you didn't."

"You are so right. Actually, I now remember where we are. At the top of the next rise there is a turn in the road, and we will be out on another meadow, and from there one can see an inn. My father and I would hike up here on Sundays. Am I right?"

"Absolutely. It's the Hameau. The old Emperor's hunting retreat."

"The Hameau…of course. That's where he would buy me a raspberry soda, as a reward for all my efforts at climbing. Shall we stop there?"

"Naturally. But the years have gone by, and we are old enough to drink beer."

"A beer it will be, and I will get so drunk that you will have to lead me down, otherwise I would become lost."

"You'd be the first person to get lost in the Vienna woods."

"Why not? I can see the headlines now: American Tourist Lost in Vienna Woods. The Russians will be certain I was a spy in disguise."

The Hameau had not changed one bit. Anton found a place under the trees, and the waitress brought two immense mugs of beer.

"Prost," Anton said raising his glass. "To us, and to our futures."

"To our future," Judith corrected him.

A family came and sat down at the table next to them. Father, mother, and three children, two of them adolescents, one a girl about eight. They ordered lemonade for the children and beer for the adults. The father unpacked his rucksack and pulled out cold veal cutlets wrapped in newspaper. There was also a container of potato salad and a lemon. The mother divided up the portions, cutting the lemon so that there would be a slice on top of each cutlet.

Anton saw Judith watch them. "What a wonderful time they are having," he remarked. "Our typical Viennese citizens. What kind of work do you think he does for a living?"

Judith was silent. She looked at the family sitting at the adjoining table and then at the meadow that spread out behind the inn.

"Anything wrong?" Anton asked.

Judith shook her head.

"I can't talk about it."

"Please tell me."

"It's as if some evil power within me makes me look at these people and demands to know what right they have to be alive. What right do they have to go on a family outing, when all my family is dead—murdered, assassinated, gassed? What did they do to deserve

to be here, and what did we do to deserve to die? We were no different. We enjoyed the same things they do. And do you know the worst? If I were to go up to them, and tell them about my family, they would not understand. I suppose if I were to sound sufficiently pathetic, they might manage a few words of polite regret. Look at them now: the father is spreading out the newspaper, putting the meat on it, he's making it look as if he were celebrating mass, as if eating veal cutlets were their sacred duty."

She jumped up and knocked over her mug of beer.

"I hate them, I hate all of them!" she cried. "Why did they have to sit down next to us? I was so happy until they arrived."

She threw her shawl on the ground and leaving her beer unfinished, hurried down the path in the direction of the city.

"Wait!" Anton called out after her, as he picked up her shawl. "Wait, Judith, we'll go back together. I still have to pay up."

For a long time they walked in silence. Only when they reached the first of the vineyards did Anton speak.

"You are so tortured, Judith, so driven. It hurts me to see you this way."

Judith looked at him coldly. "Does it, now? Well it's people like your father who made me that way."

She kicked a stone. It turned over, then gathered momentum, and rolled down the path, coming to rest in a narrow, mud-filled ditch.

"Tell me, Anton," she suddenly asked, "did you ever consider what you did during the Nazi years to be wrong?"

Anton dropped her hand. "Why do you ask?"

"Because I want so much to love you fully and with every part of myself, and I can't unless you tell me."

"I see." Anton's voice was remarkably soft. "In those days I didn't think about it…at least not at first…not until it was too late."

"Too late for what?"

"Too late to remain unsullied."

"What do you mean, unsullied?" But Anton would not reply. Instead, he put his arm around Judith. "Do you realize how much I

love you?" he whispered into her ear, and then bit softly into the bottom of her lobe.

"That feels terrible," she said and pushed him away. For a time, they walked on without speaking to each other.

They had reached the outskirts of Pötzleinsdorf, and there were sidewalks now, and low, yellow-washed houses that lined the streets. Judith stopped.

"There is one more thing you must know," she said. "In spite of everything, in spite of my memories, my pain, my anger, I can live nowhere else but here, and with no one else but you."

⇥24⇤

URSEL RECOGNIZED THE CHANGE in Anton and she knew Judith was its cause. She sought him out in the biochemical pharmacology laboratory and, sitting on a high stool, waited for him to write up his experiment and hand in the results to the laboratory assistant.

"If Mohammed does not come to the mountain, the mountain has to come to Mohammed," she said, and she steered him out of the building and down the street to a coffeehouse.

"You have abandoned me," she said, after they had been served their coffees and a tray of pastries had been deposited on their table.

"Why do you say that?"

"Please, Anton, don't fence with me. You have lost interest in me, and I sense that I am about to lose you to Judith. I ask myself what I can do to bring you back. Am I too involved in my work? Is that what it is?"

"Of course not."

"I didn't think so. Then what is it?"

"I feel Judith has the power to pardon me, to release me. That when she gives herself to me, she forgives me, and I can forgive myself."

"You have slept with her?"

"Yes."

"Then it is all over between us." She stood up and slipped into her raincoat. "You have made your decision," she said, raising her voice, "and I have just made mine. Don't say I didn't warn you." She strode off, as several heads in the coffeehouse craned in her direction, leaving Anton with two coffee cups and two untouched poppy seed–filled pastries.

><

"I hear it's all over between you and Ursel. For the time being, at least." Willi set down his beer mug and wiped a small amount of foam from his lips. The Steindl was not crowded, and the two men were able to converse without raising their voices.

"Who told you?"

"She did."

"She is jealous of Judith."

"A woman's prerogative," Willi said, as he lit a cigarette. "Particularly when her rival is an outsider, someone she doesn't fully understand. And Judith, as a Jew, is an outsider. That will never change. That doesn't mean I don't like her. As a matter of fact I have found the few Jews I know to be extremely interesting. Their view of the world is so different from ours it is refreshing. If you ever get tired of her, let me know."

"I don't think I will. There is a bond between us. When we make love I feel liberated from my past…as if I had been pardoned."

"Pardoned for doing what? For your meager contribution to the Fuehrer's war effort?" There was irony in Willi's remark. Anton hesitated before going on.

"Yes…that, and more."

"More? What more can she pardon you for?"

By this time Anton had found it easy to relate the story of the Jewish boy. The words came out as if on their own: he admitted being overtaken by a momentary loss of nerve. Willi listened and nodded. Quite a few men who served on the Eastern Front had similar and

equally comprehensible lapses. They returned home and managed to forget.

"There is something else. Something even more troubling to you," he said with crisp assurance. "You must pardon me for sounding like a father confessor, or an analyst."

"You are right, there is more." Anton was confronted by Willi's implacably unruly shock of red hair. "I have never spoken to anyone about it, not even to Ursel."

"Then it's about time. So: out with it."

Anton's instinct for compliance took over. Immersed in the quiet bustle of the Steindl, the hum of conversations at neighboring tables, he felt as if he were recounting events that never happened, some vivid dream of an early morning hour, or perhaps a fantasy that he conjured up to entertain his friend.

"I was stationed in Poland…in Auschwitz.…" he started out, and without taking note of his friend's expression or, as a matter of fact, anything else that was going on around him, he related his encounter with Judith's parents. Words and events came out in as much detail as he could muster.

"You really think you could have saved them?"

"I don't know. All I know is that I did not try. I will never forgive myself for that."

Willi leaned back in his chair and spread his hands in a gesture that was like a benediction.

"Listen, Anton, you are being unrealistic. There was nothing you could have done for them. Absolutely nothing."

"You don't know the circumstances."

Judith's mother coughs. A few isolated coughs at first, then more and more rapid, like bursts from an automatic pistol.

"How are you, Frau Berger?"

"Dreadful, dreadful…so dreadful."

"Why don't you wait here, and let me see what I can do for the two of you."

Anton turns his registration book face down and having pushed back the wobbly table which always gets on his nerves, goes up to Schuller.

"What is it, Kermauner?" Schuller asks.

"Captain Schuller, these two Jews were good friends of mine before the Anschluss. Can we put them into the work detail? I would be immensely grateful to you."

Schuller looks at Anton. After a moment's hesitation he nods, and Anton returns to the Bergers.

"Stay right here, by my desk, and don't move until I have finished registering the rest of the transport. I will then take care of your assignments."

There was no way to replay that moment. Ever again.

"I think there are certain crimes that are neither forgiven nor forgotten," Anton said.

"Your prerogative, my dear friend. For my part I don't think you would have achieved anything by reasoning with that S.S. man."

"Schuller was the officer in charge that day. He was a decent man. He would have listened to me."

"I doubt it."

"But there were a few Jews who survived Auschwitz. The Bergers could have been among them. In any case, what would have been lost by my trying to help them?"

"Ah, yes," Willi sighed. "A valid question. So what prevented you?"

"I was a coward."

"You'll never convince me of that. You say Schuller was a decent man. The worst that would have happened is that he would have told you that rules were rules and there were no exceptions. He would not have stood you against the wall for insubordination."

"Yes...so what was it?" His head turned down, Willi thought for a

while, then he looked up at Anton. Who, even when they were seated, towered over him.

"I will tell you what it was, my friend. You had some wretched need to perform as a perfect Nazi. To obey, to march in step with them, not to deviate one iota—all so that each and every decision would have been made for you, and so that you would never need to confront your freedom. If fear to confront your freedom is cowardice, then you were indeed a coward."

"So you see, I stand condemned."

"Maybe. In any case, I am much more lenient with you than you are with yourself." He lifted his mug, then put it down on the table without drinking from it. "My dear friend, you truly are in a bad way. I wish I knew how to help you. All I can say is that your crime was very ordinary and common, so common that Dante did not care to crowd his Inferno with people of your kind. He considered them deserving neither of heaven nor of hell."

"Ordinary and of no consequence."

"Right. Like most of us. Fate was kind to me. I was never put under such circumstances. Who knows how I would have acted?"

The door of the Steindl opened. With a freshet of cold, a group of students entered. Seeing Anton, they came to his table.

"How goes it?"

"Pretty good." What a relief it was to have them stop by for a chat. For Anton their appearance was like the morning light that interrupts a nightmare. "Can't wait to start in the emergency department. Get my hands on some real patients."

"I won't have that rotation until after the holidays. I still have to finish microscopic pathology. That's a real bitch."

"I know. Who do you have?"

"Sauerbruch."

"Thank God, I've never been exposed to him. I've heard he's a bastard."

They left the table without a glance at Willi, let alone exchanging a word with him. This was the way it had always been. Anton could

see the pain on the face of his old friend, and it was now his turn to offer solace.

"The trouble with you is that you are too deep for these guys. You can't make chitchat with them like I can. That sort of thing comes easy to me."

For a moment he again saw himself sitting at the wobbly table, his registration book in front of him. He fumbled for a handkerchief and wiped the corners of his mouth.

Willi leaned forward and lit a cigarette. "Does Judith know?" He put his elbow on the table and tilting back his head blew a blue cloud of smoke into the air.

"There is no way I could ever tell her. She would be unforgiving."

"As unforgiving as you are?" Willi asked with a twinkle in his eyes.

"I think so. That's why I could never be completely truthful with her."

"Don't worry about that. I don't think there ever is complete truth between a man and a woman. If there were, there could not be love." He paused and took a hefty swig from his mug. The first in quite some time. "It looks as if you are really in love with her. Am I right, my friend?"

Anton nodded, and Willi raised his mug. "Then let's drink to your love. And to all the doors that love opens. And you...you should forget what's over and done with...if you can."

⇥25⇤

WINTER CAME EARLY that year, and the city experienced several weeks of unseasonable cold. There was a shortage of coal, and while most housewives could find the time to stand in line in front of the coal dealers and get their fill of a bucket or two, Judith was much too involved with her studies to obtain her share of the rations. As a result her apartment was unbearably cold, and she was forced to work in the University library or occasionally, for a change in atmosphere, at the Steindl, where after having ordered a lunch that consisted of a pair of sausages and some bread, she would sit in the back of the *Wirtshaus*, spread out her books, and work for a few hours without being disturbed.

Her term paper dealt with the high German consonant shift. This was the change that the language of the Germanic tribes underwent when they migrated into southern Germany during the early centuries of the Christian era.

It was in this situation that Willi found her one afternoon. He pulled up a chair, sat down, and lit a cigarette.

"Tell me if I am disturbing you." She looked up at him and immediately knew he was lonely.

"Not one bit," she said. "Did you know that Jacob Grimm did much more than just collect fairy tales?"

"No…tell me."

"He was the father of linguistics. He described the changes that occur in the evolution not only of German, but of practically every language. I am doing a term paper on what Grimm called the consonant shift. I would love to think of a catchy title for it. Something like 'Grimm's True Tales.' Don't you think that's preferable over 'The Germanic Consonant Shift'?"

"I can't tell you. At least not right now. All I can tell you is that you look as if you need some fresh air. Would you like to take a break? A quick stroll through the park. It'll clear your head."

She smiled and closed her pen. "I suppose at this point I do need it. I am leaving everything right here."

She bundled herself up in her heavy leather coat, wrapped a woolen shawl around her neck, and while still in the doorway of the Steindl put on her gloves.

"Shall we brave the Siberian cold?"

Willi took her arm and steered her across the street. Together they walked the few blocks to the Schönborn Park, their breaths forming clouds before them. It was a small park, laid out like an afterthought but neatly kept with a few benches; of course it was much too cold to sit down.

"I find the evolution of languages fascinating," Judith said. Her mind was still on her term paper. "All the Germanic languages: English, German, Dutch…Yiddish, are derived from a Proto-Germanic language which we are able to reconstruct. In turn, Proto-Germanic is derived from a Proto-Indo-European language which once was spoken over most of Europe and in much of Southern and Western Asia. Can you imagine: people once spoke the same language from the shores of the Pacific Ocean to Iceland. And then…."

"There came the tower of Babel."

"Perhaps. There must have been a tradition of a unified language which was lost as the people migrated throughout Europe and Asia. What intrigues me is whether there was an even earlier and more primitive language, the language of the caveman."

Willi listened and nodded.

"I love to talk with you. It's such fun to be in the company of a smart woman."

"I am not that smart."

"But you are. Compared to most women. Take my mother, for instance. She is such a nonentity. She would have been very happy being restricted to children, church, and kitchen. That's all she ever talks about. And she—would you believe it—she considered me stupid."

"I too used to think so, you were so withdrawn and quiet. Now I know better."

"Not her. Intelligence remains invisible to someone who lacks it. She also thought my brother was a nonentity until he got a job as a news announcer. Now she listens to him every morning from eight to eight-thirty and brags to all her friends about how brilliant he is, although God knows he simply reads whatever his staff prepares for him. Of course he is quite handsome. Women fall for him all the time. Right now he is having an affair with Trudi Ansengruber."

"Who is she?"

"Don't you know? She is one of the prima ballerinas at the State Opera. Gorgeous, although a bit too skinny for my taste."

"And your father?"

"He exists in the past, trying to recreate for himself the grand and glorious days under the Emperor. He was a major in the Austrian army; the Nazis considered him to be 'politically naïve.' Right now he is preparing for the Opera Ball."

"Really? Isn't that some two months off?"

"It is. But it gives him something to do."

Judith thought of her parents. Although not unintelligent, her mother was certainly a strange woman, and her father was so immersed in his work that she scarcely got to know him. She related some lighter memories of them to Willi.

"I often think it would have been fun to know my parents as an adult," she reflected, "when they were no longer as imposing."

"One's parents remain imposing. Forever. Regardless of how old we are."

"I wouldn't know. They laid down their lives so that I would survive."

"What a burden you must carry."

Both became silent. It was rapidly growing dark; the time of day when there was only white and black. The trees in the park became black outlines, and the benches were damp and deserted.

"So where is Anton?" Willi asked.

"He is doing his rotation in the casualty department. Until two in the morning. It's his first clinical experience, and he loves it. He is beginning to feel like a real doctor."

"Medicine is much too demanding for my liking."

They were walking along the street on their way back to the Steindl. A few lights were on in the houses across the street; they could see figures move in bare and shabby rooms.

"How well do you know Anton?" Judith asked.

"Fairly well. After the Anschluss we attended the same Gymnasium."

"I often wonder what he did during the war. I know he was drafted and served on the East Front."

"You should ask him."

"I have. Several times. He becomes evasive, and I don't want to insist. It makes me afraid."

As it happened, she found out without having to ask.

<div align="center">

✣26✣

</div>

I T ALL OCCURRED VERY SIMPLY.
It was shortly before Christmas and Judith was over at Anton's apartment where she had prepared dinner. It was a plain affair, little more than stuffed sausage and turnips. Still, Judith liked to cook for Anton, even if it meant making the most austere of fares; to her it was like an offering. After dinner and some wine, they would make love; laughingly she called it a reckless love, for the table was left cluttered, and the dishes were allowed to languish in the sink.

The knock on the door came as a surprise.

"I hope it's not the landlady," Judith whispered. Guests of the opposite sex were frowned upon in Anton's apartment house, particularly when they stayed for dinner. This was the Eighth District, not too far from the Ring, and the emphasis was on morality and good decorum.

"That old dragon," Anton muttered, as he got up to answer the door. But when he opened it, there was Helmut.

"My God, Helmut! It's so good to see you. Come on in and make yourself at home. Judith, you can't imagine: this is Helmut, we were in the war together. Here, sit down and let me pour you some wine."

He took a glass from the cupboard, filled it, and set it before Helmut.

"It's about time I came back to Vienna," Helmut announced. "It's been such a long time." He looked at Anton. "You haven't changed one bit, a few pounds more weight there." He pinched him above the belt. "It doesn't matter, and you have got yourself a young lady. Will you please make the honors and introduce us."

"Of course. This is Judith, Judith Berger. She is originally from Vienna; she spent the war years in Ireland."

"Helmut Lanz. So pleased to meet you. I was born in Linz, but Vienna is my spiritual home. I love the city; I never get tired of coming here. This time I decided to see if I could find my old buddy Anton. He and I went through thick and thin, two comrades who marched together, step by step."

Helmut had been drinking before he arrived and was not quite sober. His words stumbled over each other.

"How many years has it been?" he asked. Crossing his knees, he raised his glass and looked at the lamplight through the wine.

"Too many," Anton replied. "If you knew my address you should have looked me up before. As for you, I didn't even know whether you were alive or dead."

"That's right. You took off and left us." He turned to Judith: "In some godforsaken place in Moravia, totally surrounded by partisans. They would have strung us up without even batting an eyelash. But, guess what—the Americans beat them to it. There they were, coming across the fields, a bunch of tanks from Patton's army, so we quickly surrendered to them."

"Good for you. What ever happened to Paul? I never heard from him. I tried to look him up, but his family is no longer in Vienna."

"They couldn't afford to remain. His father didn't have a clean slate. You knew he worked for Seyss-Inquart...." He turned to Judith. "That was the German governor of Austria, the Ostmark, as we called it in those days. Executed at Nuremberg. Paul's father wasn't too high up the ladder, but still, they had to leave, so they all went to Argentina. I hear they own a Volkswagen dealership, and Paul's

working for his father. He is probably making a bundle." Helmut poured himself another glass.

"Well, well…those were the days," he reflected. "But you must excuse me, Miss Berger, we are excluding you from our conversation. That's what happens when two old war buddies get together."

"That's all right. I have always wondered what Anton did during the war."

"Not much…not that I know of. Auschwitz was a pretty quiet place for two soldiers like us."

"Auschwitz!" Judith cried out. "What do you mean, Auschwitz?" Her eyes opened wide.

"Helmut, listen—" Anton tried to intercept his friend, but it was too late.

"We didn't do much there," Helmut continued. "The S.S. and the *Kapos* did most of the dirty work. Still, it wasn't a good place to be in, even though no one was shooting at us."

"Auschwitz.…" Judith repeated incredulously. "Anton, tell me, please, what were you doing at Auschwitz?"

"I worked in the office," Anton replied feebly. He wished the ceiling would fall down on them, or that something dramatic would happen to cut short this awful disclosure.

"You were at Auschwitz, and you didn't tell me!" Judith's voice mounted in intensity. She got up and stood over Anton. "You hid it from me! Why? Why?" she demanded.

"I didn't want to upset you."

"Upset me! What do you mean you didn't want to upset me? You are incredible! You watched millions of us Jews being murdered, and you have the gall, the impertinence to look at me, to touch me, to make love to me. Anton, I am going." She went to the bed and picked up her coat.

"Wait," Anton pleaded. "Don't I deserve one word of explanation?" Judith turned. Her face was flushed; angry tears were coming down her cheeks.

"I was sent to Auschwitz by the Army and I worked there. I filled out forms, nothing more than that. I had nothing to do with the gas chambers, nothing to do with the torturing and beatings. Believe me, Judith…you must believe me. I am completely innocent of all that."

"Innocent!"

"What else could I have done when I was ordered to Auschwitz?" Anton asked breathlessly. "Refuse the order and be shot as a deserter? Come now, be fair to me."

For a moment Judith stood erect and still; her eyes were half-closed. She tossed her coat back on the bed, pulled over a chair and, straddling it, sat down at a distance from the two men.

"All right," she said. "All right, Anton. Just tell me one thing. Did you kill anyone there?"

Anton was silent.

"Look, Miss Berger," Helmut interposed, "there were times when we were all under such pressure, such stress, you can't imagine. You weren't there."

"Damned right I wasn't there! I wouldn't be alive if I had been. You two would have seen to that, wouldn't you?"

Helmut shook his head.

"Don't talk like that, Miss Berger, please don't."

He was a powerful-looking man, but he had become terribly uncomfortable. "We weren't Nazis, believe me, we weren't."

"Then what were you? Cowards, criminals, or imbeciles?"

She turned to Anton.

"You haven't answered my question. Did you kill anyone?"

Anton did not reply.

"So you did kill a few of us. You didn't kill my parents, or did you, by any chance? I wouldn't put it past you. 'But of course you have to understand: this was during the War, we were fighting for our lives…,'" she mimicked.

"No, I didn't kill your parents. I had nothing to do with them. I merely registered them." The moment the words were out, he knew that there was no return.

"You what!"

"He was the one who registered the arrivals at Auschwitz," Helmut explained. "He sat on the railway platform with a big book and put down everyone's name, where they came from, and a few other vital statistics. He didn't even belong to the S.S."

Judith hardly heard him.

"You mean you registered my parents…you sent them to the gas chambers. Is that what you did?"

"No! No!"

"You registered them. You sat there filling out forms while they were being murdered."

Anton buried his face between his hands. "What could I have done? What, what? Tell me."

"I don't know what you could have done," Judith said, "and perhaps I am indeed unfair to you in that respect. But damn it, why should I be fair? Was there fairness at Auschwitz? Tell me, you worked there."

Anton was silent. It was as if he had not heard her question.

"Yes," he sighed, "Willi is right. For a time we did have a gloriously brilliant destiny, a meaning for our lives, but the price we paid for all that.…"

"The price you paid," Judith repeated with angry sarcasm. She turned away from Anton and looked at Helmut who pushed back his chair.

"This is more than I can stand," he complained. "It's like fighting the war all over again. I can see it, I'll be having nightmares from all this. And the worst of it is that it doesn't do anyone one bit of good."

Everyone was silent. In the background the radio was playing. The live broadcast from the Vienna State Opera had just begun. Tonight's performance was *Die Fledermaus*.

"Glücklich ist, wer vergisst,
was doch nicht zu ändern ist…"
"Happy he, who can be,
Resigned to grim reality…"

The overture—a lilting, meretriciously sweet melody. Judith stood up and, coat in hand, opened the door.

"Anton, I am leaving you…I don't ever want to see you again. I have loved you—no, I still love you, because after the first love there is no other. At least for me there isn't. But this is more than I can bear. You know what you are, Anton? A coward!" She paused, then added as if to herself, "There is no one now. No one to turn to."

Anton did not move.

Judith went out and closed the door. Her last view of him was as he sat at the table across from Helmut. A plate with an uneaten piece of stuffed sausage was in front of him, the mustard dried and cracked. She saw him as if in a haze, as if she were drunk, which of course she wasn't, for she had hardly finished her first glass of wine. She saw his pleading face and his half-open mouth. He looked unappetizing and ridiculous.

The streets were still and deserted. A cold wind blew against her face as she slowly walked over the cobblestones in the direction of her apartment.

That night Judith decided that she had to leave Vienna and that she would do so as soon as it was practicable, which meant it would be at the end of her first semester.

→27←

WHEN JUDITH RETURNED from her lectures a few evenings later she found a note from Willi under her door.

"How about the Cafe Kistl tomorrow night at 8? Call me, if you can't make it."

Of course Judith could make it. She had to talk to someone about Anton, and with Brigit only an impalpable form at the other end of her letters, Willi seemed the most appropriate person.

Willi was waiting for her.

"This is my treat," she said. "Agreed?"

"Agreed. I am sure you need to unburden yourself."

"You heard?"

"Anton is beside himself. Absolutely distraught. That man is head-over-heels in love with you. Completely crazy." He handed Judith the menu. "Why don't we order?"

"I must confess I don't feel like eating."

"Well I do." He ordered a *Beuschel*, which came garnished with cucumber salad and fried potatoes. Judith restricted herself to a bowl of potato soup with chives, but she allowed Willi to fill her glass with wine.

"So what are you going to do about Anton?" he asked, as he lit a cigarette.

"Nothing. I am leaving Vienna at the end of the fall semester. I will probably go back to California."

"I wish you wouldn't. Anton needs you to clear his conscience."

"Let him clear it on his own. You don't seem to understand. I trusted him. He was the only person in the city whom I fully trusted. As for the rest, I knew they presided over our deaths, over our murders, but as long as I had him it didn't matter…and now…."

"Can't you forgive him?"

"Forgive him?" She laughed bitterly. "For centuries we Jews have been tortured, murdered, driven from one country to the next, and in between the crimes that were committed against us, we were asked to forgive. Perhaps the time has come for you to forgive us Jews."

"Forgive you for what?"

"For excelling; for being the chosen people."

"You are; for that reason I would prefer that you stay. Anton is not the only one who needs you. I need you, Vienna needs you. Look what you Jews did for the city, and look what Vienna has become without you."

Judith shook her head. "I am too angry to stay. The other night, just after Anton told me he had worked at Auschwitz, for a moment there I wanted to pick up the bread knife—it was lying on the kitchen table within easy reach—and kill him. What good would that have done? It would not have been much of a retribution. I would have had to degrade him, starve and torture him to the point where life had become meaningless for him, and I would have had to do the same to his mother, and to his father who now lives a comfortable life in Switzerland—"

"And that is not possible," Willi interrupted.

"You know it isn't. I think you should also know that for me there are three great joys in life. The joy of love, the joy of power, and the joy of vengeance. I loved once, and it was a good love. I was the daughter of rich parents once, and there was a lot of power in that. And some day, I will experience my vengeance. My life will then be fulfilled."

"What kind of vengeance do you have in mind?"

"I have no idea. Perhaps my best vengeance will be to leave him alone with his conscience."

"What should I tell him? He knows I am seeing you."

"Tell him that there is nothing more we have to say to each other. Nothing. I will try to cease loving him. All I want to love is my own magical past, a past that he, you, and people like you destroyed. I thought, foolishly, that because I loved Anton when I was a girl, I could recapture my past through him. Well, I now know better. It's not possible. All I can recapture is my pain and my hatred: for him, for all of you. And that will never change; it will be with me for the rest of my life."

"You are implacable. What do you want us to do before you can forgive us?"

"I don't know. Shall we leave it at that?"

A couple of days later Willi met Anton in a pub on the Währinger Strasse a few blocks away from the medical school. The report he gave to his friend on his conversation with Judith was depressingly negative; for once it was not veiled with the euphemisms Viennese like to employ to sweeten whatever bitter pills life provides for them.

"How did you leave it with her?" Anton asked.

"She said she hoped you would stew in your own juice, or words to that effect. If I were you, I would see whether I could make my peace with Ursel. Try to do so without coming to her with your tail between your legs. You will be more effective." Willi gave a short laugh. "What a crazy world this is! Except there isn't another one." He put his hand on Anton's shoulder. "Come, man, let's have a couple more."

And he ordered two pints of beer.

><

<h1 style="text-align:center">⇝28⇜</h1>

WITH CHRISTMAS APPROACHING, Judith busied herself with shopping for presents. Brigit and the rest of the Halloran brood topped the list, followed by the Erskines, Terry, and somewhat reluctantly, Willi, her last remaining connection to Vienna.

Judith was a well-organized shopper, and even though the stores on the Graben and in the Kärntnerstrasse hardly had the variety and quality of goods they had had when Judith was a girl, she accomplished her task within a few hours.

Shopping bag in one hand, she was about to cross the Ringstrasse, when she saw her mother. The woman was dressed in a tan overcoat and a white beret and was carrying an umbrella and two shopping bags. Slightly hunched forward, she was walking briskly down the Kärntnerstrasse in the direction of St. Stephen's Square. As Judith stepped into the street, she turned to look at her....

Wisps of fog, and blurred figures as if in a dream. From somewhere in the far distance there arose an intense pain. Whose pain was it? It belonged to her, yet it did not belong to her. Then sleep again, and voices.

"Is she arousable?"

"She was earlier today."

From somewhere in the darkness came her name: repeatedly, insistently.

She tried to reply, but the words would not form themselves; they remained impalpable, like clouds. Unable to speak, she grew angry, furious. Repeatedly and violently she hit her hand, the one that did not have an intravenous line in it, against the side railing of her bed.

"Yes," she heard herself say in English, and as the words came to her, her anger evaporated. A white figure hovered over her. "Are you awake, Miss Berger?"

Am I awake, Judith thought. She was so confused, she did not know how to reply. Then she remembered that she was in Vienna, and that consequently she had to reply in German.

"*Ja. Ich bin schon aufgewacht.*"

"*Gut.*"

"I have so much pain."

"It will get better; we have just given you an injection."

When she woke up again it was dark and she was alone. A small lamp shone next to her. She looked at the circle of steady yellow light and reassured by it went back to sleep.

A sharp pain awoke her. This time she knew where the pain came from: her left thigh. She opened her eyes to daylight and a woman in white trying to turn her from one side to the other.

"Are you a nurse?" Judith asked.

"I am."

"Where am I? It's a hospital, isn't it?"

"Right you are, Miss Berger. It's the Allgemeine Krankenhaus, the City Hospital."

Things didn't gel. Did she become ill? Through the window she saw the morning light: milky winter sunlight.

"Why am I here?"

"You had an accident. You stepped in front of a streetcar."

That was all incomprehensible, for Judith did not remember

stepping in front of a streetcar. She remembered shopping for Christmas presents, remembered, in fact, the present she had bought Willi, a pair of motoring gloves. Willi was a nice man, and he had said he wanted to see her again. In an instant she remembered the evening with Anton and Helmut. The pain in her thigh grew worse, and a new pain arrived: around the left side of her face—cheek, chin, and forehead.

"I am in such pain," she said to the woman in white, who was washing her legs.

"Dr. Wagner left us a standing order for Demerol. Would you like some?"

"Would I like some? You mean I have to start making decisions?"

Then it was night again, and someone was calling her. She opened her eyes and saw Willi.

"Willi?" She wanted to test her senses.

"Right on target. Willi Moser at your service. How do you feel?"

"Awful. But sit down, Willi. Find yourself a chair and sit down."

She heard the chair being moved, but Willi had disappeared from sight.

"Where are you, Willi?"

"I am sorry. Here I am." Chair in hand, Willi appeared and sat down. "You know what happened to you, don't you?"

"A streetcar?"

"Right. The driver saw you but was going too fast to brake in time. You should see what you did to the streetcar. Completely smashed up." He laughed.

It hurt to laugh. "And what happened to me?"

"You had a bad knock on the head. A few broken ribs, and your thigh bone."

"What day is it?"

Willi laughed. "You won't believe me, but Christmas has come and gone. Today is the thirtieth of December."

"I had all these Christmas presents. There was one for you, as well. They were all in a shopping bag."

"There is a shopping bag in the closet, right over there, together with all your clothes. Or what's left of them." Willi pointed, but Judith could not see where he was pointing.

"If you bring me the bag, I'll sort out your present."

"You don't have to. Not now."

"But I want to."

Willi obliged, and Judith pulled out a muddied box.

"It doesn't look like much, but this is yours, and a Happy Christmas, Willi. Somewhat belatedly."

"Not your fault." He took the box and started to open it. That was when it came to Judith that she could not see out of her left eye. She felt her left forehead and cheeks, and encountered bandages. She closed her eyes; her right eye to be exact.

"What wonderful gloves! You are such a dear." With her eyes closed, she felt Willi's kiss on the good side of her forehead.
' "I am so tired. But please promise to come by again."

Willi promised to stop by the following evening on his way to a New Year's Eve party.

"I won't be able to have champagne with you," Judith said.

"Doesn't matter. We can catch up on it when you get out of the hospital."

Pocketing the motoring gloves Willi disappeared.

Judith was asleep when Dr. Wagner woke her the following morning.

"How are you Miss Berger?"

"Tolerable."

"Good to hear that. You have had some nasty injuries."

"That's what they tell me. I suppose they'll mend sooner or later."

"Of course. At your age...." There was a pause. "I am afraid that I have to tell you that your face will need a few surgeries."

"What do you mean?"

"Your forehead, cheek and chin were badly cut. I think we will be able to save your left eye."

"How badly?"

"Quite badly. We already have had Professor Jellinek see you. He is a world-renowned plastic surgeon."

"What happened to my face?"

"As I said, it was injured."

"How?"

"The wheel ran over it."

"The wheel? I want to see what I look like."

"There is nothing to see: you are bandaged."

"I want to see, I have to see; please bring me a mirror."

Dr. Wagner reluctantly called for the nurse, who soon enough handed Judith a mirror. The right side of the face stared at her; the left was hidden behind diagonally applied bandages. For a long time Judith looked at her face, wondering what lay behind the bandages.

When Willi stopped by that night, he was already slightly drunk.

"I am going to see Anton tonight. Anything you want me to transmit to him?" Judith thought, then shook her head.

"No...nothing."

"Are you sure? He is very anxious to visit you."

"Look, Willi, I am in pain, I am still not able to think clearly, and I am positively terrified as to what is behind that bandage. The last thing I want to do is deal with Anton."

"Got it."

"Good."

A few minutes later he took his leave. "Everything will be all right. I'm sure of that."

"I wish I were."

He wished her all the best for the New Year and promised to come back in a few days. Weather permitting, he was going to go to the Rax for some skiing.

The following afternoon Dr. Wagner made his rounds. He was in good spirits.

"*Na, wie gehts?* How are things? A happy new year to you, Miss Berger."

"Same to you, doctor."

"Time to change your bandages. Shouldn't hurt too much. We'll be as gentle as we can."

The nurse came over with the metal instrument tray and rolls of fresh gauze bandages. A few minutes later Judith felt an unnaturally cold wind across the left side of her face. She put a hand over her right eye, and lo and behold, she could see the doctor bending over her, and the nurse in the background, pushing the old bandage into a paper bag.

"I can see with my left eye."

"Great. We knew you would."

"Please bring me a mirror."

"Not yet; next week."

"I want a mirror right now. I want to see my face."

"Please, Miss Berger."

"I must see my face."

The doctor gave a heavy sigh, and asked the nurse to bring a mirror.

Two faces confronted Judith. On the right was her usual face; perhaps somewhat haggard, with her eye too boldly outlined; on the left was not a face, but only an eye that stared at her from a bloody mass of swollen and chaotic meat and bone. She opened her mouth; a black hole appeared amidst the red flesh. She felt weak and faint; as her head sank back against the pillows the mirror slid from her hand. There was a resounding crash and the shattering of glass.

"Jesus, Mary, and Joseph!" the nurse cried out. "Seven years of bad luck!"

"You moron!" the doctor shouted. "Go get someone to come in here and sweep up the glass." He sat down on the bed and took Judith's hands.

"We must not get too depressed about this. Professor Jellinek is an absolute artist. He can work wonders."

Judith tried to free her hands so that she could touch her face. Dr. Wagner held them firmly.

"Please keep your hands away. There is a tremendous risk of

infection. Even though you are on antibiotics." He growled at the nurse when she returned to the room, and after an orderly had swept up the glass, they rebandaged Judith's face. Despite being hidden behind clean white gauze, its shredded image remained in her mind.

"I was beautiful once," she told the nurse later that day. "Everyone said so. And now…oh, dear God."

Where can I go looking like that, she thought during the night. Certainly not to California. I would have to conceal my face behind a veil.

"You can't imagine what I look like," she said to Willi when he visited her following his ski trip to the Rax.

"I'm sure it's not as bad as you think." When Judith groaned softly—she had not been able to cry about her appearance—he added, reassuringly, "I'll still take you out. That is if you don't mind."

But Judith knew he was lying to her. Once or twice perhaps, out of sheer pity, then with his duty done, no more.

"Anton would like to see you."

"I knew he would. Tell him he can't. If he wants absolution, let him go to church."

"You were special to him."

"I am sure I was. He can find himself another woman to put some excitement into his life. First it was the Nazis, then it was to be me."

What she didn't tell Willi is that she also wanted Anton to remember her the way she was when she walked out of his apartment. He loved to be seen in the company of a beautiful, expensively dressed woman. He had once called her his Dollar Princess.

As Judith improved, she set out to write letters: to Brigit, to the Erskines. In them she related her accident and hinted that she had suffered serious injuries to her face. In return she received a long letter from Helen Erskine, chronicling life in California and ending with an invitation to interrupt her studies and come and recuperate in the endless sunshine.

Brigit, for her part, flew to Vienna to visit Judith, who by then was close to being discharged. A skin flap had been placed over her fore-

head, cheek, and chin. Although it covered the gaping raw flesh, it made her face appear blurred, as if one side was made of wax which had melted.

"I don't think you look so bad, Judy. All you need is a bit of make-up."

"I look grotesque. I feel as if I should crawl into some burrow and only come out at night. You don't realize how many times I have wanted to die. But I won't. Not until I have lost all hope."

"Don't say that. For me you are still the same. In fact, after being with you for a few minutes I hardly notice your face."

"You are right. I have to stop feeling sorry for myself, and just carry on as if nothing had happened to me. You know, whenever I haven't seen myself in a mirror for a few days, I forget what I look like."

"That's a blessing," Brigit said. "I'm sorry, I didn't mean that...," she quickly corrected herself.

The following afternoon, with Brigit's help, she drew up a list of tasks. First she would sit for her examinations so that she could receive credit for the semester at the University of Vienna, then she would close up her apartment, sell the few items of furniture which she had gathered—the blue chandelier, her prize possession, would be auctioned off at the Dorotheum—and, having settled all her affairs, she would return to California. Brigit approved, and before too long, Judith had carried out her plans.

A few days before she was due to leave Vienna, Judith found a note from Willi in her letterbox.

"Call me. I would like to see you before you go."

She went to a pay phone and called him.

"How about tomorrow night at the Steindl?" he suggested.

"No. I could not possibly go back there. Not the way I look."

"I understand."

"Why don't you come over to my place. It is a total mess, but we will manage."

The following evening they sat on chairs in the living room,

surrounded by suitcases and boxes of books. The chandelier had already been removed, as had the curtains, and bare windows looked down on the light reflected from the wet pavement of the Währinger Strasse.

"I am afraid the only thing I can offer you is some cheese and a bottle of wine."

She went into the kitchen, and brought back a plate of cheese which she had left outside the window to keep cold. Willi stacked two book boxes on top of each other, and she put down the plate.

"May I open the wine for us?" Judith asked.

"Do."

"We will have to drink from cups. But the wine is quite good. At least that is what the man in the store told me. When I knew you were coming I went out to buy it."

"The perfect hostess to the very end."

An image of being served a cup of cocoa by Mrs. Wolf, the rabbi's wife, appeared to Judith. The cocoa was hot, and she remembered stirring it slowly to cool it down while Mrs. Wolf told her the Nazis had torched the synagogue. Would she never be free of those images?

"I gather you are still set on leaving," Willi said. "I wish you would change your mind."

"Look around; you can see it's too late," she said with a sweep of her arm.

"Will you be back?"

"I don't know. I no longer can feel at home here."

"Neither can I. We are both outsiders. I am not one to make friends; with women it's even more difficult. Except for you. I sensed a link to you...immediately. You and I could talk about everything— endlessly, passionately."

"I know...."

"Unlike most of us who were tainted by the Nazi years, Anton has a guilty conscience. That will be with him, whatever happens." He made an operatic movement with his arm and hand. "As for my past...there is nothing."

"I know. But I couldn't stay here just because of you. When I returned, I wanted to rebuild my life as a Viennese Jewess, to the extent it was possible; now I know I cannot do it. I was born here, I grew up here, but as soon as I lost my trust in Anton, I no longer can trust anyone in this city. I see hatred and anger wherever I look. I am better off in California. There everything is new, constantly evolving. There will be nothing there to remind me of my past."

"I like America. It is a land of infinite possibilities."

"Not infinite, Willi, but certainly the possibilities there are greater than in Austria."

"What about your work?"

"I plan to finish my degree in America. I already have an idea for my thesis." She leaned back and held out her glass. Munching on a piece of cheese, Willi refilled it. "Would you like to hear it?"

"You know I would."

"It will deal with the *Ursprache*, the protolanguage, the first words that man uttered. Ever since my accident I have become fascinated by that transition between cries and words. You see, when I was recovering and still in the twilight zone that lies underneath consciousness, there was a time when I had lost my speech. I wanted to speak, but the words would not form themselves. I could hear myself moan and make horrible, disgusting sounds. You cannot imagine the anger I felt not being able to communicate. I have thought a lot about this, and I wonder whether the emergence of language prevented the hominids, the early man, from murdering each other. When a person has the ability to form words he can say: 'Keep away. This is my food, this is my woman, this is my territory. If you don't, I will smash your head with this rock.' Without words early man was reduced to threatening gestures, and if these were misunderstood, which they easily could be, there would be violence and death. What do you think?" There was a remarkable confidence in her voice.

"I think you have the germ of an interesting idea."

"Good. I suspect the Americans will agree with you." She got up,

and with her arms outstretched against the cold glass stood in front of the rain-streaked windows.

"So then," she said and abruptly turned towards Willi. "It's time we said our farewells."

"I am sorry you are leaving us."

"So am I, in a way."

"At least you must tell me how I can get in touch with you."

"That's easy."

She wrote the address of the Erskines on a slip of paper and handed it to Willi.

"I will probably come out to see you."

But he never did.

→29←

T HE SUNSHINE, the jewel box garden, and the blue swimming
pool were waiting for her, as were the elephant ears and the
Erskines, who tried their best to make Judith feel as if nothing had
changed. But Helen cried when she picked Judith up from the air-
port, and Randy talked persistently about consulting a plastic sur-
geon on Sunset Boulevard.

"He is unbelievable. The top plastic surgeon for the people in
show biz. And his office was designed by this Brazilian architect, I
forget his name—that's what happens to a person when he gets old. I
want to take you to see him."

But Judith refused. She had undergone three surgeries to her face
while still in Vienna and did not think that an American plastic sur-
geon could do much more to improve her appearance.

Terry called, absolutely delighted that she was back from Vienna,
and arranged to take her to the Mocambo, a jazz locale on the Sunset
Strip.

When he arrived at her home to pick her up he looked stunned.
Judith could tell that he had to muster all his strength in order to
accept her appearance. It was just as well that the Mocambo was
dark; Judith selected a corner table. Lately she had found that when
she rested the left side of her face in her hand, she appeared almost
normal; at least she did not evoke stares.

The music was exceptional: Oscar Peterson on the piano, Ray Brown playing bass, and Buddy Rich on the drums. After a few minutes Judith allowed the rhythms to carry her away and she forgot all about herself.

When Terry said goodbye to her that night she was grateful to him. "I had such a wonderful time. Let's do it again, soon."

"Let's."

But Terry did not call her, and Judith knew why: she had become damaged goods. So she applied herself to her work; and having a good head and few diversions, she did well, and her grades showed it.

She graduated with honors and elected to do her doctorate at Berkeley. As she had outlined for Willi, her thesis dealt with the emergence of language in early man. It was generally acknowledged as brilliant and highly original so that her defense of it became a mere formality.

Several years came and went. It was summer, and for the past two weeks Judith and Brigit had been hiking through Connemara. The weather was exceptionally fine, scarcely any rain at all. In fact, there was such a dry spell that Brigit was concerned.

"It's our poor farmers that I am thinking of," she said, "for it's almost a drought we're having this year."

The skies were clear and there was hardly more than a breeze for the boat crossing to the Aran Islands. The girls stood at the railing and looked into the water. Deep blue it was, and as smooth as glass.

For a few days they stayed on Aranmore, and Brigit was able to practice her Irish with the women of the island.

"What a wonderfully strong language it is," Judith said admiringly, as they were walking along the harbor. "It's a pity I have quite forgotten it. Remember how you taught me Irish, and I helped you with your German?"

"Of course I do. It doesn't seem that long ago."

A few steps later Judith added, "We Jews and you Irish live with our memories; it prevents us from experiencing each moment in isolation."

That night, in a little bed and breakfast place outside Kilronan, they stayed up late and talked. The moon was full and a silver world lay outside their window. It was on nights such as this that the Little People were said to be afoot.

"Are you coming back to stay?" Brigit asked.

"Perhaps, but not for a few years. First I'll finish my degree and then I'll decide whether to return. But there are so few opportunities for someone with my educational background."

"You know we'd love to have you come back; all of us would, even the boys."

"Oh yes, the boys...."

Judith smiled. "Don't worry about them," she said, "they're getting more sense with each passing year. Don't you see, you can always come and make your home with us?"

"No, not yet." Judith sat up in bed. Through the curtained windows she saw the outline of Dun Aengus. The prehistoric fortress was perched on the crags overlooking the ocean: Europe's last bastion against the West.

"You know," she added, turning to Brigit, "there was a time, it seems so long ago now, when I loved Anton because I thought it would be a means of regaining my home. But that was all wrong, all childish fantasy. Actually it's far more difficult than that. Someday, perhaps, although I don't think this will be ordained for me, I might love someone again, and if that happens then my home will be there, with him, wherever he may be."

"I understand." Brigit was engaged to marry Frank Hearne, and she was not sure she was doing the right thing. But Frank was about to become a solicitor, and he was a steady boy who hardly ever took to the bottle, so her parents were delighted with him.

The next morning they climbed to Dun Aengus. There they found themselves in a harsh and rocky world: stones, boulders,

crevasses, and hardly a patch of green. During the night it had become overcast and now a bitter wind blew in from the sea. At a turn of the path Judith stopped and bent down. Growing at her feet, out of a mass of sheer rock, was a clump of tiny, pale blue flowers. She crouched to feel their stems and petals. Theirs was a gentle, marvelous color, a surprise in this most barren of all places. She pointed them out to Brigit.

"Aren't they beautiful," she said.

"Very," Brigit agreed, "but I can't tell you what they are called."

"It doesn't matter."

Brigit looked down at her friend, whose hands were cupped lovingly around the flowers.

"Your face looks quite at home amidst these rocks." Once again she had put her foot into her mouth, and she said so.

"It's all right," Judith said and smiled. "I know you mean well. Let's get on, though, before the rain comes in on us." Indeed a heavy bank of clouds had swept in from the sea, and it had started to drizzle.

She straightened out and followed Brigit up the hill. Don Aengus was not too far off now, and she could already make out the bare windows of the fortress starkly outlined against the sea. As they climbed the last part of the way, its immense black form loomed above them, unyielding, stark, an immutable witness to the passage of time.

"I'm glad we've come here," Judith said simply, and for that moment at least, she was at peace.

><

⇥Epilogue⇤

THE NEXT TIME Judith returned to Vienna she was an old woman. Her hair had thinned and it was white, and she walked hunched forward, although still briskly; her mother's gait as it was imprinted in her memory. The years had softened the scar across the left side of her face, and since most faces of old women bear the brunt of time, her appearance had become less repellent. It was early fall, and the chestnut trees lining the Main Avenue of the Prater were in their most radiant gold. The occasion was the biannual meeting of the International Linguistic Society, and Judith was to give the keynote address: "Language and Violence," the title of her latest book.

As academic works go, *Language and Violence* was an astounding success. It was reviewed in several newspapers, both in the United States and in Europe, and was described as being "brilliant, precise, powerful, and passionately argued." As a consequence, Judith had numerous invitations to be interviewed and propound her ideas on television. These she turned down with neither hesitation nor regret. She did, however consent to write an editorial for the *New York Times*.

Man needs language to communicate in a nonviolent manner, she stated in her editorial. Early man found words to be more accurate and error-free, and more importantly, less physical and therefore less

threatening, than physical gestures as a means of transmitting positive needs and demands to fellow men. When it came to negation, that is the conveyance of the concept: "I will not attack you if you don't take my food," a verbal message, allowed even less latitude for misinterpretation than gestures. Now however, with the increasing prominence of movies and television in which language takes a backseat to action and visual images, man is in the process of losing his ability to communicate by means of words. She concluded that the impoverishment of language leads inevitably to an increase in violence.

The evening Judith arrived in Vienna, she had an early dinner with a group of colleagues. It was at The Three Husars, an establishment designed with the tourist in mind, and the food was hardly the kind that Judith remembered from her childhood. The talk at her table was about University politics and the forthcoming excursion to the Imperial palace at Schönbrunn, which had been arranged for members of the Society. Judith listened with her hand covering the left side of her face, a habitual gesture. She was an outsider. It was late when she returned to the hotel, planning to make some finishing touches on her lecture.

She washed hands and face. Then as if compelled by outside forces, she looked up Anton's phone number and dialed it. A male voice answered.

"*Ja, hallo, hier spricht Dr. Anton Kermauner.*"

"Anton! It's Judith, Judith Berger."

"Jesus! Judith! After all these years. Let me get Ursel on the other line."

"Don't. I would like to talk to you."

"How have you been? Tell me? Are you well?"

"Just fine. I teach linguistics at Berkeley. That's a branch of the University of California. And you?"

"We are all well. I am practicing internal medicine, and Ursel is doing psychiatry. Can you imagine, the daughter of a surgeon has become a psychiatrist. And we are about to become grandparents for the third time."

"*Mazel tov.*"

"What?"

"It's a Hebrew word. It means good luck. And your parents?"

"They have passed away. My mother died…nine years ago. And my father…did you know he was allowed to return to Vienna? He lived in retirement for nearly fifteen years. Surrounded by his books and his friends. Never once did he talk about politics. For him it was, as he put it, the forbidden land."

"And Willi?"

"He died, poor man, quite some time ago. He had a heart attack."

"What a shame. He must have been quite young."

"He smoked too much, ate too much, and refused to listen to me. He never married. Ursel says he had a death wish. Listen, Judith, we must see you. We are having a little soiree tomorrow night, a light supper, and then some music. Schubert and Mendelssohn. Can we get you to attend? It would be so lovely."

"I don't think I want to come."

"Then how about dinner? How long will you be here?"

"No. It is best we only talk over the telephone. Your voice is your essence, and that is enough."

There was a long pause. Judith knew that Anton was thinking about her appearance.

"It has nothing to do with my face, Anton. I have become used to that."

"Then what is it?"

"I am afraid; I don't think I will ever be strong enough to see you and Ursel. You see, if I had to confront the reality of you, the anger which smolders within me could again flare up, and that is not how I want live my remaining years."

Even so, she still was suffering from nightmares. Her Death March, as she termed it in her letters to Brigit.

"You are not married?"

"No. With my face the way it is, I suspected ulterior motives from every man who became interested in me."

"I understand."

"So, Anton, how is your conscience?"

"My conscience...."

"You know what I mean." There was a long pause.

"There were many things I did or didn't do that give me a lot of pain. I think about them every once in a while."

"But not all the time?"

"I suppose not." Then after a pause. "Have you forgiven me?" There was another long pause; she had known he would ask that question. "Judith...are you still there?"

"I am...and I have forgiven you. I wanted you to be a hero, my hero, and you were not. Almost no one is. In those days I might have judged too harshly."

"Thank God. This is what I have waited to hear from you."

"Anything else we should say to each other?"

"I still love you."

"Don't let Ursel hear you say that."

"I won't. And you?"

"When I told you that after the first love there is no other, I was right. For you I feel both love and anger. Both have been dulled by the years. But the sense of loss is still there, as strong and as poignant as ever. It overcame me last night, as I walked along the Graben." Another pause ensued.

"Are you happy?" Anton asked.

"I like my work."

"Is that all you have to tell me?" Anton said at last.

"Did you expect me to invite you to run away from wife and family and elope with me to Berkeley? Is that what you were waiting for?" She laughed.

"Perhaps." He joined in her laughter.

"You are such an incurable romantic! First Cameroon, then the Nazi mirage, and now California. I suppose there will always be a part of you that will search for your miraculous kingdom."

"You are right."

"I know I am. Goodbye, Anton, and stay well."

"You too."

She hesitated, then hung up. Everything she had to say had been said.

She went to the window. A glitter of lights. In the morning she would look out at a skyline that decades had done little to alter: St. Stephen's Cathedral, the giant Ferris wheel, in the distance the surrounding blue hills. A few new high rises had made their appearance, but that was all.

It was time to get ready for bed. As she combed out her hair, she looked into the mirror.

It was the first time she had done so in fifty years.